LOW-CARB
Quick & Easy

LOW-CARB
Quick & Easy

Frances Towner Giedt

HPBooks

HPBooks
Published by The Berkley Publishing Group
A division of Penguin Group (USA) Inc.
375 Hudson Street
New York, New York 10014

First HPBooks trade-paperback edition: March 2004

ISBN: 1-55788-427-7

Library of Congress Cataloging-in-Publication Data

This book has been cataloged by the Library of Congress

Printed in the United States of America

10 9 8 7 6 5 4 3 2 1

To my son, Kevin, whose very existence today is living testimony of the effectiveness of a low-carb diet—and to the team of doctors who, thirty-three years ago, had the wisdom and courage to put me on Dr. Atkins's diet years before it became fashionable, which ultimately saved my life and that of my unborn son.

Acknowledgments

Not too many cookbook projects get their start the way this one did. It was a rainy day in March when I got a phone call from my friend, former editor, and agent, Coleen O'Shea, asking if I'd like to do a couple of low-carb cookbooks. Since I am very familiar with eating and cooking low-carb, and promote carb-counting on my two websites, I said "Sure," and asked some pertinent questions as to the publisher, time frame, and nature of the low-carb books wanted. She asked me to e-mail her a short bio and a short list of possible book titles. Three weeks later we had a vocal commitment on two titles: *Low-Carb, Quick & Easy* (this book) and *Cooking Low & Slow* (fall of 2004). This is our tenth book together and once again, I am extremely appreciative of Coleen's publishing knowledge and her skill in leading us all forward to a common goal.

I am also grateful to John Duff, publisher of HPBooks, for giving me this opportunity to share my low-carb recipes with you. He has made himself and his office available for advice and consultation every step of the way. A big thanks, also, to John's assistant Katie McHugh—a helpful, friendly voice at the other end of the phone.

My editor, Jeanette Egan, and copyeditor, Candace Levy, deserve special recognition and thanks. I am privileged to be working with such knowledgeable and capable editors.

On the production of this book—thanks to Liz Sheehan who designed the

cover, I fell in love with its clean, bright look at first sight . . . and to Tiffany Es-treicher for her crisp and spirited book design.

Last but not least, I would never have started this book project without the support of my husband, David. Not only does he keep me focused on my writing, but he's also my toughest recipe critic. Bless you.

Introduction

I HAVE BEEN following a carb-counting regime since April 1970. That's when my obstetrician informed me that recent blood tests indicated that my body was no longer able to metabolize carbohydrates and that at 20 weeks pregnant, without any history of diabetes in my family, I had developed gestational diabetes. He went on to say that my life was at risk and he felt it advisable to terminate the pregnancy, which would have resulted in almost certain death of my baby. After getting a second opinion, it was decided to try an experimental and highly controversial low-carb diet that had been written up in the *Journal of the American Medical Association*. So with the article in hand and my agreement to twice weekly fasting blood draws (self-testing was unheard of in those days) and a once-a-week, 2-hour-after-eating draw, a weekly appointment with my internist, and twice monthly visits to my obstetrician, I embarked on carb counting. I was allowed to have a total of 45 total carbs per day and not one more. It was also fully agreed among my doctors, my husband, and I that if my blood glucose didn't lower from its alarmingly high level, termination of the pregnancy would be the only alternative.

So the daily carb counting began and, armed with my scribbled list of carb counts of foods I might eat, I changed my diet and my lifestyle. As the mother of a 2-year-old, I was already getting lots of exercise, but I increased that, taking long walks, pulling my son in his wagon, and spending hours a day gardening while he

played in his playhouse nearby. Little by little, my blood glucose levels started to creep down and, at the end of each week, it was decided that I could continue for yet another week and then another, until in early July I was informed that my fasting and my 2-hour-after-eating tests showed normal blood glucose levels. We all breathed a profound sigh of relief, but I was kept on the strict diet and, later that month, I delivered a healthy, robust 7-pound, 4-ounce son. Today that son is a six-foot, 2-inch man who has never experienced anything more serious that an occasional cold. And I ended up after delivery 10 pounds lighter than I had been before my pregnancy! Do low-carb or carb-counting diets work? It certainly did for me, saving both my life and that of our son. By the way, Robert C. Atkins, M.D., wrote that medical article several years before the publication of his first book, *Dr. Atkins' Diet Revolution*, in 1973. Dr. Atkins's diet at the first level calls for 45 *net* carbs (carb grams minus dietary fiber grams) per day, whereas the diet I was given was 45 *total* carbs per day.

Some 16 years later, carb counting would come again into my life when I was again diagnosed as having diabetes, only this time there was no pregnancy and there would be no reversal of my inability to metabolize carbohydrates. In years since, I have always been in tight control of my blood glucose levels, with my cholesterol and triglyceride levels well within ideal range. I have subsequently studied about diabetes and worked with a writing partner who has type 1 diabetes and with the world-famous Joslin Diabetes Center of Boston to publish four definitive cookbooks for diabetics—*Gourmet, Quick and Easy, Healthy Carbohydrate,* and *Great Chefs Cook Healthy.* My partner and I also publish *Diabetic-Lifestyle,* an online monthly magazine for people who are living with diabetes, which is accessed monthly by millions in this and 134 other countries.

When the American Diabetes Association (ADA) in 2000 decided that counting carbohydrates would become a recognized way to control diabetes, giving an alternative to the exchange system, it was still considered that 60 percent of the day's calories should come from carbohydrates. As a person who would rather eat a potato than a piece of chocolate, a whole loaf of bread than a great steak, or a piece of fruit than most anything, I now know that I simply cannot metabolize 165 total grams of carbohydrate each day, which would be 60 percent of my supposed 1,500 calorie diet. I gain weight quickly. At 100 total carbs a day, I can

maintain weight, but at 80 grams or 60 grams, I feel even better and can actually lose 1 or 2 pounds a week, respectively.

Although the ADA has yet to come out in full support of a low-carb diet, they have now published their own reduced-carb cookbook. Recently, heart doctors have also started investigating low-carb diets for their patients. My own doctors at Baylor Heart Place here in Dallas and at the Heart Center at Cleveland Clinic suggested to me and their other patients in 2002 that more closely following a lower-carb diet would be advisable. Little did they know that I've been doing that for years.

When you're counting carbs, do you have to worry about anything else? Not really, if you are eating reasonable portion sizes. If you think a 24-ounce porterhouse steak is a reasonable portion, think again. Restaurants offer them, but look at who's actually eating them—for the most part, people who need to lose weight. Dietary fat occurs in meat, fish, poultry, and diary products (such as cheese, butter, milk, and cream). Limit these, and when you're adding fat to prepare a dish, try to use "good" fat such as olive or canola oil, nut and avocado oils, and the foods that they come from. The most healthy of fats are the omega-3 fatty acids found in fish and some plants, such as flaxseed and purslane, nuts, and canola and soybean oils. Epidemiology experts at the Harvard School of Public Health reported in the *Journal of the American Medical Association* that long-term clinical trials have not provided good evidence that reducing dietary fat per se leads to weight loss. At the same time, a study at Duke University concluded that a low-carbohydrate diet could lead to significant and sustained weight loss. Even best-selling authors of low-fat cookbooks such as the *New York Times*'s Jane Brody and Marian Burros have recently come out in favor of more fat in the diet. Doctors and nutrition experts alike think that radical changes are needed in the U.S. Department of Agriculture's Food Guide Pyramid that is due to be revised in 2005.

Before you start a low-carb diet or carb counting or any diet regime, check with your doctor first, as there may be a need to adjust your medications, especially when you start to lose weight. This is particularly true of people who have diabetes and are taking insulin, as the amount of insulin injected is in direct relation to the number of grams of carbohydrate they will be eating at a particular meal. People on oral diabetes medication may need less medication as their

weight begins to drop. Doing self-testing of your blood glucose levels is crucial. While keeping a food diary may be boring, it can be a highly valuable diagnostic tool. Remember, when you're counting carbs, every mouthful of food must be counted. Buy a pocket-size book on carb counting. There are several good ones available at most bookstores that are handy to carry with you all times.

Starting Out: What Is a Carb and What Do You Count?

A carbohydrate is one of the three basic food elements that contain calories (the others are protein and fat). It's composed of carbon, hydrogen, and oxygen and, contrary to what some people think, it's not just sugar. Carbohydrate is found in varying amounts in all foods except those that are totally protein and fat. Carbs are present in sugars, flours, starchy vegetables, fruit, milk products, and nonstarchy vegetables. They are even present in some shellfish such as clams, mussels, and Tiger prawns.

Lest you think you'll live on just steak, bacon, and Brie, think again. You'd be bored within a week and once again off your diet, scarfing mashed potatoes, white bread, and who knows what else. Some say to just keep away from the "whites"— the white flour, white sugar, and white pasta. That doesn't really work, as beets are high in carbs, as are corn, peas, dried beans, and all grains. That's not to say that you won't ever enjoy these foods again. I do, as will you, but occasionally and in moderation. These foods have essential ingredients—dietary fiber and fruits and vegetables have vitamins and minerals that we all need. You may not miss them on the first week of a low-carb diet but your body will, and it's healthier to include them from the very first. Again, it's all a matter of moderation.

What else will you miss—maybe that all-out decadent dessert that we all crave from time to time? I suggest waiting to have this at the best restaurant you can af- ford, and then order one serving, with two spoons or two forks to share with someone. That way there's no leftovers waiting in the refrigerator to beckon you in the middle of the night. Otherwise, a low-carb diet can be satisfying and full of great tastes from morning to night. Remember, there are millions of others on this diet with you, and there are support groups at many local hospitals as well as on the Internet.

Just remember, a carb is a carb, and every carb must be counted or, like any diet on which you cheat, this won't work.

The Low-Carb Kitchen

If your pantry, refrigerator, and freezer are not already low-carb, now's the time to make them so. Call a friend who's not counting carbs (some people such as my own sister can metabolize carbs just fine) to join you for coffee and then cart home all of those staples of a low-fat diet—rice cakes, popcorn, white pasta, crackers, pretzels, and jams and jellies. You'll be using minute amounts of flour and sugar, and you can keep the grains to use on occasion. Also, keep the beans, as you can add a spoonful or handful to soups and stews without much consequence since these are good carbs, full of fiber.

Stock your pantry and refrigerator with the best you can afford and keep the inventory turning. Spices lose their flavor with age, and oil losses its freshness. Because you're going to be spending as little time preparing these recipes as possible, I keep my spices in view so they're handy to use, but away from the stove because they fare better when kept cool and dry. Beans, grains, and pastas are stored in clear glass jars. Garlic and shallots are stored in a special ceramic jar that has air holes. Onions and new potatoes are kept in baskets. Citrus and other fruits not needing refrigeration are in a fruit bowl.

Many of my recipes call for canned low-sodium broth. If there's any left after making a dish, I pour the remainder into airtight freezer storage bags in ¼-cup portions, which are then frozen to use later.

The following items are what you'll see in my kitchen.

IN THE PANTRY

- **Baking Needs:** Unbleached all-purpose flour, whole wheat flour, baking powder, baking soda, cream of tartar, cocoa powder, salt, kosher salt, pure vanilla extract, Splenda sugar substitute, sugar, and brown sugar

- **Canned and Packaged Goods:** No-salt-added canned tomatoes, low-sodium broth (beef, chicken, and vegetable), reduced-sodium soy sauce,

olives (kalamata and niçoise), canned pumpkin, no-sugar-added fruit spread, natural peanut butter, no-sugar-added dried fruits, evaporated skim milk, powdered buttermilk, Worcestershire sauce, Tabasco and other hot sauces, mustard (Dijon, regular, coarse-grain), unsweetened fruit juices, and alcohol for cooking (dry red and white wines, Cognac, dry sherry, and tequila)

- **Grains:** Brown rice, basmati rice, wild rice, quick-cooking couscous, kasha, rolled oats, stone-ground cornmeal (white and yellow), and grits

- **Legumes:** Canned black beans, cannellini, garbanzo (chickpeas), navy beans, white beans, and lentils (red and brown)

- **Oils:** Extra-virgin olive, canola, grapeseed, peanut, and sesame oils. Working with 100 of the greatest chefs to put together my last cookbook, I found that they all used extra-virgin olive oil for cooking, not just salad making. It does make a better dish.

- **Pasta:** Angel hair, bow ties, linguine, penne, spaghetti (all whole wheat or soy); and Asian rice stick noodles

- **Spices:** Ground allspice, black pepper, dill (seed and weed), celery flakes, celery seed, chili powder, ground cinnamon, cloves (ground and whole), coriander (ground and seed), ground cumin, curry powder (mild and imported Indian), fennel seed, ground ginger, paprika, poppy seed, and crushed red pepper flakes

- **Vinegars:** Aged balsamic, fruit-infused (with no sugar added), herb-infused, red wine, white wine, sherry, champagne, cider, malt, and rice wine vinegars

IN THE FREEZER

- No-sugar-added frozen fruit and berries

- Boneless, skinless chicken breast halves (pounded and individually wrapped)

- Ground turkey breast in 1-pound packages

- Browned ground beef sirloin mix in 6-ounce packages (see page 62)

- Turkey cutlets (individually wrapped)

- Nuts

- Vegetables (chopped bell peppers, chopped onions)

- Breads and rolls (whole wheat, multigrain, low-carb breads, and low-carb tortillas (see page 47)

IN THE REFRIGERATOR

- Hard cheeses (Asiago, Parmesan, and Romano)

- Part-skim mozzarella cheese, ricotta cheese, and cream cheese

- Sour cream

- Unsalted butter

- Fresh ginger

- Fresh fruit juices

- Scallions

- Fresh herbs

- Plain yogurt

- Salad ingredients (lettuces, bell peppers, celery, carrots, cucumbers, radishes, and so forth)

- Dill pickles

- Almond flour

- Tomato paste (in a tube)

- Eggs

- Milk

- Anchovy paste (in a tube)

MISCELLANEOUS

- Fresh fruit in season

- Citrus fruits (lemons, oranges, and limes)

- Garlic

- Onions

- New potatoes

- Shallots

- Tomatoes (cherry, medium vine-ripened, and plum)

Reading Labels

Confused reading labels? Here's what to look for when you're on a carb counting diet.

- Total carb count and fiber count

- Sugar count

- "Good fats"—avoiding the hydrogenated, partially hydrogenated, and saturated fats and trans-fatty acids whenever possible

Be Careful with Condiments

We all use a vast array of condiments with our food. When you are purchasing them, keep this in mind.

NO PROBLEM

- Mustard

- Prepared horseradish

WATCH OUT—READ THE LABELS

- Ketchup

- Cocktail sauce

- Salsa

- Hot sauce

- Soy sauce

- Worcestershire sauce

- Steak sauce

- Mayonnaise

What about Salt?

When you look at the recipes, you will notice that only when it's needed do I call for a specific amount of salt. I have otherwise left the amount of salt used during cooking up to you. Many people, me included, must limit their sodium intake each day because of medical conditions or medicines they are taking.

I personally use little or no salt in cooking. I do taste the food and add some if needed to bring out the flavors, but many dishes go to my table prepared entirely without salt. Other than one friend who reaches for the salt shaker before he even tastes the food, I've noticed that very few people feel their food needs salting.

Some foods, such as canned tomatoes and soy sauce, are high in sodium. I use no-salt-added tomatoes and reduced-sodium soy sauce. You'll never know the difference. I also rely on herbs and spices for seasoning without salt.

Butter versus Margarine

Whether you use butter or margarine in your cooking is a decision that only you and your doctors can make. First let's look at why both are maligned. Butter contains two cholesterol-raising ingredients: dietary cholesterol and saturated fat. Be-

cause dietary cholesterol is found only in animal products, margarine, which is a plant-based product, is cholesterol free.

Not everybody handles dietary cholesterol the same way—some people can consume a diet high in cholesterol without their blood cholesterol levels changing, while others' blood cholesterol levels soar after eating only a little dietary cholesterol. There are 11 milligrams of cholesterol in 1 teaspoon of butter; when that is spread over let's say four servings, the less than 3 milligrams is a virtually insignificant portion of the 200 milligrams per day, an optimum consumption level as set by the American Heart Association.

The second culprit is saturated fat, which is associated with increases in the risk of heart disease. The American Heart Association considers 10 to 15 grams of saturated fat per day as a healthy rate of consumption. With butter weighing in at a little over 2 grams per teaspoon, again over four servings, that would add a little more than ½ gram per serving.

Margarine does not contain saturated fat, but it does contain trans-fats, which are also artery clogging fat. Trans-fats are formed when hydrogen is added to vegetable oils, making the oil more solid at room temperature. Soft margarine (tub) has less trans-fats than stick margarine.

Trans-fats have been shown to lower the "healthy" (high-density lipoprotein, or HDL) cholesterol and increase the "bad" cholesterol (low-density lipoprotein, or LDL) in a way similar to saturated fat. It's also believed that trans-fats may make our blood platelets stickier. In the summer of 2003, the Food and Drug Administration (FDA) ordered that the amount of trans-fats in a food product must appear on the mandatory nutrition label by 2006. We are already seeing manufacturers cutting their trans-fat levels by switching their first ingredient from partially hydrogenated vegetable oil to water or liquid vegetable oil. If they can get the trans-fats level to less then ½ gram per serving, they may call the margarine "trans-fat free" or "zero trans-fat."

Butter or margarine—I use so little in cooking and I prefer the taste of butter, so I always use butter, unsalted to reduce sodium intake. Now that you know the facts, the decision of using butter or margarine is yours, but if you have heart disease or diabetes, it's most likely your doctor's as well.

Some Quick-Cooking Tips

- Make use of time-saving devices such as a food processor, mini herb chopper, and the microwave.

- Prepare everything that you can ahead of time.

- Enlist the help of others when preparing a meal—it's a way to teach your kids (and significant other) how to cook. It's also a great way to spend time together.

- Read through a recipe *before* you start to cook to make sure you have the ingredients, or reasonable substitutions, on hand.

Nutritional Information

Nutritional information and diabetic exchanges are listed for each recipe using the latest data available from ESHA (*The Food Processor*, Version 8.1), the U.S. Department of Agriculture, and, when necessary, manufacturer's food labels.

Rise and Shine for Breakfast

RESEARCH SHOWS THAT breakfast may really be the most important meal of the day, yet it seems to pose the most problems for people on a low-carb or carb-counting diet. Most of us grew up eating white toast with jam; a bowl of sweetened cereal; bagels with cream cheese; doughnuts; a stack of fluffy pancakes; a light, crisp waffle with lots of maple syrup; and the list could go on and on. This problem of what to eat for breakfast is particularly hard for people with diabetes who must match what they eat with the insulin or oral diabetes medications they are taking. Of the hundreds of e-mails that I receive each week on my websites for diabetics, most of the writers want to know what they can eat for breakfast. Since we've all been fasting all night, it's necessary to give our bodies the right fuel that it needs to run efficiently.

At the American Heart Association's 43rd Annual Conference on Cardiovascular Disease Epidemiology and Prevention, researchers reported that obesity and insulin-resistance syndrome rates, both common problems for people with type 2 diabetes, were 35 to 50 percent lower among people who ate breakfast every day compared to those who frequently skipped it.

When everyone became concerned about blood cholesterol levels, we were all told to avoid eggs since they contained both dietary cholesterol and fat. That contradicted what I'd learned in the early 1970s while working with Gayelord Hauser, the internationally revered health foods expert, on the revision of two of his best-

selling health and beauty books. He claimed that one shouldn't worry about the dietary cholesterol in eggs, as they are also high in lecithin and the B vitamins that help keep cholesterol on the move. He also claimed that the body makes more cholesterol than is ingested in food. New studies indicate that eggs don't raise blood cholesterol levels; they may, in fact, lower them. An American Cancer Society study found that those who eat eggs have fewer heart attacks and strokes than people who avoid eggs. With that in mind, an occasional egg or two is not going to hurt you, and eggs are a good source of protein for your morning meal.

Breakfast meats or fish are also great solutions for getting sufficient protein for breakfast. You can even make your own sausage with ground white meat turkey (see page 16), or have an occasional strip of lean bacon or slice of Canadian bacon. Keep in mind that dietary guidelines do not apply to a single meal, recipe, or food substance, but to your diet over a period of time. Practice moderation by balancing foods high in fat or cholesterol with low-fat selections. When you do consume carbs, make them healthy carbs like those found in fruits, vegetables, and whole grains.

All of the recipes in this chapter are designed to tease and then satisfy sleepy appetites. If you're following a net carb diet, don't forget to subtract the grams of dietary fiber from the grams of carbohydrate. If you're following a diabetic carb-counting diet, you need to count all the grams of carbohydrate.

If you're running late and need to catch something on the go (we all have those days), follow this simple recipe for a smoothie made in a blender—a delicious breakfast in a glass. Since the variations are endless, you'll need to consult a carb counter to get the exact number of carb grams for each variation you try.

Blender Smoothie

MAKES 1 SERVING

- **Start with a base** of skim milk, fresh fruit juice, nonfat yogurt (plain or flavored), or nonfat frozen yogurt.

- **Add some flavoring,** such as vanilla or almond extract, unsweetened cocoa, ground cinnamon or nutmeg, or coffee.

- **Plus** add some fresh or frozen unsweetened fruit.

- **Blend** to desired consistency and taste. If you want it sweeter, add sugar substitute to taste and blend again. Pour into a glass and drink.

Western Burrito

MAKES 1 SERVING

1 teaspoon unsalted butter

2 large eggs

2 tablespoons finely chopped
 green bell pepper

2 tablespoons finely chopped
 onion

¼ cup chopped extra-lean
 cooked ham

2 tablespoons shredded
 cheddar cheese

Salt and freshly ground pepper,
 to taste

1 (6½-inch) whole wheat low-
 carb tortilla, warmed (see
 page 47)

Purchased hot or mild salsa
 (optional)

Like in a Denver omelet, scrambled eggs are combined with chopped ham, onion, and green bell pepper. When tucked into a warm tortilla, it becomes a tasty, quick breakfast.

Melt the butter in a heavy omelet pan over medium-low heat. In a bowl, whisk the eggs with the bell pepper, onion, and ham. Pour the mixture into the skillet and stir the eggs, bringing the set eggs in from the sides of the skillet to form soft curds. Continue to cook, stirring the eggs, until done to taste, about 1½ minutes for softly set eggs and 2 minutes for firmer eggs. Sprinkle the eggs with the cheese and season with salt and pepper. Transfer the eggs to the tortilla and, if using, sprinkle with salsa. Roll up burrito style and serve.

○ PER SERVING: 16 g carbohydrate (includes 10 g dietary fiber), 30 g protein, 23 g fat, 371 calories

○ DIABETIC EXCHANGES: 1 bread/starch, 1 very lean meat, 2 lean meat, 2½ fat

Baked Chiles and Cheese

This is a favorite Sunday brunch dish at my house. At the end of the summer when Hatch chiles arrive from New Mexico, I order 45 pounds from a nearby farm stand and have them roast the chiles for me. Once home, I package them six chiles to a bag in small self-closing plastic freezer bags. Frozen they will keep for a year or more, but I've never really gotten to test the actual freezer life as no matter how much I increase my order from year to year, I always run out before I can get more. You could roast poblano chiles (4 to 5 inches in length) for this recipe or use the whole canned green chiles from the supermarket.

If you can find the Mexican cheeses, your casserole will have a more interesting depth of flavor, but I've given alternatives that will work fine.

MAKES 6 SERVINGS

Unsalted butter for greasing the casserole, plus 1 tablespoon, melted

2 cups chopped onions

¼ cup golden raisins

2 large cloves garlic, minced

¾ cup shredded Mexican manchego or Monterey Jack cheese

2 ounces añejo or grated Parmesan cheese

2 tablespoons crumbled blue cheese

9 green chiles, roasted, peeled, cut in half lengthwise, and seeds removed

¼ cup well-packed fresh cilantro leaves

3 large eggs

¾ cup evaporated skim milk

Preheat the oven to 375°F. Lightly butter a shallow 2-quart casserole.

In a medium bowl, combine the onions, raisins, and garlic. Set aside. In another bowl, mix the cheeses. Set aside.

Arrange 6 chile halves in the prepared casserole. Sprinkle with one-third of the onion mixture and one-third of the cheese mixture. Sprinkle with half of the cilantro. Repeat with another layer of the chiles, onion mixture, and cheese mixture. Top with remaining cilantro leaves. Top with the remaining chiles, onion mixture, and cheese mixture.

In a medium bowl, whisk the eggs until frothy. While whisking, gradually add the milk and melted butter. Pour the egg mixture over the layers. Using a knife, gently move the layered chiles to allow the egg mixture to flow to the bottom of the casserole.

Bake, uncovered, for 25 to 30 minutes, until the cheese is melted and bubbly and egg mixture looks set when the casserole is shaken gently. Serve at once.

○ **PER SERVING:** 21 g carbohydrate (includes 2 g dietary fiber), 13 g protein, 11 g fat, 228 calories

○ **DIABETIC EXCHANGES:** ½ skim milk, 2 vegetable, 1 lean meat, 1½ fat

Perfect Omelets with Five Filling Choices

Having worked early in my career as a home economist for the California Egg Advisory Board in charge of a weekly press release to the nation's newspaper food editors, I have developed hundreds of omelet recipes, written volumes on making omelets, and even produced a film that shows the omelet cooking technique for junior high and high school cooking classes. Here's how to make a 2-egg omelet:

MAKES 1 SERVING

- In a small bowl and using a fork, quickly beat 2 large eggs with 1 tablespoon water until the whites are completely incorporated. If desired, season with a pinch each (about ⅛ teaspoon) of salt and pepper.

- If you want an herb omelet, blend in 1 tablespoon chopped fresh herbs—basil, *fines herbes*, parsley, or tarragon.

- Place a nonstick omelet pan on the stove over high heat. Add 1 teaspoon unsalted butter and, when the butter is melted and before it browns, tilt the pan to evenly coat the bottom with the butter.

- Pour in the eggs. Tilt the pan to let the eggs flow evenly over the bottom of the pan. The eggs will start to set in 2 to 3 seconds. Using the back side of a pancake turner, push the cooked portion of the eggs toward the center and turn the pan so that the raw egg runs in its place.

- When the eggs are set but still slightly runny, place the filling, if using (see choices on the next page), across the middle of the pan, perpendicular to the pan handle. You'll need 3 to 4 tablespoons filling for each 2-egg omelet.

- Run the spatula or wooden spoon around the edge of the omelet to loosen the edges. Fold the side closest to you up and over, almost covering the filling. Flip the omelet upside down onto a waiting plate or simply slide the omelet onto the plate.

 - PER OMELET (without filling, except herbs, if using): 1 g carbohydrate (includes 0 dietary fiber), 13 g protein, 14 g fat, 188 calories
 - DIABETIC EXCHANGES: 2 lean meat, 2 fat

Spinach and Ricotta

Cook the omelet as directed. Wilt the spinach in the water for 1 minute over medium-high heat, tossing to cook evenly. Drain and squeeze out all moisture. In a small bowl, mix the spinach with the cheese and nutmeg. Fill the omelet, fold, and serve.

- ○ PER OMELET: 6 g carbohydrate (includes 2 g dietary fiber), 19 g protein, 17 g fat, 251 calories
- ○ DIABETIC EXCHANGES: ½ vegetable, 2 lean meat, 2 fat

1 plain or herb omelet (see page 6)
4 ounces fresh spinach, tough stems trimmed and leaves coarsely chopped
1 tablespoon water
2 tablespoons part-skim ricotta cheese
Dash ground nutmeg

Tomato and Basil

Cook the omelet as directed. In a small bowl, combine the tomato and basil. Fill the omelet, fold, and serve.

- ○ PER OMELET: 4 g carbohydrate (includes 1 g dietary fiber), 13 g protein, 15 g fat, 222 calories
- ○ DIABETIC EXCHANGES: ½ vegetable, 1½ lean meat, 2 fat

1 plain omelet (see page 6)
1 large plum tomato, seeded and diced
1 tablespoon minced fresh basil

Green Chile and Cheese

Cook the omelet as directed. In a small bowl, combine the chiles and cheeses. Fill the omelet, fold, and serve.

- ○ PER OMELET: 2 g carbohydrate (includes trace dietary fiber), 16 g protein, 19 g fat, 246 calories
- ○ DIABETIC EXCHANGES: 2 lean meat, 2½ fat

1 plain or herb omelet (see page 6)
1 tablespoon minced canned green chiles
1 tablespoon shredded Monterey Jack cheese
1 tablespoon shredded cheddar cheese

Smoked Salmon and Cream Cheese

1 plain or herb omelet
 (see page 6)
1 ounce chopped smoked
 salmon
1 tablespoon whipped cream
 cheese
1 finely minced scallion
 (white part only)

Cook the omelet as directed. In a small bowl, combine the salmon, cheese, and scallion. Fill the omelet, fold, and serve.

O PER OMELET: 1 g carbohydrate (includes 0 dietary fiber), 19 g protein, 19 g fat, 257 calories
O DIABETIC EXCHANGES: 2½ lean meat, 2½ fat

Ham and Cheese

1 plain or herb omelet
 (see page 6)
1 tablespoon finely minced
 onion
3 tablespoons chopped extra-
 lean ham
1 teaspoon golden raisins
½ teaspoon Dijon mustard
1 tablespoon shredded
 Monterey Jack cheese

Preheat the broiler. In an oven-proof skillet, cook the omelet as directed. In a small bowl, mix the onion, ham, raisins, and mustard. Fill the hot omelet, fold, and sprinkle the omelet with the cheese. Pop the skillet under the broiler until the cheese melts, about 1 to 2 minutes.

O PER OMELET: 6 g carbohydrate (includes 1 g dietary fiber), 20 g protein, 18 g fat, 270 calories
O DIABETIC EXCHANGES: ½ vegetable, 2 lean meat, 2½ fat

Bacon and Eggs with Cheese

Usually a breakfast order of bacon and eggs means two or three strips of crisp-cooked bacon alongside a couple of fried or scrambled eggs. The breakfast buffet at a restaurant in Strongsville, Ohio, offered this version with a bowl of shredded cheese on the side to add as desired. Easy to fix at home, it's a great way to start the day with a mug of hot coffee.

MAKES 2 SERVINGS

1 teaspoon unsalted butter

3 ounces sliced Canadian bacon, cut into ¹/₂-inch-wide strips

2 tablespoons minced onion

4 large eggs

2 tablespoons reduced-fat sour cream

Salt and freshly ground pepper, to taste

2 tablespoons shredded Swiss cheese (optional)

Melt the butter in a nonstick skillet over medium heat. When the butter foams, add the bacon and onion. Cook, stirring occasionally, until the bacon begins to brown and the onion is limp, about 5 minutes.

Meanwhile, in a small bowl, whisk the eggs, sour cream, salt, and pepper until the whites are completely incorporated. Lower the heat to medium-low and pour the eggs into the skillet over the bacon-onion mixture. Stir the eggs, bringing the set eggs in from the sides of the skillet to form soft curds. Continue to cook, stirring the eggs, until done to taste, about 1½ minutes for softly set eggs and 2 minutes for firmer eggs. If using, sprinkle the eggs with cheese and serve immediately.

HANDY IN THE KITCHEN

A rubber scraper that can tolerate heat up to 400°F (or more) is now available. Look for these at specialty cookware shops or on the Internet. They make scrambling an egg so easy—without destroying the surface of your nonstick skillet or melting the end of the scraper.

○ **PER SERVING:** 2 g carbohydrate (includes 0 dietary fiber), 17 g protein, 14 g fat, 207 calories

○ **DIABETIC EXCHANGES:** 2¹/₂ lean meat, 1¹/₂ fat

Scrambled Eggs—Texas Style

MAKES 4 SERVINGS

1 spicy sausage such as Mexican chorizo or Cajun andouille, cut into thin slices

1 teaspoon unsalted butter

3 tablespoons minced onion

1 serrano or jalapeño chile, seeded and minced (leave the seeds in if you can *really* take the heat)

6 large eggs

2 tablespoons sour cream

Salt and freshly ground pepper, to taste

1 small ripe avocado, peeled, pitted, and cut into ½-inch dice

3 tablespoons shredded Mexican cheese blend or Monterey Jack cheese

Tabasco or other hot sauce

Here in Texas, my friends like their food hot and spicy—the hotter, the better, even for breakfast. These eggs are well seasoned and sure to wake up lagging appetites.

In a large nonstick skillet, brown the sausage over medium heat, 3 to 5 minutes. Transfer the sausage to paper towels to drain, and wipe out the skillet.

Melt the butter in the skillet over medium heat. When the butter foams, add the onion and chile. Sauté, stirring occasionally, until the onion wilts, about 5 minutes.

Meanwhile, in a small bowl, whisk together the eggs, sour cream, salt, and pepper until the whites are completely incorporated. Lower the heat to medium-low and pour the eggs into the skillet. Return the sausage to the skillet and stir the mixture, bringing the set eggs in from the sides of the skillet. Continue to cook, stirring the eggs, until done to taste, about 1½ minutes for softly set eggs and 2 minutes for firmer eggs. Fold in the avocado and cheese. Spoon the eggs onto 4 plates and pass the hot sauce to sprinkle over each serving as desired.

○ PER SERVING: 4 g carbohydrate (includes 3 g dietary fiber), 11 g protein, 15 g fat, 195 calories

○ DIABETIC EXCHANGES: 1½ lean meat, 2 fat

Sunday Morning Frittata

An excellent alternative to quiche, a frittata, like an omelet, can be varied according to your family's tastes. You can be as creative as you wish when it comes to what vegetables to use. If you happen to have any leftover frittata, it makes a great cold lunch the next day.

Heat the oil in a large nonstick skillet over medium heat. Add the scallions, bell pepper, and broccoli; sauté for 2 minutes.

In a large bowl, whisk the eggs, parsley, oregano, and hot sauce until the whites are completely incorporated. Pour the eggs over the vegetables and season with salt and pepper. Sprinkle the cheeses on the surface and cover with a tight-fitting lid. Reduce the heat to the lowest possible level. Cook without disturbing the egg mixture until the eggs are set, about 10 minutes. Cut into wedges and serve.

O PER SERVING: 5 g carbohydrate (includes 1 g dietary fiber), 12 g protein, 12 g fat, 176 calories

O DIABETIC EXCHANGES: $1/2$ vegetable, $1^1/2$ lean meat, $1^1/2$ fat

MAKES 6 SERVINGS

2 teaspoons extra-virgin olive oil

6 scallions, white part and 1 inch green, finely chopped

1 medium red bell pepper, cut in half crosswise, seeds and ribs removed, and cut into lengthwise julienne strips

1 cup fresh broccoli florets, cooked for 2 minutes in boiling water and drained

8 large eggs

2 tablespoons minced fresh parsley

1 teaspoon crushed dried oregano

$1/8$ teaspoon Tabasco or other hot sauce

Salt and freshly ground pepper, to taste

$1/2$ cup grated sharp cheddar cheese

1 tablespoon grated Parmesan cheese

Low-Carb Huevos Rancheros

MAKES 6 SERVINGS

2 (14½-ounce) cans peeled
 whole plum tomatoes
2 teaspoons chili powder
½ tablespoon crushed dried
 oregano
1 large onion, chopped
2 cloves garlic, minced
2 jalapeño chiles, seeded and
 minced
2 teaspoons extra-virgin olive
 oil
6 large eggs
Salt and freshly ground pepper,
 to taste
¼ cup chopped fresh cilantro

Eggs poached in a ranchero sauce enriched with fiery chiles and spices make a great one-pan breakfast. If you can find low-carb whole wheat tortillas (see page 47) in your market, serve one per person with the eggs. The 6½-inch size will add 12 grams total carbs and 3 grams net carbs per serving (1 bread/starch diabetic exchange).

Another time, for an entirely different flavor experience, try the variation, Eggs Baked in Curried Tomatoes.

Drain the tomatoes and measure the juice. If there is less than 2 cups juice, add enough water to make up the difference. Place the tomatoes and the juice into a food processor and pulse until chopped with some tomato pieces remaining. Pour the mixture into a wide nonstick skillet and stir in the chili powder and oregano. Slowly bring to a simmer, stirring occasionally.

Meanwhile, in another skillet, sauté the onion, garlic, and chiles in the oil over medium heat. Cook, stirring, until vegetables are limp, about 5 minutes. Set aside.

Carefully crack the eggs into the simmering sauce. Distribute the vegetable mixture over the eggs and sauce. Simmer the sauce, occasionally basting the eggs with the sauce, until the yolks are set to your liking, about 20 minutes for firm yolks. Season the eggs with salt and pepper and serve sprinkled with the cilantro.

○ **PER SERVING:** 11 g carbohydrate (includes 2 g dietary fiber), 8 g protein, 7 g fat, 136 calories
○ **DIABETIC EXCHANGES:** 2 vegetable, 1 lean meat, 1 fat

VARIATION

Eggs Baked in Curried Tomatoes

Follow the recipe, adding 1 tablespoon minced fresh ginger to the vegetable mixture, and substituting 2 teaspoons curry powder for the chili powder and ½ teaspoon cumin seeds for the dried oregano. Proceed as directed.

- O PER SERVING: 11 g carbohydrate (includes 2 dietary fiber), 8 g protein, 7 g fat, 136 calories
- O DIABETIC EXCHANGES: 2 vegetable, 1 lean meat, 1 fat

Poached Eggs on Asparagus with Ham and Parmesan Shavings

MAKES 4 SERVINGS

1 pound fresh asparagus,
 trimmed
2 ounces lean baked ham,
 minced
4 large eggs
4 teaspoons extra-virgin olive
 oil
Salt and freshly ground pepper,
 to taste
1 (2-ounce) piece Asiago cheese,
 thinly shaved (see page 78)

Serve this fabulous low-carb variation of eggs Benedict with slices of melon and a pot of freshly brewed coffee for a lazy breakfast with friends. If your market doesn't carry Asiago cheese, substitute Parmesan or Romano.

Steam the asparagus until crisp-tender, 3 to 7 minutes, depending on the size of the spears. Distribute them evenly onto 4 large serving plates. Sprinkle with the ham.

Gently poach the eggs until set, 3 minutes for soft yolks (see below). Using a slotted spoon, remove each egg and place it on a serving of asparagus. Drizzle each serving with 1 teaspoon of the olive oil. Season with salt and pepper and sprinkle with cheese. Serve at once.

○ PER SERVING: 7 g carbohydrate (includes 2 g dietary fiber), 15 g protein, 15 g fat, 213 calories
○ DIABETIC EXCHANGES: 1 vegetable, 1½ lean meat, 2 fat

POACHING AN EGG

If you have an egg poacher, use it, following the manufacturer's directions.

Otherwise, in a large nonstick skillet over medium-low heat, bring 4 cups water and 1 tablespoon white or cider vinegar to a gentle simmer. Break the eggs, one at a time, into a cup and gently slip into the simmering water. It's best not to cook too many eggs at once, as they tend to migrate and stick together. With care, I can poach up to 4 eggs at a time, but I use a very large skillet. Poach to desired consistency, 3 minutes for soft yolks. Using a slotted spoon, remove an egg and rest briefly (still in the spoon) on a paper towel to drain. Trim away any strands of stray egg white.

David's Flat Eggs

My husband, David, learned how to make these eggs on the Caribbean island of St. Martin. The hotel served a breakfast buffet on the beach where eggs were cooked to order. After some experimentation, David and the attending chef came up with this creation, which he frequently fixes for us at home.

MAKES 1 SERVING

1 teaspoon unsalted butter
1 teaspoon minced garlic
4 or 5 slices fresh mushroom
Pinch of crushed dried thyme
2 large eggs, lightly beaten
 with 1 teaspoon water
1 tablespoon grated Parmesan
 cheese

Melt the butter in a nonstick omelet pan over medium-low heat. Add the garlic, mushroom, and thyme. Sauté for 2 minutes. Pour the egg mixture into the pan; do not stir. When egg mixture is partially set, flip the eggs and top with the Parmesan cheese. Cook 1 minute, cut into 4 wedges, and serve.

○ PER SERVING: 3 g carbohydrate (includes trace dietary fiber), 15 g protein, 16 g fat, 220 calories
○ DIABETIC EXCHANGES: 2 lean meat, 2 fat

Turkey and Apple Sausage

MAKES 12 SERVINGS

2 large egg whites

1 large Granny Smith apple,
peeled and finely diced

2 scallions, white part and 1
inch green, thinly sliced

3/4 teaspoon crushed dried sage

1/2 teaspoon freshly ground
pepper

1/2 teaspoon sweet paprika

1/8 teaspoon fennel seeds,
crushed

Dash ground nutmeg

1 1/2 pounds ground turkey
breast

1 tablespoon unsalted butter

*It's quite easy to make your own sausage. This rendition has a won-
derful fresh flavor without all of the preservatives of store-bought
sausage. Check the label when you're buying ground turkey and make
sure it doesn't contain any skin. You can also buy a turkey breast and
have your butcher grind it fresh after removing the skin.*

In a large bowl, beat the egg whites until frothy. Stir in the ap-
ple, scallions, sage, pepper, paprika, fennel seeds, and nutmeg.

Place the ground turkey in another large bowl and make a
well in the middle. Pour in the egg white mixture and knead
together until well combined. Pinch off a very small amount of
the meat mixture and cook in a large nonstick skillet over
medium-high heat. Taste for seasoning and correct as necessary.
Shape the remaining mixture into 12 (1/2-inch-thick) patties.

Melt the butter in the skillet. Add the sausage patties and
cook until browned on one side, about 7 minutes, then turn
over and cook until the patties are cooked through, about 6
more minutes.

○ **PER SERVING:** 2 g carbohydrate (includes trace dietary fiber), 12 g
protein, 4 g fat, 93 calories

○ **DIABETIC EXCHANGES:** 1 1/2 very lean protein, 1/2 fat

Country Morning Muffins

These moist little gems freeze beautifully. Bake them when you have the time, then freeze in self-sealing bags to reheat as needed, in your oven or microwave. Sweetened by apples, carrots, and raisins, they make a delicious accompaniment to a scrambled egg.

Preheat the oven to 375°F. Grease 12 standard muffin cups or line with paper liners.

In a large bowl, whisk together the whole wheat flour, wheat germ, baking powder, and salt. Make a well in the center and set aside.

In a medium bowl, combine the eggs, oil, apple juice, and applesauce with an electric mixer. Pour the egg mixture into the well of the flour mixture and stir just until the dry ingredients are evenly moistened. Do not overmix. Fold in the apple, carrot, and raisins. Spoon the batter into prepared muffin cups, filling the cups two-thirds full. Bake for 25 to 30 minutes, until lightly browned and a tester inserted into the centers comes out clean. Cool in the pan on a rack for 5 minutes before removing from the pan.

○ PER SERVING: 27 g carbohydrate (includes 4 g dietary fiber), 7 g protein, 5 g fat, 168 calories

○ DIABETIC EXCHANGES: 1 bread/starch, 1 fat

MAKES 12 SERVINGS

Unsalted butter, for greasing
　the muffin cups (optional)
2 cups whole wheat flour
1 cup toasted wheat germ
1 tablespoon baking powder
$1/2$ teaspoon salt
2 eggs, lightly beaten
2 tablespoons canola oil
1 cup unsweetened apple juice
$1/3$ cup unsweetened applesauce
1 medium red apple such as
　McIntosh, Rome, or Gala,
　cored and coarsely shredded
$1/2$ cup grated carrot
$1/4$ cup dark raisins

Crustless Ham Quiche

MAKES 6 SERVINGS

Unsalted butter, for greasing
 the quiche pan
½ cup diced lean cooked ham
2 tablespoons grated onion
6 large eggs
1 cup half-and-half
⅛ teaspoon cayenne pepper
Salt and freshly ground pepper,
 to taste
1 cup shredded Swiss or
 Monterey Jack cheese

This goes together quickly and can bake unattended while you finish dressing for the day, or you can make this the night before and reheat it or serve at room temperature.

Preheat the oven to 350°F. Lightly butter an 8-inch quiche pan or round shallow casserole.

Distribute the ham and onion evenly over the bottom of the prepared pan. In a bowl, beat the eggs with the half-and-half and cayenne pepper until the whites are completely incorporated. Season with salt and pepper. Add the cheese and mix well. Pour the mixture into the pan and bake for 30 to 35 minutes, until the quiche is set and the top is golden brown.

○ PER SERVING: 2 g carbohydrate (includes trace dietary fiber), 15 g protein, 16 g fat, 218 calories
○ DIABETIC EXCHANGES: 2 lean meat, 2½ fat

Hot Apple Yogurt Sundaes

Yogurt makes a wonderful breakfast and, when it's topped with cinnamon apples and crunchy walnuts, it will get sleepy appetites awake and satisfied for the morning.

In a saucepan, combine the apple, apple juice, cinnamon, allspice, and nutmeg. Bring to a boil over medium heat. Lower the heat, partially cover, and simmer until the apple is tender, 8 to 10 minutes.

Divide the yogurt equally between two cereal bowls. Top each with half of the apple mixture and sprinkle with half of the walnuts. Serve at once.

○ **PER SERVING:** 23 g carbohydrate (includes 2 g dietary fiber), 9 g protein, 12 g fat, 220 calories
○ **DIABETIC EXCHANGES:** 1 fruit, 1 skim milk, 1¹/₂ fat

MAKES 2 SERVINGS

1 large Granny Smith apple,
 unpeeled, cored, and thinly
 sliced
¹/₄ cup unsweetened apple juice
¹/₂ teaspoon ground cinnamon
Dash ground allspice
Dash ground nutmeg
1 cup plain low-fat yogurt
¹/₄ cup coarsely chopped
 walnuts

Low-Carb Lunch at Home or Away

LUNCH SEEMS TO BE a dilemma for people on a low-carb or carb-counting diet; this is particularly true for people who work away from home. Lunch at home alone can be lonely, but at your work desk, it's even lonelier. If your office or plant provides a lunch area, take your lunch there and join your colleagues. Make a date with a coworker to walk to the nearest park. Or go alone—at least you'll be around others there, and maybe you'll meet up with someone you know.

You actually have a lot of choices at lunchtime, but a quick bite at the local fast-food restaurant or from the office vending machine isn't one of them. Planning is what you need; it's easy to add a bit of extra meat or chicken to what you were cooking the night before or earlier in the week to turn into something delicious and satisfying for lunch. You need just enough to fuel you for the rest of the day but not wreck your carb count so that you essentially can't eat anything for dinner.

In addition to salads, a hot cup of soup makes a great solo lunch and can be easily carried to work in a preheated wide-mouth thermos. I've included some of my quick favorites.

Wraps make a great lunch, but forget about wraps from fast-food restaurants, as they are high in both fat and carbs. However, they are so easy to make yourself. Once you've gotten the technique down, you'll want to make them often. Here're a few tips:

- Use a low-carb whole wheat flour tortilla (see page 47). If the tortilla starts to crack, warm it briefly to soften it.

- Don't overfill wraps.

- Use lettuce or another flat green as the wrap liner.

Let's Do Lunch

For those who want to or must occasionally do lunch at a restaurant, I have some suggestions to help you take control and ensure that you're getting a delicious, healthy meal that stays within your carb allowance.

Here's what to order:

- Shrimp or seafood cocktail.

- Steamed or grilled vegetable plate. Don't eat any starchy vegetables (potatoes, corn, parsnips, pumpkin, sweet potato, or winter squash that might be on the plate).

- Caesar salad with chicken or shrimp—leave the croutons alone.

- Grilled or poached fish—ask for a nonstarchy vegetable or sliced tomato instead of the pasta, rice, or potatoes that might accompany the fish.

- At Mexican restaurants, the seviche, some grilled fish or meat, as well as fajitas, are all suitable choices—just leave the chips and tortillas alone.

- Middle Eastern or Greek restaurants usually have Greek salads, which are fine, as well as grilled fish. You can eat a little hummus, but ask for sliced cucumbers instead of the pita bread. Even a bit of tabbouleh, if made correctly with more parsley than grain, is also fine.

- At Asian restaurants, avoid the rice and noodles. Order a clear soup and then look at the stir-fry or fish possibilities.

- At French or Italian restaurants, avoid the carb items and choose from the many vegetable or protein possibilities.

Don't hesitate to explain to your wait person that you are following a low-carb or diabetic carb-counting diet. They are trained to help you make choices.

Main-Dish Salads

BLT Salad

I could happily eat this every day for lunch during the long basil-growing season for, as you'll note, the "L" in its name refers not only to lettuce but also to the minced leaves of fresh basil. Keep the dressing separate until you're ready to eat, which means toting a small container of it if you're taking this to work.

In a small plastic container with a lid, combine the tomatoes, bacon, basil, and lettuce. In an even smaller container, beat the vinegar with the tines of a fork as you add a dash of salt and pepper. While still beating, slowly add the oil and beat until well blended. When ready to serve, shake the container of vinegar and oil until combined. Pour over the salad and toss to coat well. Serve at once.

○ PER SERVING: 8 g carbohydrate (includes 2 g dietary fiber), 7 g protein, 23 g fat, 264 calories

○ DIABETIC EXCHANGES: 1¹/₂ vegetable, 1 lean meat, 4 fat

MAKES 1 SERVING

8 cherry tomatoes, halved

3 slices bacon, cooked crisp and crumbled

2 tablespoons chopped fresh basil

2 crisp inner leaves of romaine lettuce, chopped

¹/₂ tablespoon red wine vinegar

Salt and freshly ground pepper, to taste

1 tablespoon extra-virgin olive oil

LUNCHBOX SAFETY

Be sure to sure to think about food safety when you pack your lunchbox, as not all workplaces have a refrigerator where you can store your food. Freeze small bottles of water or small gel packs and place in the bag or lunch carrier to keep other foods cool. The water will thaw to just the right drinking temperature by lunchtime. The gel pack can be refrozen to use again. Use an insulated wide-mouth thermos, preheated for hot foods like soups and stews and prechilled for cold salads.

Hawaiian Chicken Salad

MAKES 1 SERVING

1 (4-ounce) boneless, skinless
 chicken breast half, cooked
 and cut into 1-inch dice
⅓ cup diced celery
⅓ cup diced fresh pineapple
2 tablespoons mayonnaise
1 tablespoon fresh lime juice
Arugula and watercress leaves,
 rinsed and dried, for serving
 (optional)

This was on the menu at a beachside restaurant on Kaanapali Beach on Maui. There it was served in a hollowed-out pineapple shell that had been lined with arugula and watercress leaves. My version is great packed in a container to take to work. Some markets will peel and core a fresh pineapple. If your market doesn't have that service, plan to peel and core it the night or day before.

In a bowl, combine the chicken, celery, and pineapple. In a small bowl, thin the mayonnaise with the lime juice. Add to the chicken mixture and toss to evenly coat. Pack into a container, cover, and chill until ready to serve.

If you wish, fill a small self-sealing plastic bag with a mixture of arugula and watercress leaves. Chill until ready to use. To serve, place the leaves on a plate and top with the salad.

O PER SERVING: 9 g carbohydrate (includes 1 g dietary fiber), 33 g protein, 26 g fat, 404 calories
O DIABETIC EXCHANGES: ½ fruit, 4½ very lean meat, 4½ fat

Layered Cobb Salad

Early in my career I worked for a food public relations firm within easy reach of the famous Brown Derby on Hollywood Boulevard, the creator of this delicious salad. It was my lunch of choice at the restaurant more times than not. It's easy to make at home and a great salad to tote to work. If you have a plastic container that will hold the salad as it's traditionally served, with a horizontal presentation, use that, but it can also be layered into one bowl.

Plan to cook an extra half chicken breast when you fix dinner the night before. The rest of the salad is likely already in your refrigerator for quick early morning cooking and easy assembly. Keep the dressing separate until you're ready to eat.

Place the chicken in the bottom of a 2-cup plastic container. Toss the avocado with the lemon juice and place on top of the chicken. Top with the bacon, tomato, egg, salad greens, and cheese. Sprinkle with the scallion and close to seal. Pack dressing separately in a small plastic container. Keep chilled until ready to serve. Pour on dressing and serve.

○ PER SERVING: 20 g carbohydrate (includes 9 g dietary fiber), 34 g protein, 31 g fat, 477 calories

○ DIABETIC EXCHANGES: ½ fruit, 2 vegetable, 3 very lean meat, 1 lean meat, 4½ fat

MAKES 1 SERVING

½ cup diced cooked chicken breast

½ small avocado, pitted, peeled, and cubed

1 tablespoon fresh lemon juice

1 slice bacon, cooked crisp and crumbled

1 medium tomato, seeded and coarsely chopped

1 large egg, hard-cooked (see below), peeled and coarsely chopped

1 cup mixed salad greens

1 tablespoon crumbled Roquefort or other blue cheese

1 scallion, white part and 2 inches green, chopped

2 tablespoons purchased vinegar and oil or Italian salad dressing

HARD-COOKED EGGS

Hard-cooked eggs are no longer boiled. Instead, place the eggs in a single layer in a saucepan. Add cold tap water to cover the eggs by at least 1 inch. Cover and quickly bring just to the boiling point. Turn off the heat and remove the pan from the burner. Let eggs stand, covered, in the hot water for 18 minutes for extra-large eggs, 15 minutes for large eggs, and 12 minutes for medium eggs. Drain and run cold water over the eggs until completely cooled. Peel and use as directed.

Curried Egg Salad in Lettuce Scoops

MAKES 1 SERVING

2 hard-cooked eggs (see page
25), peeled and chopped
1 tablespoon finely minced
onion
1 tablespoon finely minced
celery
1 tablespoon finely minced red
bell pepper
1 tablespoon finely minced
fresh basil
$^{1}/_{4}$ teaspoon curry powder, or to
taste
$^{1}/_{8}$ teaspoon dry mustard
1$^{1}/_{2}$ tablespoons mayonnaise
6 small inner leaves romaine
lettuce, washed and crisped

*Fresh basil and a smidgen of curry powder update traditional egg
salad for a quick lunch that's easy to tote to work or the park. Be sure
to have a way to keep the egg salad and the lettuce cold until serving
time. No eating utensils needed other than possibly a small plastic
spoon to help the lettuce scoop up the egg salad.*

In a small bowl, combine all the ingredients *except* the lettuce.
Transfer to a covered container and chill until ready to serve. To
serve, place the egg salad in the center of a small plate. Surround
with lettuce leaves.

○ **PER SERVING:** 4 g carbohydrate (includes 2 g dietary fiber), 14 g pro-
tein, 28 g fat, 321 calories
○ **DIABETIC EXCHANGES:** $^{1}/_{2}$ vegetable, 2 lean meat, 4$^{1}/_{2}$ fat

Mexican Shrimp Cocktail

I frequently order a similar dish for a light supper at my favorite Mexican cantina just minutes from my Texas home, but I find this even better as a cold lunch. If you're toting this to work, make sure you have access to refrigeration, use a cold thermal pack in your lunch carrier, or pack it in a prechilled wide-mouth thermos. You want to keep this icy cold not only for food safety reasons but for the best flavor as well. Yes, the recipe's expensive in carb count, but it's so filling you won't need anything else until dinnertime.

MAKES 1 SERVING

1 (5.5-fluid ounce) can spicy tomato-vegetable juice cocktail

2 tablespoons tomato-based chili sauce

1 to 2 teaspoons prepared horseradish, or to taste

2 scallions, white part and 1 inch green, chopped

2 tablespoons minced celery

2 tablespoons minced green bell pepper

2 tablespoons minced fresh cilantro

4 ounces cooked, peeled very small shrimp (often called salad shrimp)

In a container, combine all the ingredients. Cover and refrigerate until ready to use.

○ PER SERVING: 19 g carbohydrate (includes 2 g dietary fiber), 25 g protein, 2 g fat, 203 calories

○ DIABETIC EXCHANGES: 2 vegetable, 3 very lean meat

Year-Round Cottage Cheese Salad

MAKES 1 SERVING

1 medium tomato

½ cup 2% fat cottage cheese

½ tablespoon snipped fresh
 chives or minced scallions

2 large pimiento-stuffed olives,
 chopped

¼ teaspoon finely grated
 lemon zest

Salt and freshly ground pepper,
 to taste

Throughout the year, I eat this low-carb salad more frequently than any single other dish for lunch. It's quick, easy, and travels well to work.

Cut a thin slice from the stem end of the tomato, remove the core, and cut the tomato into 8 wedges. Arrange the tomato wedges in a portable container to resemble the petals of a flower.

In a small bowl, combine the cottage cheese, chives, olives, and lemon zest. Season with salt and pepper. Pile the mixture into the center of the tomato. Cover and keep cold until ready to eat.

○ PER SERVING: 11 g carbohydrate (includes 2 g dietary fiber), 17 g protein, 4 g fat, 142 calories

○ DIABETIC EXCHANGES: 1½ vegetable, 2 very lean meat, ½ fat

Deli Antipasto Salad

If this is a take-to-work salad, pack the dressing separately to pour over the salad just before eating. Look for the pickled vegetables in the pickle aisle. The kind that I buy contains cauliflower, roasted peppers, celery, and pepperoncini.

To make the salad: Arrange the lettuce on a large plate or in a shallow plastic container. Distribute the pickled vegetables on the lettuce and scatter the pastrami and cheese on top. Cover and chill until ready to serve.

To make the dressing: In a small bowl, whisk together the onion, mustard, vinegar, olive oil, and herbs. Set aside or pack into a portable container. Just before eating, remix the dressing and drizzle over the salad.

○ PER SERVING: 8 g carbohydrate (includes 3 g dietary fiber), 14 g protein, 18 g fat, 247 calories

○ DIABETIC EXCHANGES: 1 vegetable, 1 very lean meat, 1 lean meat, 3 fat

MAKES 1 SERVING

Salad

4 to 5 small inner leaves of romaine lettuce, washed and crisped

$1/2$ cup assorted pickled vegetables from a jar of giardiniera

1 ounce thinly sliced turkey pastrami, cut into thin strips

1 ounce provolone cheese, cut into $1/2$-inch pieces

Dressing

1 tablespoon minced red onion

$1/8$ teaspoon Dijon mustard

$1/2$ tablespoon red wine vinegar

2 teaspoons extra-virgin olive oil

Dash dried Italian herb seasoning

Tomato Mozzarella Salad

MAKES 1 SERVING

1 large tomato, cut into 4
 crosswise slices
2 (1-ounce) slices part-skim
 mozzarella cheese, cut in
 half
8 large leaves fresh basil
2 tablespoons purchased
 balsamic vinaigrette
Freshly ground pepper, to taste

When the summer tomatoes are at their peak, so is the fresh basil. You'll need large basil leaves for this delightful and light lunch. If you're taking this to work, pack the items separately to assemble on the spot. Don't forget to take a few grindings of black pepper along in a self-sealing bag to sprinkle on top.

Stack the tomato slices, cheese slices, and basil leaves in alternating layers. Drizzle with the vinaigrette and sprinkle with pepper. Serve immediately.

○ PER SERVING: 12 g carbohydrate (includes 2 g dietary fiber), 17 g protein, 13 g fat, 228 calories
○ DIABETIC EXCHANGES: 1½ vegetable, 2 lean meat, 1 fat

Shrimp Louis

My favorite way to make this salad is with the classic cooked, cracked Dungeness crab that's used in San Francisco restaurants, but this version is easier to handle away from home. Almost every supermarket sells already cooked peel-and-eat shrimp, the focus of this salad. The other elements are easy to come by in most well-stocked kitchens. Who says you have to be in San Francisco to enjoy a Louis for lunch?

To make the salad: Place the lettuce in the bottom of a container or on a plate. Arrange the shrimp on one side of the lettuce and the tomato and egg wedges on the other side. Chill until ready to serve.

To make the dressing: In a small bowl, combine all the ingredients. Mix well. Spoon the dressing onto the tomato and egg wedges, if eating at once, or place in a small container and chill until ready to serve.

○ PER SERVING: 16 g carbohydrate (includes 3 g dietary fiber), 15 g protein, 21 g fat, 304 calories

○ DIABETIC EXCHANGES: 2 vegetable, 1 very lean meat, 1 lean meat, 3 fat

MAKES 1 SERVING

Salad

1 cup shredded iceberg lettuce

5 medium cooked peel-and-eat shrimp

1 medium tomato, cut into wedges

1 hard-cooked egg (see page 25), peeled and cut into wedges

Louis Dressing

1 tablespoon mayonnaise

1 tablespoon sour cream

1 tablespoon tomato-based chili sauce

1 teaspoon fresh lemon juice

1 scallion, white part and 1 inch green, chopped

EXERCISE YOUR CUSTOMER RIGHTS

Don't be afraid to ask your fish monger to weigh out exactly five cooked shrimp (as needed in the recipe above) or whatever small amount of meat or fish that you need when preparing meals for one or two. Most meat markets have trained their personnel to cater to their customers' requests, and that includes splitting up the store's own pre-packaged items to suit your needs. You won't be charged extra for the service.

Easy Salad Niçoise

MAKES 1 SERVING

Salad

2 ounces green beans, trimmed

2 or 3 small butter lettuce
 leaves, rinsed and crisped

5 cherry tomatoes, cut in half

1 (3-ounce) can water-packed
 tuna, drained and broken
 into large chunks

1 large hard-cooked egg (see
 page 25), peeled and
 quartered lengthwise

5 pitted black olives, preferably
 imported

1 scallion, white part and 2
 inches green, chopped

½ teaspoon capers, rinsed and
 drained

Dressing

2 teaspoons extra-virgin olive
 oil

2 teaspoons red wine vinegar

Salt and freshly ground pepper,
 to taste

⅛ teaspoon Dijon mustard

For a variety of reasons, this salad makes a great at-work lunch—it's delicious, substantial enough to keep away mid-afternoon hungriness, and so easy to make and tote to the office. To keep the lettuce from becoming soggy, put the dressing in a separate container to add just before eating.

To make the salad: Cook the green beans in boiling water to cover for 3 minutes. Drain and refresh under running cold water. Drain again.

Place the lettuce in a shallow container. Arrange the beans, tomatoes, tuna, egg wedges, and olives on the lettuce. Scatter the scallion and capers over all. Cover and chill.

To make the dressing: Place the oil in a small container. Pour the vinegar into a large spoon and lightly sprinkle with salt. Using a fork, start beating the vinegar and tilt the spoon to drizzle over the side into the oil. Add pepper and the mustard. Beat again with the fork. Cover. Just before serving, beat the dressing again and drizzle over the salad. Serve at once.

- PER SERVING: 14 g carbohydrate (includes 4 g dietary fiber), 27 g protein, 20 g fat, 350 calories
- DIABETIC EXCHANGES: 2 vegetable, 2 very lean meat, 1 lean meat, 3 fat

Asian Chicken Salad

This Asian-inspired chicken salad makes a marvelous, filling lunch. Although you could wrap the salad in butter lettuce leaves, I prefer the crunch of romaine lettuce. Pack the salad and the condiments separately, but be sure to keep them all chilled until you're ready to eat. This is a great lunch to share with a friend.

Place the chicken in a medium bowl. In a cup, whisk together the hoisin sauce, peanut butter, ginger, chili paste, red pepper flakes, vinegar, canola oil, and sesame oil. Pour over the chicken and toss to coat evenly. Season the chicken with salt and pepper. Cover and chill, or transfer to a container and chill.

Place the lettuce in a shallow container or place in a self-sealing plastic bag. Place the carrot, scallion, radishes, and cilantro in separate bowls or separate containers. Chill until ready to serve.

When ready to serve, stir the chicken mixture and spoon about 2 tablespoons along the center of a lettuce leaf. Top with some of the carrot, scallion, radishes, and cilantro. Roll up the leaf from the sides and eat.

○ PER SERVING: 12 g carbohydrate (includes 3 g dietary fiber), 30 g protein, 15 g fat, 299 calories

○ DIABETIC EXCHANGES: 1 vegetable, 3½ very lean meat, 2½ fat

MAKES 2 SERVINGS

1 (6-ounce) boneless, skinless chicken breast half, cooked and shredded

1½ tablespoons hoisin sauce

1 tablespoon creamy peanut butter

½ teaspoon grated fresh ginger

¼ teaspoon Thai chili paste

⅛ teaspoon crushed red pepper flakes

1 tablespoon rice vinegar

2 teaspoons canola oil

1 teaspoon dark sesame oil

Salt and freshly ground pepper, to taste

8 large leaves romaine lettuce, washed and crisped

½ cup shredded carrot

¼ cup thinly sliced scallion

¼ cup thinly sliced red radishes

¼ cup chopped fresh cilantro

Spinach Salad with Balsamic Vinaigrette

MAKES 1 SERVING

2 cups fresh baby spinach
 leaves

2 white mushrooms, cleaned
 and sliced

1/4 cup fresh mung bean
 sprouts, rinsed and drained

1 large hard-cooked egg (see
 page 25), sliced

1 scallion, white part and 1 inch
 green, chopped

2 teaspoons extra-virgin olive
 oil

1 teaspoon balsamic vinegar

1/8 teaspoon Dijon mustard

Salt and freshly ground pepper,
 to taste

This is an easy salad to carry to work, especially if you buy the packaged baby spinach for salads that's available in most markets. Don't dress the salad until you're ready to eat.

In a container, combine the spinach, mushrooms, bean sprouts, egg, and scallion. Keep chilled until ready to serve. In a small dish, whisk together the olive oil, vinegar, and mustard. Season with salt and pepper. Place in a separate container to drizzle over the salad just before serving.

○ PER SERVING: 8 g carbohydrate (includes 3 g dietary fiber), 11 g protein, 16 g fat, 213 calories

○ DIABETIC EXCHANGES: 1 1/2 vegetable, 1 lean meat, 2 1/2 fat

Cucumber and Smoked Salmon Sandwiches

I have a friend who makes all kinds of sandwiches using slices of hothouse (seedless) cucumber cut on the bias as the sandwich "bread." This works particularly well with herbed cream cheese and smoked salmon. Don't peel the cucumber; the peel helps it hold together.

Spread the cream cheese on 2 of the cucumber slices. Divide the smoked salmon between these slices and, if using, sprinkle with dill. Cover with the remaining slices of cucumber and serve.

○ **PER SERVING:** 4 g carbohydrate (includes 1 g dietary fiber), 13 g protein, 13 g fat, 185 calories
○ **DIABETIC EXCHANGES:** ½ vegetable, 1 lean meat, 2 fat

MAKES 1 SERVING

3 tablespoons whipped cream cheese with chives
4 slices hothouse (seedless) cucumber, cut on the bias
2 ounces smoked salmon
Chopped fresh dill (optional)

Greek Salad for One

MAKES 1 SERVING

1 cup romaine lettuce, rolled
 and shredded chiffonade-
 style
½ hothouse (seedless)
 cucumber, sliced
1 large plum tomato, quartered
 lengthwise
2 scallions, white part and 1
 inch green, finely chopped
⅓ cup crumbled feta cheese
2 teaspoons extra-virgin olive
 oil
2 teaspoons champagne
 vinegar
Crushed dried oregano, to taste
5 kalamata olives
5 fresh mint leaves (optional)

Easy to make and so perfect for lunch. If you're taking this to work, pack the dry ingredients in separate self-sealing plastic bags and assemble the salad just before eating on a disposable plate. Don't forget to pack a fork.

Place the lettuce on a serving plate. Arrange the cucumber and tomato on the lettuce. Scatter the scallions on top and sprinkle with the feta cheese. In a small container, combine the olive oil, vinegar, and oregano. Drizzle over the salad and add the olives. If using, tear the mint leaves into small pieces and scatter over the top.

○ PER SERVING: 15 g carbohydrate (includes 4 g dietary fiber), 11 g protein, 25 g fat, 317 calories
○ DIABETIC EXCHANGES: 2 vegetable, 1 lean meat, 4 fat

THE BEST BEVERAGE FOR LUNCH

Water—tap, filtered, or bottled—tops the list. More than just a thirst quencher, water is a necessary element for a healthy, attractive body. A person of average weight is advised to consume eight 8-ounce glasses of water a day, more if overweight and trying to lose weight. This is particularly important if you have diabetes, as some diabetics tend to become dehydrated more easily than the rest of the population. The body functions best when fully hydrated, affecting the skin, muscle tone, and body functions. With a few exceptions of specific medical disorders, it's virtually impossible to drink too much water. The body will use only the water it needs and will expel the rest. Other beverages to enjoy at lunchtime are iced tea or hot tea and coffee. Check with your doctor as to whether or not these need to be decaffeinated.

Ham and Swiss Cheese Salad with Mustard Dressing

You can use leftover baked ham or ham purchased from a deli for this easy, filling salad.

In a bowl, combine the ham, cheese, grapes, and celery. Stir in the yogurt, mayonnaise, mustard, and basil. Mix well. Transfer to a container. Cover and refrigerate until ready to serve.

○ PER SERVING: 14 g carbohydrate (includes 1 g dietary fiber), 23 g protein, 22 g fat, 346 calories
○ DIABETIC EXCHANGES: ½ fruit, 1½ very lean meat, 1 lean meat, 3½ fat

MAKES 1 SERVING

2 ounces extra-lean cooked ham, cubed

1 ounce Swiss cheese, cubed

6 seedless grapes, cut in half

¼ cup sliced celery

3 tablespoons plain nonfat yogurt

1 tablespoon mayonnaise

⅛ teaspoon Dijon mustard

1 tablespoon chopped fresh basil

Parmesan and Basil Chicken Salad

MAKES 1 SERVING

1 (3-ounce) cooked boneless, skinless chicken breast half

¼ cup chopped celery

2 tablespoons mayonnaise

½ tablespoon fresh lemon juice

2 tablespoons minced fresh basil

½ teaspoon minced garlic

1 tablespoon grated Parmesan cheese

This pesto-flavored chicken salad can be served in the hollow of red bell pepper chunks, wrapped in a large lettuce leaf, or spread onto a piece of low-carb bread for eating out of hand. Be sure to keep the salad chilled until just before serving. To save time, cook the chicken the night before or use leftover cooked chicken or turkey.

Cut the chicken into thin crosswise strips and place in a small bowl. Add the celery and toss.

In a food processor, purée the mayonnaise, lemon juice, basil, garlic, and Parmesan cheese. Spoon onto the chicken mixture and toss again. Chill until ready to serve.

○ **PER SERVING:** 4 g carbohydrate (includes 1 g dietary fiber), 23 g protein, 25 g fat, 331 calories

○ **DIABETIC EXCHANGES:** ½ vegetable, 3 very lean meat, 4½ fat

Curried Chicken Spread on Veggies

I love almost everything curried—especially chicken. By cooking an extra piece of chicken breast a day or two before, you have your lunch almost made. Mince everything fine so that your spread doesn't fall off the veggies. Be sure to keep the spread chilled until lunchtime, whether at home or away.

MAKES 1 SERVING

In a small bowl, toss the chicken with the lime juice. Add the celery, scallion, yogurt, mayonnaise, curry powder, and cumin. Mix well. Season with salt and pepper. Mix again. Cover and chill until ready to serve.

When ready to serve, spoon a small amount onto a piece of raw vegetable or lettuce leaf.

○ **PER SERVING:** 6 g carbohydrate (includes 2 g dietary fiber), 28 g protein, 14 g fat, 268 calories

○ **DIABETIC EXCHANGES:** 1 vegetable, 3¹/₂ lean meat, 2¹/₂ fat

1 (3-ounce) boneless, skinless chicken breast half, cooked and finely minced

1 teaspoon fresh lime juice

¹/₄ cup finely minced celery

1 scallion, white part and 1 inch green, minced

1 tablespoon plain nonfat yogurt

1 to 1¹/₂ tablespoons mayonnaise

¹/₄ teaspoon curry powder, or to taste

¹/₈ teaspoon ground cumin

Salt and freshly ground pepper, to taste

8 pieces cut-up raw vegetables such as celery, slices of hothouse (seedless) cucumber, 2-inch square pieces of bell pepper, slices of zucchini, or small inner leaves of lettuce

Hot Soups

Broccoli Cheese Soup

MAKES 1 SERVING

1 (4-ounce) stalk fresh broccoli

3 tablespoons minced onion

2 tablespoons minced celery

1 tablespoon unsalted butter

1/2 tablespoon unbleached all-
 purpose flour

Pinch crushed dried thyme

1/2 cup canned low-sodium
 chicken broth

1/2 cup whole milk

2 tablespoons shredded sharp
 cheddar cheese

Salt and freshly ground pepper,
 to taste

A cup of this warming soup makes a satisfying low-carb lunch. The soup is surprisingly rich despite its use of whole milk instead of heavy cream.

Peel the stalk of the broccoli and thinly slice. Break the top into small florets. Cook the broccoli in a medium saucepan in simmering water to cover until just tender, 4 to 5 minutes. Drain the broccoli and set aside.

In the same saucepan, sauté the onion and celery in the butter until the vegetables are limp, about 5 minutes. Sprinkle the mixture with the flour and thyme; stir in the chicken broth. Bring to a boil, reduce heat, and simmer for 5 minutes. While stirring, add the milk and reheat the soup, but do not let it boil. Add the reserved broccoli and the cheese. Cook, stirring, for 2 to 3 minutes. Season with salt and pepper. Transfer to a soup bowl or to a preheated wide-mouth thermos. Serve hot.

○ PER SERVING: 16 g carbohydrate (includes 4 g dietary fiber), 13 g protein, 21 g fat, 296 calories

○ DIABETIC EXCHANGES: 1/2 skim milk, 1 1/2 vegetable, 1/2 lean meat, 3 1/2 fat

Turkey or Chicken Vegetable Soup

The addition of leftover chicken or turkey to a basic vegetable soup gives the soup enough "staying power" to tide you over until supper. I usually use a mix of white and dark meat, but you could save some calories and fat grams by using all white meat.

In a small saucepan, combine all the ingredients and simmer for 10 minutes. Pour into a bowl or a preheated wide-mouth thermos. Serve hot.

○ PER SERVING: 14 g carbohydrate (includes 3 g dietary fiber), 16 g protein, 4 g fat, 149 calories

○ DIABETIC EXCHANGES: 2 vegetable, 1½ very lean meat, ½ lean meat

MAKES 1 SERVING

1¼ cups canned low-sodium chicken broth

4 cherry tomatoes, halved

¼ cup diced carrot

¼ cup diced celery

¼ cup diced onion

¼ cup diced zucchini

Pinch crushed dried Italian herb seasoning

¼ cup diced cooked turkey or chicken

Freshly ground pepper, to taste

Vegetable Soup

MAKES 2 SERVINGS

1 teaspoon extra-virgin olive oil

¼ cup chopped onion

¼ cup chopped celery

1 small carrot, diced

1 small zucchini, diced

1 tablespoon lentils, rinsed and
 picked over

½ cup canned tomatoes with
 juice, coarsely chopped

2 cups canned low-sodium
 chicken broth

¼ teaspoon crushed dried
 oregano

⅛ teaspoon crushed dried
 thyme

1 tablespoon tomato paste

Salt and freshly ground pepper,
 to taste

Years ago I developed this vegetable soup recipe for a diner in Connecticut that makes it 5 gallons at a time to serve to their hungry lunch and supper crowds. Scaled down and with a few adjustments, it makes a delicious take-along lunch.

Heat the oil in a medium saucepan over medium heat. Add the onion and celery. Sauté, stirring occasionally, until the onion is limp, about 4 minutes. Stir in the carrot, zucchini, lentils, and tomatoes. Add the broth, oregano, and thyme. Bring to a simmer and cook until the vegetables and lentils are tender, 10 to 12 minutes. Stir in the tomato paste and season with salt and pepper.

Divide the soup into two equal portions. Freeze or refrigerate half and put remaining soup into a plastic container to reheat later or pour into a preheated wide-mouth thermos container.

○ PER SERVING: 18 g carbohydrate (includes 5 g dietary fiber), 8 g protein, 5 g fat, 135 calories

○ DIABETIC EXCHANGES: 2½ vegetable, ½ lean meat, ½ fat

Spicy Chicken Tortilla Soup

Tortilla soup has become a favorite repast at restaurants and homes. It's so simple to make, it deserves to be added to your repertoire of quick lunch recipes. Assemble the soup just before eating.

Preheat the oven to 450°F. Lightly oil a baking sheet. Arrange the tortilla strips in a single layer on the baking sheet and bake, tossing the strips occasionally, for 5 to 7 minutes, until crisp. Set aside.

Meanwhile, place the chicken broth, onion, tomato, oregano, and pepper flakes into a small saucepan. Bring to a boil, reduce the heat, and simmer, stirring occasionally, for 5 minutes. Add the chicken and simmer for another 5 minutes.

If serving now, place the cheese and tortilla strips in the bottom of a soup bowl and ladle the soup on top. Sprinkle with cilantro leaves and serve hot. Otherwise transfer the soup to a preheated wide-mouth thermos and place the cheese and tortilla strips in separate self-sealing plastic bags.

○ **PER SERVING:** 19 g carbohydrate (includes 10 g dietary fiber), 22 g protein, 12 g fat, 242 calories

○ **DIABETIC EXCHANGES:** 1 bread/starch, 1 vegetable, 2 lean meat, 1/2 fat

MAKES 1 SERVING

Canola oil for brushing the baking sheet

1 (6½-inch) whole wheat low-carb tortilla (see page 47), cut into thin strips

1¼ cups canned low-sodium chicken broth

3 tablespoons minced onion

1 plum tomato, finely chopped

¼ teaspoon crushed dried oregano

⅛ teaspoon crushed red pepper flakes, or to taste

¼ cup diced cooked chicken

2 tablespoons shredded Monterey Jack cheese

4 to 5 fresh cilantro leaves

It's a Wrap

Goat Cheese, Tomato, and Arugula Wrap

MAKES 1 SERVING

1 (6½-inch) low-carb whole wheat tortilla (see page 47)
3 tablespoons soft goat cheese
1 teaspoon snipped chives or minced scallion
6 or 7 arugula leaves
1 plum tomato, seeded and chopped

Buy a creamy goat cheese and use it when it's still very fresh. If the cheese is covered in edible ash, herbs, or cracked pepper, there will be no significant change to the calorie or carb count.

Lay the tortilla on a work surface, spread with the goat cheese, and sprinkle with the chives, leaving the bottom inch of the tortilla empty. Lay the arugula on the goat cheese and sprinkle the tomato down the middle third of the goat cheese and arugula, again leaving the bottom inch empty.

Fold the bottom of the tortilla up over the filling, holding it there while you fold one side over and then the other side, overlapping the first side. Slip the wrap into a self-sealing plastic bag or cover in aluminum foil. Keep cold until ready to serve.

○ **PER SERVING:** 17 g carbohydrate (includes 10 g dietary fiber), 15 g protein, 15 g fat, 232 calories

○ **DIABETIC EXCHANGES:** 1 bread/starch, ½ vegetable, 1 lean meat, 1½ fat

Ham and Cheese Wrap

The addition of low-sugar peach jam to Dijon mustard elevates an ordinary ham and cheese wrap to the sublime.

MAKES 1 SERVING

1 (6^1/$_2$-inch) low-carb whole wheat tortilla (see page 47)

2 teaspoons grainy Dijon mustard

1 teaspoon low-sugar peach jam

2 (1-ounce) slices extra-lean baked ham

1 (1-ounce) slice provolone cheese

1 leaf green leaf lettuce, washed and crisped

Lay the tortilla on a work surface. Mix the mustard and jam and spread on the tortilla, leaving the bottom inch of the tortilla empty. Place the ham and cheese on the mustard mixture and top with the lettuce leaf.

Fold the bottom of the tortilla up over the filling, holding it there while you fold one side over and then the other side, overlapping the first side. Slip the wrap into a self–sealing plastic bag or cover in aluminum foil. Keep cold until ready to serve.

○ **PER SERVING:** 17 g carbohydrate (includes 9 g dietary fiber), 22 g protein, 12 g fat, 243 calories

○ **DIABETIC EXCHANGES:** 1 bread/starch, 1 very lean meat, 1 lean meat, 1 fat

Crunchy Vegetable Wrap

MAKES 1 SERVING

1 (6½-inch) low-carb whole wheat tortilla (see page 47)

2 tablespoons whipped cream cheese

1 sun-dried tomato (packed in oil), drained and minced

6 fresh spinach leaves, washed and crisped

¼ cup radish or alfalfa sprouts

⅓ cup shredded red cabbage

1 tablespoon crumbled feta cheese

1 teaspoon minced red onion

At least twice a week I eat an all-vegetable meal for lunch. This wrap is a winner—full of crunchy fiber and the bright flavors of the many vegetables. If you are counting net carbs, the wrap comes in at only 6 grams. If you're on a diabetic carb-counting regime, you will use the total carb count of 18 grams.

Lay the tortilla on a work surface. Mix the cream cheese and sun-dried tomato and spread on the tortilla, leaving the bottom inch of the tortilla empty. Place the spinach leaves on the cheese mixture and top with the radish sprouts and shredded cabbage. Lay the feta cheese and red onion down the middle third of the filling, again leaving the bottom inch of the tortilla empty.

Fold the bottom of the tortilla up over the filling, holding it there while you fold one side over and then the other side, overlapping the first side. Slip the wrap into a self-sealing plastic bag or cover in aluminum foil. Keep cold until ready to serve.

○ PER SERVING: 18 g carbohydrate (includes 12 g dietary fiber), 10 g protein, 12 g fat, 185 calories

○ DIABETIC EXCHANGES: 1 bread/starch, 1 vegetable, ½ lean meat, 1½ fat

Taos Turkey Wrap

Canned chipotle chile and pepper jack cheese add just the right amount of flavor kick to an otherwise mundane turkey wrap.

Lay the tortilla on a work surface. Mix the mayonnaise and chipotle chile and spread on the tortilla, leaving the bottom inch of the tortilla empty. Place the turkey slices and cheese slice on top of the chile mixture. Place the lettuce on top and lay the bell pepper strips down the middle third of the filling, again leaving the bottom inch of the tortilla empty.

Fold the bottom of the tortilla up over the filling, holding it there while you fold one side over and then the other side, overlapping the first side. Slip the wrap into a self-sealing plastic bag or cover in aluminum foil. Keep cold until ready to serve.

○ PER SERVING: 13 g carbohydrate (includes 9 g dietary fiber), 29 g protein, 17 g fat, 297 calories
○ DIABETIC EXCHANGES: 1 bread/starch, 2 very lean meat, 1 lean meat, 2 fat

MAKES 1 SERVING

1 (6½-inch) low-carb whole wheat tortilla (see page below)

½ tablespoon mayonnaise

1 teaspoon minced canned chipotle chile

2 ounces sliced turkey breast

1 (1-ounce) slice pepper jack cheese

¼ cup shredded lettuce

3 (¼-inch-wide) lengthwise strips of red or green bell pepper

LOW-CARB TORTILLA

La Tortilla Factory of Santa Rosa, California, makes the only commercially available low-carb tortilla. The original flavor is made from whole wheat flour and measures 6½ to 7 inches in diameter and weighs 36 grams. The company also makes a large-size tortilla that measures 8½ to 9 inches, weighing 62 grams. Both are low-fat and have a carb count of 12 grams (includes 9 grams dietary fiber) and 21 grams (includes 15 grams of dietary fiber), respectively.

Although the tortillas are widely available in supermarkets and whole food stores across the country, you can find out exactly where to buy them in your ZIP code area from the company's Web site (www.latortillafactory.com). You can also order directly from the Web site or by calling 800-446-1516. The tortillas will keep for 2 months in the refrigerator or 6 months in the freezer.

The Main Attraction

THERE ARE MANY DAYS that I stand in front of my refrigerator when it's time to make dinner and fervently wish that some fairy godmother had left our dinner there ready to pop into the oven. When I'm testing recipes for a new book or my Web site, dinner's no problem, as there are plenty of leftovers. But when I'm doing a day of writing, checking page proofs, or research for an article on diabetes, the last thing I want to do is spend a long time in the kitchen. I've learned, though, from 40 years of experience that great food doesn't need to take long to make. It just takes some organization in the kitchen (see page xv) and recipes that are quick and easy. With few exceptions, the recipes in this chapter require less than 30 minutes active kitchen time—and most everything can be prepared ahead of time.

Along with the ease of preparation, these recipes highlight just how our tastes have changed over the years. Wimpy flavors are out and bright, fresh tastes are in, using supermarket ingredients that were unheard of or unavailable just a few years ago. As any great chef will tell you, the quality of the ingredients you use will determine the excellence of the prepared dish. So buy the best you can afford.

Here's what's for dinner; I hope you enjoy it.

Grains Are Great—In Moderation

Lest you think that I never fix a starch with a meal—while it's true that I seldom eat a potato these days (just their all but empty baked skins)—I do occasionally fix rice, couscous, or another grain for dinner. Just remember that every gram of carb counts, and you shouldn't have a total carb count for the day over your allotment.

Grains can be cooked with a variety of herbs, spices, and other seasonings that add hardly any extra calories or carbs. Use these freely with the grains on your diet or meal plan. Remember that ⅓ cup of cooked grain provides 15 grams of carbohydrate and equals 1 bread/starch diabetic exchange. By the way, these same seasonings can be used to flavor whole wheat pasta—½ cup of cooked pasta also provides 15 grams of carbohydrate and equals 1 bread/starch diabetic exchange.

- Basil
- Chiles
- Cilantro
- Cinnamon
- Cumin
- Curry powder
- Fennel seed
- Fresh and dried ginger
- Mint
- Orange zest
- Paprika
- Parsley
- Saffron
- Tarragon
- Thyme

Succulent Meats and Poultry

Grilled Steaks with Fire-Roasted Salsa Sauce

MAKES 4 SERVINGS

Salsa

4 large plum tomatoes, halved

4 scallions, trimmed

½ bunch fresh cilantro, washed and dried on paper towels

1 clove garlic, minced

2 canned chipotle chiles, stemmed and rinsed off

2 tablespoons fresh lime juice

½ teaspoon salt

Freshly ground pepper, to taste

¼ teaspoon crushed dried oregano

Steaks

Olive oil, for brushing the grill rack

4 (6-ounce) boneless New York strip steaks, cut about ¾ inch thick

⅓ cup sour cream

Watercress sprigs for garnish

This is a quick and easy dinner party dish. I learned to make this salsa from Liz and Jim Baron, the culinary geniuses behind the several Blue Mesa Grill restaurants dotted around the Dallas/Fort Worth metroplex. At the restaurants, they use serrano chiles, but I like the added smokiness of chipotle chiles—smoked jalapeño chiles canned in adobo sauce—which can be found in Mexican markets and many supermarkets.

The salsa recipe makes about 2 cups. In this dish, I've mixed the salsa with a little sour cream to make a luscious sauce for the steaks. Use the leftover salsa on just about anything, including scrambled eggs, tacos, and grilled chicken.

To make the salsa: Prepare a grill for medium-high grilling. Place the tomatoes and scallions on the grill. Pile the cilantro on top so that it does not touch the grill. Grill the vegetables until they are blistered, about 7 minutes.

Remove the cilantro leaves from the stems. Place the tomatoes, scallions, cilantro leaves, garlic, and chiles in a food processor and pulse until coarsely ground. Transfer to a bowl and add the lime juice, salt, pepper, and oregano. Mix well and set aside.

To grill the steaks: Light a grill and lightly brush the grill rack with olive oil. Grill the steaks for 4 to 5 minutes per side, turning once, for medium-rare. Transfer the steaks to a carving board and slice on the diagonal into ½-inch-thick slices. Stir the sour cream into 1 cup of the salsa; refrigerate the remaining salsa for another use. Spoon some of the salsa mixture onto a serving platter and place the steak slices, slightly overlapping, on

top. Garnish with the watercress sprigs and serve immediately. Pass the remaining salsa mixture separately to spoon over each serving.

○ PER SERVING: 8 g carbohydrates (includes 2 g dietary fiber), 35 g protein, 18 g fat, 334 calories

○ DIABETIC EXCHANGES: 1¹/₂ vegetable, 4¹/₂ lean meat

GRILLING RACKS AND BASKETS

Tired of having small vegetables like mushrooms falling through the grates of the grill? You might want to invest in a grill rack or basket made specifically for small foods that allows the smoke to flavor vegetables and pieces of fruit. There are several styles available from gourmet shops, barbecue grill shops, discount stores, and some supermarkets.

The simplest is a flat wire mesh grill topper that's coated for nonstick cooking with easy grip handles. Another style is a basket made of two pieces of nonstick steel hinged at one side to allow for variances in the thickness of what's being grilled. A long stay-cool handle makes flipping the basket over a cinch. A larger grill basket with sides nearly 4 inches high sits on the grill rack with an open top; it comes with a removable handle and tongs for turning the food. All make grilling small foods easy and safe. Costs range from $4 to $25.

Grilled Steak Skewers with Peaches and Red Peppers

MAKES 4 SERVINGS

1 tablespoon extra-virgin olive oil, plus extra for brushing the grill rack

1 tablespoon minced fresh basil

1 clove garlic, minced

1 tablespoon grated fresh ginger

2 teaspoons ground cumin

1 teaspoon salt (optional)

1/2 tablespoon freshly ground pepper

1 1/4 pounds boneless top sirloin steak, trimmed of all fat and cut into 32 (1-inch) pieces

2 firm-ripe peaches, pitted and each cut into 8 wedges

1 small red onion, cut into 8 wedges

1 large red bell pepper, cut into 8 pieces

Though beef and peaches may seem like the odd couple, the sweetness of the best of the season's peaches and red bell peppers heighten the spicy flavor of the steak. Another time, try this recipe using nectarines or plums. Yum.

Light a grill and lightly brush the grill rack with olive oil.

In a bowl, combine 1 tablespoon olive oil with the basil, garlic, ginger, cumin, salt, if using, and pepper. Add sirloin pieces and toss to coat evenly.

Thread 4 steak pieces, 2 peach wedges, 1 onion wedge, and 1 piece of bell pepper alternately onto each of 8 (12-inch) metal skewers. Place the skewers on the grill rack and grill, turning occasionally, for 3 to 4 minutes per side for medium rare, or to desired doneness.

○ PER SERVING: 9 g carbohydrate (includes 2 g dietary fiber), 32 g protein, 14 g fat, 291 calories

○ DIABETIC EXCHANGES: 1/2 fruit, 1/2 vegetable, 4 lean meat, 1/2 fat

Tenderloin Steaks with Shiitake Mushroom Sauce

If you love beef, you're bound to love this steak with a savory mushroom sauce. Have most of the meal ready and waiting, as this cooks up in a flash. For sides, serve the Smashed Cauliflower with Jalapeño and Cheese (page 159) and Pan-Steamed Asparagus (page 153).

Rub both sides of the steaks with salt, pepper, and thyme. Heat the butter and oil in a large, heavy skillet over medium heat. When the butter foams, add the steaks and shallots. Sauté the steaks, turning once, to desired doneness, 4 to 6 minutes per side for medium-rare. Transfer the steaks to a plate and keep warm.

Add the mushrooms to the skillet, raise the heat to high, and sauté for about 4 minutes, stirring occasionally. Transfer the mushrooms to a bowl.

Stir the wine and broth into the skillet, scraping the bottom of the skillet to release any browned bits. Reduce to about ½ cup. Return the steaks and mushrooms to the skillet along with any juices that have accumulated. Spoon the pan sauce over the steaks. Transfer the steaks with some of the sauce to individual plates and serve immediately.

○ PER SERVING: 4 g carbohydrate (includes 1 g dietary fiber), 37 g protein, 20 g fat, 368 calories

○ DIABETIC EXCHANGES: ½ vegetable, 1 fat, 5 lean meat

MAKES 4 SERVINGS

4 (6-ounce) beef tenderloin steaks, cut about 1 inch thick

Salt and freshly ground pepper, to taste

1 tablespoon fresh thyme leaves or 1 teaspoon crushed dried

½ tablespoon unsalted butter

½ tablespoon extra-virgin olive oil

2 fresh shallots (see page 56), minced

8 ounces fresh shiitake mushrooms, cleaned and sliced

½ cup dry red wine

1 cup canned low-sodium beef broth

Asian Beef over Stir-Fried Bok Choy

MAKES 4 SERVINGS

Asian Beef
1/2 cup canned low-sodium beef
 broth
1/4 cup reduced-sodium soy
 sauce
1 tablespoon dry sherry
1/4 teaspoon crushed red pepper
 flakes
1/4 teaspoon five-spice powder
1 1/4 pounds boneless top sirloin
 steak
1 tablespoon canola oil
3 cloves garlic, thinly sliced
6 scallions, white part and 1
 inch green, chopped
2 tablespoons minced fresh
 ginger
1 1/2 tablespoons cornstarch
 dissolved in 2 tablespoons
 water

Stir-Fried Bok Choy
1 tablespoon canola oil
1 tablespoon minced fresh
 ginger
4 cups shredded bok choy

Tender pieces of beef combine with Asian flavors for this quick work-day dish. Look for the five-spice powder in Asian markets or the spice section of your supermarket. Also called Chinese white cabbage, bok choy looks like a large bunch of celery with wide ribs and dark green leaves.

To prepare the beef: In a small bowl, combine the beef broth, soy sauce, sherry, red pepper flakes, and five-spice powder. Set aside.

Trim all fat from the steak and slice with the grain into 1 1/2-inch-wide strips. Cut each strip across the grain into 1/8-inch-thick slanting slices.

Heat 1/2 tablespoon of the oil in a wok or large skillet over medium-high heat. Add the garlic, scallions, and ginger and stir-fry for 30 seconds. Raise the heat to high and add half of the beef. Stir-fry until the beef is lightly browned, about 2 minutes. Transfer the mixture to a plate. Add the remaining oil to the wok and when hot, add the remaining beef and stir-fry for about 2 minutes. Return the already cooked beef and vegetables to the wok and pour in the reserved beef broth mixture. Cover and simmer for 3 minutes.

Whisk the cornstarch mixture and gradually stir into the beef mixture. Simmer, stirring to coat the meat, until slightly thickened, 1 minute.

To prepare the bok choy: Heat the oil in a wok or large skillet over medium heat. Add the ginger and stir-fry for 30 seconds. Raise the heat to high and add the bok choy. Stir-fry for 1 minute. Cover and cook for another 2 minutes, until the bok choy is crisp-tender. Arrange the bok choy on a large serving platter and top with the hot beef. Serve immediately.

○ PER SERVING: 15 g carbohydrate (includes 5 g dietary fiber), 34 g protein, 18 g fat, 364 calories
○ DIABETIC EXCHANGES: 2 vegetable, 4 lean meat, 2 fat

○ PER SERVING BOK CHOY ONLY: 2 g carbohydrate (includes 1 g dietary fiber), 1 g protein, 4 g fat, 41 calories
○ DIABETIC EXCHANGES: ½ vegetable, 1 fat

Roasted Boneless Rib-Eye with Mustard and Shallots

MAKES 6 SERVINGS

1 (2-pound) boneless rib-eye
 steak, cut 2 inches thick
Extra-virgin olive oil, for
 brushing the steak
Salt and freshly ground pepper,
 to taste
2 teaspoons Dijon mustard
2 teaspoons finely minced fresh
 shallot (see below)

Here's a hearty steak to satisfy those who love prime rib roast. Ask your butcher to cut this steak to order, as you'll want a thick cut for it to roast to perfection. Because butchers traditionally leave the market early, so be sure to order ahead or get to the market by early afternoon. Use the best beef you can afford to buy. I usually splurge on Black Angus beef when I want a really tender, juicy steak.

Preheat the broiler. Lightly brush the steak with olive oil and season with salt and pepper. Mix together the mustard and shallots.

 Place the steak on the broiler pan and broil for 13 minutes. Spread the top side of the steak with half of the mustard-shallot mixture. Broil for another 2 minutes. Turn the steak and broil for another 8 minutes. Spread the top side of the steak with the remaining mustard-shallot mixture and continue to broil for another 2 minutes for medium-rare. Let rest for 5 minutes before slicing and serving.

○ PER SERVING: trace carbohydrate (includes trace dietary fiber), 40 g
 protein, 20 g fat, 344 calories
○ DIABETIC EXCHANGES: 6 lean meat, ½ fat

NO SHALLOTS?

Although fresh shallots are truly wonderful and some cooks consider shallots a "must" for a recipe, some markets never carry them and others only sporadically. If this is true where you live, I suggest you invest in a bottle of freeze-dried shallots. I worked on the development team of this freeze-dried product; in taste tests in the test kitchen, we found very little difference in the finished product when compared to fresh. It's truly a boon for quick cooks. Look for it in the spice section of your supermarket.

Cold Beef Salad

This is one of my favorite recipes when the temperature is soaring and I'm really short on time. You can roast your own beef the night before—eye of round roast or a small sirloin roast works best, or you can purchase sliced beef from the deli at your supermarket. The salad benefits from a little time for the flavors to mingle, making this a great make-ahead dish. You'll find the tomato-based chili sauce next to the ketchup in your supermarket.

Place the beef, pimientos, bell pepper, onion, tomatoes, and garlic in a large bowl. In another bowl, whisk together the wine, salad dressing, eggs, and chili sauce. Pour over the beef mixture and lightly toss. Cover and refrigerate until ready to serve, or up to 12 hours.

Line a serving platter with the arugula. Top with the beef mixture and sprinkle with the basil. Serve chilled.

○ PER SERVING: 9 g carbohydrate (includes 1 g dietary fiber), 36 g protein, 17 g fat, 346 calories
○ DIABETIC EXCHANGES: 1 vegetable, 5 lean meat, 1 fat

MAKES 8 SERVINGS

2 pounds thinly sliced, cooked rare or medium-rare, lean roast beef, cut into strips

1 (2-ounce) jar pimientos, drained and cut into thin strips

1 small green bell pepper, finely chopped

1 small red onion, cut in half and thinly sliced

2 medium tomatoes, chopped

1 clove garlic, minced

1/2 cup burgundy wine

1 cup purchased vinegar and oil salad dressing

2 hard-cooked eggs (see page 25), peeled and chopped

1/4 cup tomato-based chili sauce

1 bunch fresh arugula or green leaf lettuce, washed and crisped

1/3 cup finely chopped fresh basil

Grilled Sirloin Burger Salad, Caesar Style

MAKES 6 SERVINGS

Caesar-Style Dressing
1/4 cup extra-virgin olive oil
1 tablespoon red wine vinegar
1 anchovy fillet, drained and
 chopped
1 clove garlic, minced
1 teaspoon fresh lemon juice
1/2 teaspoon Dijon mustard
1/4 teaspoon Worcestershire
 sauce
1/3 cup freshly grated Romano
 cheese
Salt and freshly ground pepper,
 to taste

Salad
1 small onion, thinly sliced
1 cup cherry tomato halves
1/2 cup thinly sliced radishes
1/4 cup thinly sliced celery
6 romaine lettuce leaves, torn
 into bite-size pieces
Extra-virgin olive oil, for
 brushing the grill rack
1 pound ground beef sirloin
2 cloves garlic, minced
1 teaspoon salt
1/2 teaspoon freshly ground
 pepper
1/4 cup chopped fresh flat-leaf
 parsley
1/3 cup pecans, toasted and
 coarsely chopped

You're going to love this Caesar-style dressing and will find yourself making it again and again to drizzle over just romaine lettuce pieces or the romaine pieces topped with grilled shrimp or chicken. It's a great way to enjoy a burger—without the carb-laden bun. Toasted pecans nicely take the place of the croutons.

To make the dressing: In a food processor or blender, combine the olive oil, vinegar, anchovy fillet, garlic, lemon juice, mustard, and Worcestershire sauce. Process until smooth. Add the cheese and blend for 15 seconds. Taste and season with salt and pepper.

To make the salad: In a bowl, combine the onion, tomatoes, radishes, celery, and lettuce. Toss, cover with a damp towel, and refrigerate.

Light a grill and lightly oil the grill rack. In a large bowl, combine the ground beef, garlic, salt, pepper, and parsley. Shape into 6 patties, about 1/2 inch thick. Grill over medium–high heat, turning occasionally, until juices run clear and patties are cooked through, 9 minutes total cooking time. Remove to a plate and let stand for 5 minutes.

Break the meat patties into bite-size pieces and add to the salad. Pour the dressing over the salad and toss to combine. Place in a serving bowl and garnish with the pecans.

○ PER SERVING 4 g carbohydrate (includes 1 g dietary fiber), 17 g protein, 16 g fat, 225 calories
○ DIABETIC EXCHANGES: 1/2 vegetable, 2 1/2 lean meat, 2 fat

Quick Cincinnati-Style Chili

Cincinnati is famous for its chili parlors. Each restaurant serves a slightly different version, but all include the aromatic spices and herbs of Greece. The exact recipes are such a closely guarded secret that the mixing of the seasonings takes place behind closed doors away from the kitchen. My version may look complicated because of the number of spices, but there's nothing really exotic here and the dish from start to finish takes about 20 minutes. If you can afford the extra carbs on the day, serve this chili the traditional way on a bed of spaghetti—just make sure it's whole wheat or a lower-carb pasta made from soy flour.

MAKES 6 SERVINGS

1½ pounds ground beef sirloin
2 cups chopped onions
½ cup chopped celery
4 cloves garlic, minced
2 tablespoons chili powder
1 tablespoon sweet paprika
½ teaspoon crushed dried basil
½ teaspoon crushed dried oregano
½ teaspoon crushed dried thyme
1 teaspoon ground cinnamon
½ teaspoon cayenne pepper
½ teaspoon ground cumin
½ teaspoon crushed red pepper flakes
¼ teaspoon ground allspice
Salt and freshly ground pepper, to taste
1 (28-ounce) can whole canned tomatoes, coarsely chopped, including juice
¾ cup shredded sharp cheddar cheese for garnish (optional)
½ cup chopped onion for garnish (optional)

In a large pot, brown the ground beef, onions, celery, and garlic until the vegetables are limp and the beef is no longer pink, about 5 minutes. Drain off the excess fat.

Stir in the chili powder, paprika, basil, oregano, thyme, cinnamon, cayenne pepper, cumin, red pepper flakes, and allspice. Season with salt and pepper. Add the tomatoes with juice and simmer briskly, uncovered, stirring occasionally, until the chili is thickened, 8 to 10 minutes.

Ladle the chili into soup bowls and, if using, offer the cheese and onion in separate bowls to sprinkle over the hot chili.

○ PER SERVING: 15 g carbohydrate (includes 4 g dietary fiber), 29 g protein, 7 g fat, 226 calories
○ DIABETIC EXCHANGES: 2½ vegetable, 3½ very lean meat, ½ fat

NOTE:

You may use 4 (6-ounce) packages Ground Beef Sirloin and Onion Mix (see page 62) for the ground beef, onion, and garlic. Preheat the mix, combine with the celery, and then proceed as directed.

Enchilada Meatloaves

MAKES 6 SERVINGS

1 pound ground beef sirloin

1 pound lean ground pork

1 medium onion, finely
 chopped

3/4 cup finely chopped red bell
 pepper

1 tablespoon finely minced
 garlic

2 teaspoons ground cumin

1/2 teaspoon crushed dried
 oregano

1/4 teaspoon freshly ground
 pepper

2 large eggs

2 tablespoons soft low-carb
 bread crumbs

1/3 cup shredded Mexican
 cheese blend—cheddar,
 Monterey Jack, asadero, and
 queso blanco

1 (8-ounce) jar enchilada sauce

Sometimes a great new recipe comes out of the need for substitution. Such is the case here—when I went to my pantry for a can of tomato sauce to use as a topping for my southwestern version of meatloaf, I found the cupboard was bare. Luckily, I had just purchased a jar of enchilada sauce the day before, so once my mini-meatloaves were formed, I poured on the sauce and sprinkled the tops with a blend of Mexican cheeses I had on hand. The result was great enchilada flavor—without the carbs of the tortillas.

Preheat the oven to 450°F. In a large bowl, combine the beef, pork, onion, bell pepper, garlic, cumin, oregano, and pepper. Mix well. Add the eggs and bread crumbs; mix again. Divide the meat mixture into six equal parts and form each part into an oval about ¾ inch thick. Place in a baking pan.

Cover each loaf with some of the enchilada sauce and sprinkle with the cheese. Bake for about 20 minutes, until loaves are cooked through. Transfer loaves and sauce to individual plates and serve hot.

○ **PER SERVING:** 8 g carbohydrate (includes 1 g dietary fiber), 32 g protein, 24 g fat, 379 calories

○ **DIABETIC EXCHANGES:** 1 vegetable, 4½ very lean meat, 1 fat

Taco Skillet

This is a delicious family dish—and a sneaky way to get everyone at your table to eat and enjoy cooked cabbage. If you've taken my tip on keeping Ground Sirloin and Onion Mix (page 62) in your freezer, you'll be even quicker getting this skillet casserole on the table.

Brown the beef, onion, and garlic in a large heavy skillet over medium-high heat. Stir in the seasoning mix along with the tomatoes and their juice. Simmer for 5 minutes.

Add the cabbage and cook, stirring occasionally, until the cabbage is cooked but still crisp to the bite, 4 to 5 minutes. Top with the cheese and cook until the cheese melts, about 2 minutes. Serve hot with a dollop of sour cream on top of each serving. If using, sprinkle some cilantro on each serving.

○ PER SERVING: 14 g carbohydrate (includes 2 g dietary fiber), 33 g protein, 17 g fat, 334 calories
○ DIABETIC EXCHANGES: 1^1/$_2$ vegetable, 3 very lean meat, 1 lean meat, 2 fat

NOTE:

You may use 4 (6-ounce) packages ground beef sirloin and onion mix (see page 62) for the ground beef, onion, and garlic. Reheat the mix and continue as directed.

MAKES 6 SERVINGS

1^1/$_2$ pounds ground beef sirloin (see Note)

1 medium onion, chopped (see Note)

2 cloves garlic, minced (see Note)

1 (1-ounce) package taco seasoning mix

1 (14^1/$_2$-ounce) can chopped tomatoes, including juice

1 (10-ounce) bag shredded cabbage for coleslaw

1 cup shredded sharp cheddar cheese

3/$_4$ cup sour cream

Chopped cilantro for garnish (optional)

Ground Beef Sirloin and Onion Mix

MAKES 4 (6-OUNCE) PACKAGES

1¹/₂ pounds ground beef sirloin
1 large onion, chopped
4 cloves garlic, minced

Keep containers of this beef and onion mix in your freezer to have a head start on making chili, soups, casseroles, and one-skillet dishes. Using the microwave makes the browning of the ground meat quick while extracting most of the fat. Package in 6-ounce containers and freeze. Use in recipes as needed within three months. This mix can also be made with ground turkey breast.

Crumble the ground beef into a 3-quart microwave-safe casserole. Cover and microwave on High for 5 minutes. Stir to break up the meat. Drain the meat in a colander to remove any fat.

Stir in the onion and garlic. Divide the mixture equally among 4 microwave-safe freezer containers. Cover and freeze. When ready to use, defrost following the manufacturer's instructions for your microwave. Use in recipes as instructed.

○ PER PACKAGE: 6 g carbohydrate (includes 1 g dietary fiber), 40 g protein, 10 g fat, 284 calories
○ DIABETIC EXCHANGES: 5¹/₂ very low-fat meat, 1 vegetable

Grilled Pork Chops with Fresh Tomato Relish

Dressed up with a snappy tomato relish, these pork chops make mighty fine eating for family or company. You'll find lots of other uses for this versatile relish—over other grilled meats, fish, or poultry.

To make the relish: In a bowl, combine all the ingredients for the relish. Set aside at room temperature for at least 5 minutes or up to 30 minutes.

To grill the pork chops: Meanwhile, light a grill and lightly oil the grill rack. Sprinkle the pork chops with the oregano, salt, and pepper. Grill over medium heat, turning once or twice, until the pork chops are cooked through, about 6 minutes per side. Transfer the pork chops to serving plates and spoon the relish over the tops. Serve at once.

○ PER SERVING: 9 g carbohydrate (includes 2 g dietary fiber), 21 g protein, 14 g fat, 238 calories
○ DIABETIC EXCHANGES: 1½ vegetable, 2½ lean meat, 1 fat

MAKES 4 SERVINGS

Fresh Tomato Relish
¾ pound plum tomatoes, seeded and chopped
¾ cup finely chopped red onion
1 jalapeño chile, seeded and minced
1 clove garlic, minced
2 tablespoons fresh lemon juice
2 tablespoons extra-virgin olive oil
2 tablespoons chopped fresh cilantro

Grilled Pork Chops
Olive oil, for brushing the grill rack
4 (1-inch-thick) center-cut pork chops
Crushed dried oregano, to taste
Salt and freshly ground pepper, to taste

TODAY'S PORK

As a nation, America grew up on pork. In fact, we ate more pork than any other meat until well into the twentieth century. But today's pork has little resemblance (other than flavor) to the pork of yesterday. It can be leaner than veal and contains less cholesterol. Pork actually vies with chicken as a lean meat. While I was writing the first of four diabetes cookbooks, pork was changed from a medium-fat meat to a lean meat in diabetic food exchange lists. Pork is so succulent and marries so well with whatever seasoning or sauce you introduce, your options are almost endless.

Pork Chops Braised in Milk

MAKES 4 SERVINGS

1 teaspoon extra-virgin olive oil

1 teaspoon unsalted butter

4 (1-inch-thick) boneless pork chops

1 teaspoon fresh thyme leaves

1 teaspoon minced garlic

Salt and freshly ground pepper, to taste

2 cups whole milk

2 teaspoons cornstarch

1 tablespoon water

½ teaspoon Dijon mustard

This is a marvelous way to prepare boneless pork loin chops. The milk and the pan juices form a delicious rich sauce that needs only a quick pulse in a food processor or blender to smooth it out. I originally learned this cooking method for pork in an Italian cooking class taught by Marcella Hazen in New York, but I've since added a few touches of my own.

Heat the oil and butter in a large skillet over medium-high heat. Season one side of the pork chops with the thyme, garlic, salt, and pepper. Place seasoned side down in the skillet and brown the pork chops on both sides, turning once, about 3 minutes per side. Pour off excess fat from the skillet.

Pour in the milk. Bring the milk to a boil, reduce heat to low, and cover. Braise the pork chops for about 25 minutes, turning once after 15 minutes. (The milk will appear curdled.)

Transfer the pork chops to a heated serving platter. Bring the milk mixture back to a boil. In a bowl, whisk together the cornstarch, water, and mustard. Stir the mixture into the skillet and boil, whisking constantly, for 1 minute. Transfer the mixture to a food processor or blender and pulse until it forms a smooth sauce. Pour the sauce over the pork chops and serve.

○ PER SERVING: 7 g carbohydrate (includes trace dietary fiber), 24 g protein, 18 g fat, 296 calories

○ DIABETIC EXCHANGES: ½ skim milk, 3 lean meat, 2 fat

Pan-Fried Pork Chops with Mustard Sauce

MAKES 4 SERVINGS

This is a superb way to quickly cook pork chops. Add Sautéed Broccoli with Toasted Almonds and Bacon (page 155) and a crisp green salad, and your meal is done.

1 tablespoon fresh thyme leaves
2 cloves garlic, minced
4 (about 3/4-inch-thick) center-cut pork chops
1 teaspoon extra-virgin olive oil
1 teaspoon unsalted butter
1/2 cup champagne vinegar
1/2 cup heavy cream
1 tablespoon Dijon mustard
Freshly ground pepper, to taste

Press the thyme and garlic onto both sides of the pork chops. Heat the oil and butter in a large nonstick skillet over medium-high heat. Add the pork chops and sauté for 5 minutes on each side, turning once. Reduce the heat, cover, and cook until the pork is cooked through, 15 to 20 minutes.

Transfer the pork chops to a heated serving platter and keep warm. Add the vinegar to the skillet and stir to loosen any browned bits in the bottom of the skillet. Cook over high heat until reduced by half. Add the cream and continue to reduce until the mixture coats the back of a wooden spoon. Whisk in the mustard and season with pepper. Spoon the sauce over the pork chops and serve.

○ **PER SERVING:** 4 g carbohydrate (includes trace dietary fiber), 21 g protein, 25 g fat, 332 calories

○ **DIABETIC EXCHANGES:** 3 lean meat, 3 fat

Sautéed Pork Steak—Jalisco Style

MAKES 4 SERVINGS

1 (1-pound) boneless pork
 tenderloin

1½ tablespoons sweet paprika

1½ tablespoons ground ancho
 chiles or good-quality chili
 powder

½ tablespoon ground cumin

½ tablespoon crushed dried
 oregano

½ teaspoon salt

2 cloves garlic, minced

2 tablespoons red wine vinegar

1 tablespoon extra-virgin olive
 oil

1 small orange, cut into
 8 wedges

Jalisco is the Mexican state along the Pacific Ocean west of Mexico City. The cooks of this region pound pork until it's very thin and then give it a strong spice rub for flavor. The pork cooks quickly, needing only a squeeze of fresh orange juice to finish it off.

Rinse the pork and trim off any fat. Place the pork between two sheets of heavy-duty plastic wrap. Using a flat mallet, pound the pork until it is an even ¼-inch thickness. Cut the pork into 4 equal pieces.

In a small bowl, mix together the paprika, chiles, cumin, oregano, salt, garlic, and vinegar. Evenly distribute the spice mixture on both sides of the pork pieces.

Heat the oil in a large skillet over high heat. When the oil is hot, add the pork and sauté for about 2 minutes per side, turning once. Lower the heat to medium and cook, turning occasionally, until the pork is cooked through in the center (cut to test), 7 to 8 minutes. Transfer the pork to individual plates. Place 2 orange wedges alongside for squeezing over the pork before eating.

○ **PER SERVING:** 6 g carbohydrate (includes 2 g dietary fiber), 26 g protein, 11 g fat, 229 calories
○ **DIABETIC EXCHANGES:** ½ fruit, 3 lean meat, ½ fat

Pork Satay with Spicy Peanut Sauce

An Indonesian favorite, I had these delicious morsels of pork in Maui. Served on a bed of shredded red cabbage, they can be the highlight of your next dinner party. Be sure to buy the light coconut milk—it's available nowadays in most supermarkets.

For another great use for sambal oelek, see the recipe headnote on page 146. A jar of this spicy Indonesian chile paste will keep for months in the fridge. Use it sparingly, as it's very hot!

MAKES 4 SERVINGS

2 teaspoons peanut oil, plus extra for brushing the grill rack

⅓ cup minced onion

2 cloves garlic, minced

⅓ cup creamy peanut butter

½ teaspoon sambal oelek (see page 146)

½ cup canned light coconut milk

1 teaspoon honey

1 teaspoon plus ¼ cup soy sauce

2 (10-ounce) unseasoned pork tenderloins, cut into 1-inch cubes

2 tablespoons fresh lime juice

4 cups shredded red cabbage

¼ cup chopped fresh basil

About ⅓ cup canned low-sodium chicken broth

Light a grill and lightly brush the grill rack with oil.

Heat the 2 teaspoons oil in a heavy nonstick skillet over medium heat. Add the onion and garlic. Sauté until the vegetables are limp, 4 minutes. Stir in the peanut butter and sambal oelek. Gradually whisk in the coconut milk, honey, and 1 teaspoon of the soy sauce. Let the sauce cook for 1 minute; set aside.

In a large bowl, combine the pork cubes with ¼ cup of the soy sauce and the lime juice. Thread the pork onto metal skewers and grill, turning occasionally, until the pork is cooked through, 4 to 5 minutes per side.

Place the red cabbage on a large serving platter and arrange the pork skewers on top. Sprinkle with the basil.

Reheat the sauce until it is simmering, then thin as needed with the chicken broth. Drizzle the sauce over the pork and serve at once.

○ **PER SERVING:** 16 g carbohydrate (includes 3 g dietary fiber), 39 g protein, 25 g fat, 433 calories

○ **DIABETIC EXCHANGES:** 1 vegetable, 4½ lean meat, 2½ fat

Grilled Italian Sausages and Pepper Stew

MAKES 4 SERVINGS

Canola oil, for brushing the grill rack

1 pound fresh Italian sausages (hot, sweet, or mixture of both)

1 tablespoon extra-virgin olive oil

2 cloves garlic, thinly sliced

1 large onion, cut in half and thinly sliced

2 medium red bell peppers, cut into 2-inch pieces

2 medium yellow bell peppers, cut into 2-inch pieces

1 (14½-ounce) can crushed Italian plum tomatoes

1 cup dry red wine

½ teaspoon crushed dried basil

½ teaspoon crushed dried oregano

Salt and freshly ground pepper, to taste

2 tablespoons chopped fresh parsley for garnish

Poaching the pricked sausages reduces the fat in the final dish and quickens the grilling time. Keep this in mind when you're grilling sausages to stuff into low-carb buns with mustard and relish.

Light a grill and lightly oil the grill rack. Bring a large pot of water to a rapid boil over high heat. Using a long fork, poke each sausage several times. Add the sausages to the boiling water, reduce the heat, and simmer for 8 minutes.

Meanwhile, in a large skillet with a lid, heat the olive oil over medium-high heat. Add the garlic, onion, and bell peppers and cook, stirring frequently, until the onion is limp, about 5 minutes.

Drain the sausages. Place the sausages on the grill and grill, turning occasionally, until the sausages are cooked through, 15 to 20 minutes.

While the sausages are grilling, add the tomatoes, wine, basil, and oregano to the skillet. Cover and simmer, stirring occasionally, about 15 minutes, until thickened. Season with salt and pepper.

Transfer the sausages to a carving board and cut each sausage into 4 pieces. Pile the sausages onto a serving platter and spoon the pepper mixture over all. Sprinkle with the parsley and serve at once.

○ **PER SERVING:** 22 g carbohydrate (includes 4 g dietary fiber), 26 g protein, 30 g fat, 475 calories

○ **DIABETIC EXCHANGES:** 4 vegetable, 3 lean meat, 4 fat

Grilled Lamb Chops with Rosemary and Balsamic Vinegar

This is a marvelous way to finish off grilled lamb or beef steak. The meat juices combine with the olive oil and balsamic vinegar to form a savory sauce. Begin the meal with Bonnell's Gazpacho (page 134) and serve the lamb with Smashed Cauliflower with Jalapeño and Cheese (page 159). For dessert, try Sparkling White Sangria with Frozen Grapes (page 182).

MAKES 4 SERVINGS

Canola oil, for brushing the
 grill rack
1 clove garlic, minced
1 tablespoon finely minced
 fresh rosemary
½ tablespoon Dijon mustard
8 (¾-inch-thick) loin lamb
 chops
2 tablespoons extra-virgin olive
 oil
2 teaspoons balsamic vinegar
Fresh rosemary sprigs for
 garnish (optional)

Light a grill and lightly oil the grill rack. In a small bowl, combine the garlic, rosemary, and mustard. Brush over the lamb chops and set aside until the grill is ready.

Grill the lamb chops for 5 to 7 minutes per side, turning once, for medium-rare. Whisk together the olive oil and vinegar. Transfer the lamb chops to individual serving plates and spoon 1 teaspoon of the oil-vinegar mixture over each chop. Garnish each lamb chop with a rosemary sprig, if desired. Serve at once.

○ **PER SERVING:** 1 g carbohydrate (includes trace dietary fiber), 21 g protein, 23 g fat, 300 calories
○ **DIABETIC EXCHANGES:** 3 lean meat, 3 fat

Lamb Meatballs in Apple-Onion Curry Sauce

MAKES 4 SERVINGS

Meatballs

1 pound lean ground lamb

1 large egg, lightly beaten

1 medium onion, grated

$\frac{1}{3}$ cup roasted cashews,
coarsely chopped

2 tablespoons chopped fresh
parsley

1 teaspoon ground cumin

$\frac{1}{2}$ teaspoon chili powder

$\frac{1}{2}$ teaspoon ground cinnamon

Apple-Onion Curry Sauce

1 tablespoon extra-virgin olive
oil

1 Granny Smith apple, peeled,
cored, and chopped

1 cup chopped onion

4 cloves garlic, minced

1 large plum tomato, seeded
and finely minced

1 to 2 teaspoons curry powder,
or to taste

1 cup canned low-sodium
chicken broth

$\frac{1}{2}$ cup dry white wine

$\frac{1}{3}$ cup heavy cream

Salt and freshly ground pepper,
to taste

These little meatballs could also be made of ground chicken, ground turkey, or ground beef sirloin. Remember this cooking technique when making any kind of meatball. It's much quicker and easier then pan-frying. The curry sauce would also be delicious spooned over slices of grilled pork tenderloin.

To make the meatballs: Preheat the oven to 500°F. In a large bowl, combine all the the ingredients for the meatballs. Form into balls about 1 inch in diameter and place in a large baking pan. Bake for 5 minutes. Remove from the oven and set aside.

To make the curry sauce: Heat the oil in a large heavy skillet over medium–high heat. Add the apple, onion, and garlic. Sauté for 2 minutes. Add the tomato and curry powder. Stir in the chicken broth, wine, and cream. Place the meatballs in the skillet and stir gently to coat the meatballs with the sauce. Simmer gently until the meatballs are heated through and the sauce thickens slightly, about 5 minutes. Taste and season with salt and pepper. Serve immediately.

○ PER SERVING: 17 g carbohydrate (includes 3 g dietary fiber), 25 g protein, 33 g fat, 472 calories

○ DIABETIC EXCHANGES: $\frac{1}{2}$ fruit, 1 vegetable, 3 lean meat, 4 fat

○ PER SERVING SAUCE ONLY ($\frac{1}{4}$ RECIPE): 10 g carbohydrate (includes 2 g dietary fiber), 2 g protein, 11 g fat, 157 calories

○ DIABETIC EXCHANGES: $\frac{1}{2}$ fruit, $\frac{1}{2}$ vegetable, 2 fat

Grilled Asian Chicken Breasts with Avocado, Cucumber, and Mint Relish

This delicious chicken dish is short on preparation time and long on flavor. You'll find the hoisin sauce and chile paste with garlic in most well-stocked grocery stores or look for them in an Asian market.

To prepare the chicken: Light a grill and lightly oil the grill rack.

Remove all visible fat from the chicken; rinse, and pat dry with paper towels. In a small bowl, combine the soy sauce, hoisin sauce, and chile paste. Brush over the chicken. Grill the chicken until cooked through, turning two or three times, 7 to 10 minutes per side.

To make the relish: Meanwhile, combine all the ingredients for the relish in a small bowl, stirring gently to avoid mashing the avocado. Set aside.

To serve, transfer the chicken to individual serving plates and top with the relish. Garnish with the scallions and serve.

○ **PER SERVING:** 13 g carbohydrate (includes 5 g dietary fiber), 36 g protein, 15 g fat, 330 calories
○ **DIABETIC EXCHANGES:** ¹/₂ vegetable, 4¹/₂ very lean meat, 2¹/₂ fat

MAKES 4 SERVINGS

Grilled Asian Chicken Breasts

4 (5-ounce) boneless, skinless chicken breast halves

¹/₃ cup reduced-sodium soy sauce

2 tablespoons hoisin sauce

1 teaspoon chile paste with garlic

Olive oil, for brushing the grill rack

2 scallions, white part and 2 inches green, chopped, for garnish

Avocado, Cucumber, and Mint Relish

1 hothouse (seedless) cucumber, cut into ¹/₄-inch dice

2 tablespoons minced fresh mint

2 tablespoons extra-virgin olive oil

2 tablespoons white wine vinegar

1 large ripe avocado, cut into ¹/₄-inch dice

Cuban-Style Chicken and Peppers

MAKES 4 SERVINGS

4 (5-ounce) boneless, skinless chicken breast halves

4 cloves garlic, minced

¼ cup fresh lime juice

¼ cup fresh orange juice

1 teaspoon ground cumin

½ teaspoon crushed dried oregano

¼ teaspoon freshly ground pepper

1 medium onion, thinly sliced and separated into rings

1 medium red bell pepper, cut into thin strips

1 medium yellow bell pepper, cut into thin strips

1 poblano chile, seeded and thinly sliced crosswise

1 tablespoon extra-virgin olive oil

¼ cup chopped fresh cilantro

On my last trip to New York, I revisited my favorite Cuban restaurant, Victor's, in the theater district where this luscious chicken dish is made with the sour juice of Seville oranges. I can't get the juice here in Texas, but an equal blend of lime juice and regular orange juice gives a similar taste. Put the chicken and the seasonings into a large, heavy-duty self-closing bag early in the morning. Then, when it's time for dinner, just quickly brown the chicken and you're almost done.

Remove all visible fat from the chicken, rinse, and pat dry. Cut the chicken into strips about 1 inch wide and place in a large, self-sealing, heavy-duty plastic bag.

In a measuring cup, mix together the garlic, lime juice, orange juice, cumin, oregano, and pepper. Pour over the chicken. Add the onion, bell peppers, and chile to the bag. Seal the bag and refrigerate for at least 2 hours or as long as 24 hours, turning the bag over several times.

When ready to cook, heat the oil in a large heavy nonstick skillet over high heat. Add the chicken pieces and the rest of the

POBLANO CHILES

If you've ever eaten *chiles rellenos*, you may have eaten a poblano chile. Looking something like a small, thin green bell pepper, the poblano is richly flavored yet not fiercely hot and is therefore a good place to start if you're new to cooking with fresh chiles. Be sure to wash your hands with soap and hot water after handling fresh chiles, and avoid touching your eyes or mouth.

ingredients in the bag and stir-fry for 5 minutes. Reduce the heat to medium-low and cook until the chicken is cooked through and the bell peppers are still crisp-tender, 5 to 10 minutes.

Using a slotted spoon, transfer the chicken and vegetables to a large serving platter. Turn the heat to high and boil the pan juices until the mixture has formed a slightly thickened sauce, 2 to 3 minutes. Spoon the sauce over the chicken and vegetables; sprinkle with the cilantro, and serve.

○ PER SERVING: 12 g carbohydrate (includes 2 g dietary fiber), 34 g protein, 6 g fat, 235 calories

○ DIABETIC EXCHANGES: 1$\frac{1}{2}$ vegetable, 4$\frac{1}{2}$ very lean meat, $\frac{1}{2}$ fat

Chicken Skewers with Cauliflower and Red Onion

MAKES 6 SERVINGS

1 tablespoon cumin seeds

1 tablespoon coriander seeds

3/4 teaspoon mustard seeds

3 cloves garlic, quartered

1 medium onion, cut into small
 pieces

1/3 cup chopped fresh cilantro

1 (2-inch) piece fresh ginger,
 peeled and cut into 4 pieces

1/2 teaspoon crushed red pepper
 flakes

1 1/2 cups plain low-fat yogurt

2 tablespoons fresh lemon juice

1 1/2 pounds boneless, skinless
 chicken breast halves,
 trimmed of fat and cut into
 1-inch pieces

Extra-virgin olive oil, for
 brushing the grill rack

1 1/2 pounds cauliflower, cut into
 florets

1 large red onion, cut into 2-
 inch pieces

Every Middle Eastern country has a recipe for chicken marinated in seasoned yogurt. I like to toast the spices briefly to intensify their aroma. Once the chicken is marinated—you can do it up to a day ahead of time—the rest of the dish goes together in a matter of minutes. I like to serve this on a bed of Quick Kale with Lemon (page 162).

In a small nonstick skillet over medium heat, toast the cumin, coriander, and mustard seeds, shaking the skillet constantly, until they become fragrant, about 2 minutes.

Place the seeds in a food processor or blender, along with the garlic, onion, cilantro, ginger, red pepper flakes, yogurt, and lemon juice. Process until smooth. Pour 1/3 cup of the yogurt mixture into a container, cover, and refrigerate.

Pour the remaining yogurt mixture into a large bowl. Add the chicken pieces, and stir to coat evenly. Cover and refrigerate for at least 4 hours or up to 24 hours.

Light a grill and lightly brush the grill rack with oil. When ready to cook, bring a pot of water to a boil. Add the cauliflower and cook for 2 minutes. Drain and return the cauliflower to the pot. Stir in the reserved 1/3 cup of the yogurt mixture.

Thread the chicken pieces, cauliflower, and onion onto 6 metal skewers. Grill, turning occasionally, until the chicken is cooked through (cut to test), about 7 minutes per side. Transfer the skewers to individual plates and serve immediately.

○ PER SERVING: 13 g carbohydrate (includes 4 g dietary fiber), 28 g protein, 3 g fat, 190 calories

○ DIABETIC EXCHANGES: 1/2 skim milk, 1 1/2 vegetable, 3 very lean meat

Quick Chicken Paprika

Best made with Hungarian sweet paprika, this homey dish can be made in minutes. Low-carb noodles are surely on their way, but until they get here, you'll have to do without the traditional buttered noodle accompaniment. You could serve this over cooked spaghetti squash, using the recipe on page 169, leaving out the shavings of Asiago cheese.

You can save preparation time by purchasing packaged sliced mushrooms at the market. They are cleaned and ready to use.

MAKES 4 SERVINGS

4 (5-ounce) boneless, skinless
 chicken breast halves
1 tablespoon sweet paprika
2 teaspoons unsalted butter
2 cups sliced mushrooms
1 small onion, thinly sliced
²/₃ cup dry white wine
1 tablespoon tomato paste
²/₃ cup crème fraîche (see page
 150) or heavy cream
Salt and freshly ground pepper,
 to taste

Remove all visible fat from the chicken, rinse, and pat dry. Using ½ tablespoon of the paprika, sprinkle both sides of the chicken pieces.

Melt 1 teaspoon of the butter in a large, heavy skillet over medium-high heat. Add the chicken and sauté until the chicken is cooked through (cut to test), 4 minutes per side. Transfer the chicken to a plate and keep warm.

Add the remaining butter to the skillet and add the mushrooms and onion. Cover and reduce the heat to medium. Sauté until the onion and mushrooms are limp and most of the mushroom liquid has evaporated, about 10 minutes. Uncover and stir in the remaining ½ tablespoon paprika, the wine, and tomato paste. Simmer, stirring, until the sauce thickens slightly, about 2 minutes. Stir in the crème fraîche and return the chicken to the skillet. Simmer until the chicken and sauce are heated through, spooning the sauce over the chicken. Do not allow the mixture to boil. Season with salt and pepper and serve.

O **PER SERVING:** 5 g carbohydrate (includes 1 g dietary fiber), 35 g protein, 17 g fat, 340 calories
O **DIABETIC EXCHANGES:** 1 vegetable, 4½ lean meat, 3 fat

COOKING WITH ALCOHOL

Alcohol boils at a lower temperature than water, so much of the alcohol used in cooking is burned off, leaving only the flavor of wine, beer, or spirits used. This chart shows the percentage of alcohol remaining and is based on the most recent research by the U.S. Department of Agriculture.

COOKING METHOD	PERCENTAGE ALCOHOL REMAINING
Alcohol added to boiling liquid and removed from the heat	85
Flamed	75
Stirred in and baked or simmered for:	
15 minutes	40
30 minutes	35
45 minutes	30
1 hour	25
1½ hours	20
2 hours	10
2½ hours	5

For ideas on what to substitute for alcohol in recipes, see page 106.

Roasted Herbed Chicken and Vegetables

If the tomatoes at the store are less than perfect, you can use canned plum tomatoes. The best of the lot are imported from Italy, where they were packed at the peak of their season.

Preheat the oven to 450°F. Line a baking pan with aluminum foil.

Rinse the chicken thighs and remove any visible fat. Discard the skin if you wish to cut down on fat. Pat the thighs dry and place in the middle of the prepared pan.

Peel the eggplants with a vegetable peeler and cut into 1-inch pieces. Place the eggplants, onion, and garlic in a large bowl. Drizzle with 2 tablespoons of the oil and lightly stir to combine. Spread the vegetables around the chicken and place the tomato halves, cut side up, on top of the vegetables. Drizzle the chicken with the remaining oil. Sprinkle the herb seasoning over all and season with salt and pepper.

Roast in the oven for 20 minutes. Turn the chicken and tomatoes and gently stir the onion–eggplant mixture. Roast for 10 to 15 minutes, until the chicken juices run clear and the vegetables are tender. Transfer the chicken to a heated platter and surround with the tomatoes and other vegetables. Serve hot.

○ **PER SERVING:** 25 g carbohydrate (includes 7 g dietary fiber), 27 g protein, 21 g fat, 386 calories

○ **DIABETIC EXCHANGES:** 4½ vegetable, 3 very lean meat, 2 fat

MAKES 4 SERVINGS

4 (6-ounce) bone-in chicken thighs

2 (1-pound) eggplants

1 large onion, coarsely chopped

3 cloves garlic, thinly sliced

3 tablespoons extra-virgin olive oil

4 large plum tomatoes, cut in half lengthwise

1 teaspoon crushed dried Italian herb seasoning

Salt and freshly ground pepper, to taste

Grilled Chicken and Pepper Salad with Olives and Basil

MAKES 4 SERVINGS.

5 tablespoons extra-virgin olive oil, plus extra for brushing the grill rack

4 (5-ounce) boneless, skinless chicken breast halves

1 large red bell pepper

1 large yellow bell pepper

1 large green bell pepper

Salt and freshly ground pepper, to taste

3 tablespoons red wine vinegar

½ tablespoon balsamic vinegar

1 clove garlic, minced

¼ teaspoon crushed red pepper flakes

1 medium red onion, cut in half and thinly sliced

6 ounces cherry tomatoes in assorted colors and shapes (red, yellow, grape, orange, pear), cut in half

⅓ cup imported black olives such as Gaeta, kalamata, or niçoise

30 large fresh basil leaves

1 (2-ounce) piece Parmesan cheese, thinly shaved (see insert)

When the temperature is soaring, light the grill and do all of the cooking outside. This colorful salad makes use of summer's bounty of colorful peppers and cherry tomatoes. All that's needed now is a pitcher of iced tea.

Light a grill and lightly oil the grill rack. Remove any visible fat from the chicken, rinse, and pat dry with paper towels. Brush the chicken with 1 tablespoon of the olive oil.

Place the chicken and bell peppers on the grill rack.

Grill the chicken until cooked through, 4 to 5 minutes per side. Roll the bell peppers around frequently to cook all sides. The bell peppers are ready when they collapse and are nicely charred, about 8 minutes total. Transfer the chicken and bell peppers to a cutting board.

Let the chicken sit while you cut the bell peppers in half lengthwise. Remove the ribs and seeds. Slice the bell peppers into thin strips and place in a large bowl. Cut the chicken breasts across the grain into very thin strips and add to the bowl.

SHAVING HARD CHEESE

To add texture and make the cheese more pronounced in a dish, I've sometimes called for shaving a hard cheese such as Parmesan, Romano, or Asiago instead of grating. It's easy to strip away pieces with a vegetable peeler, a handy tool in most every kitchen.

In a small bowl, whisk together the remaining 4 tablespoons olive oil, the salt, pepper, vinegars, garlic, and red pepper flakes. Pour over the chicken and bell peppers and toss to combine. Add the onion, tomatoes, and olives. Stack 10 basil leaves, roll up lengthwise, and cut into very thin crosswise strips to make a chiffonade. Repeat twice more. Add to the salad and toss again. Sprinkle with the Parmesan cheese and serve.

○ PER SERVING: 14 g carbohydrate (includes 3 g dietary fiber), 41 g protein, 28 g fat, 468 calories
○ DIABETIC EXCHANGES: 2$\frac{1}{2}$ vegetable, 4$\frac{1}{2}$ very lean meat, $\frac{1}{2}$ lean meat, 4$\frac{1}{2}$ fat

Chicken Stuffed with Italian Sausage in Rich Tomato Sauce

MAKES 4 SERVINGS

Chicken Stuffed with Italian Sausage

4 (6-ounce) boneless, skinless chicken breast halves

2 tablespoons extra-virgin olive oil

1 small onion, minced

2 cloves garlic, minced

¼ cup minced celery

½ pound bulk sweet Italian sausage

½ teaspoon crushed dried thyme

¼ teaspoon crushed dried sage

⅛ teaspoon crushed dried rosemary

Rich Tomato Sauce

1 medium onion, chopped

2 cloves garlic, minced

1 tablespoon extra-virgin olive oil

1 (28-ounce) can crushed tomatoes

½ cup dry red wine

1 tablespoon balsamic vinegar

2 tablespoons tomato paste

½ teaspoon crushed dried oregano

¼ teaspoon crushed red pepper flakes

¼ cup chopped fresh basil

For an authentic Italian meal, this savory dish would be served with crisp Polenta Triangles (page 82). The sauce is great with other meats, such as beef or turkey meatballs. You can make it separately, simmer for about 15 minutes to thicken it slightly, and then freeze for future use.

To prepare the chicken: Remove all visible fat from the chicken, rinse, and pat dry with paper towels. Place each breast half between two sheets of plastic wrap and pound to ⅛-inch thickness. Set aside.

Place a large nonstick skillet with a lid over medium heat. Add 1 tablespoon of the oil, the onion, garlic, and celery. Sauté until the vegetables are limp, about 5 minutes. Transfer the mixture to a large bowl and add the sausage, thyme, sage, and rosemary. Mix well.

Place the chicken on a work surface and divide the sausage mixture among the chicken breasts, spreading the stuffing down the middle of each breast half, leaving the edges empty. Fold in the two long edges to partially cover the stuffing. Starting at one short edge, roll up the chicken breast to completely enclose the stuffing. Tie each roll twice with a piece of kitchen string.

Pour the remaining 1 tablespoon olive oil into the skillet and place over medium-high heat. Add the chicken rolls and sauté, turning frequently, until chicken is nicely browned on all sides, about 8 minutes total. Remove the chicken from the skillet and keep warm.

To make the sauce: Using the same skillet, sauté the onion and garlic in the oil over medium heat for 5 minutes. Stir in the tomatoes, wine, vinegar, tomato paste, oregano, and red pepper flakes. Bring to a simmer. Return the chicken rolls to the skillet

and baste with the tomato sauce. Cover and simmer until the chicken is cooked through, about 15 minutes.

Transfer the chicken rolls to a heated serving platter, removing and discarding the strings. Pour the sauce over the rolls and sprinkle with the basil. Serve immediately.

○ PER SERVING: 21 g carbohydrate (includes 5 g dietary fiber), 52 g protein, 27 g fat, 551 calories
○ DIABETIC EXCHANGES: 3¹/₂ vegetable, 5¹/₂ very lean meat, 1 lean meat, 4 fat

○ PER SERVING SAUCE ONLY: 20 g carbohydrate (includes 4 g dietary fiber), 4 g protein, 3 g fat, 133 calories
○ DIABETIC EXCHANGES: 3¹/₂ vegetable, ¹/₂ fat

Polenta Triangles

MAKES 6 SERVINGS

Extra-virgin olive oil for
 brushing the baking dish
 plus 1 tablespoon
1²/₃ cups canned low-sodium
 chicken broth
¼ cup heavy cream
¼ teaspoon salt
½ cup coarse yellow cornmeal,
 preferably stone ground
⅓ cup freshly grated Parmesan
 cheese

Optional Flavorings
1 tablespoon chopped oil-
 packed sun-dried tomatoes;
 1 tablespoon minced
 kalamata olives; or 1
 tablespoon minced fresh
 basil, rosemary, or thyme

If you thought you couldn't eat polenta on a low-carb or carb-counting diet, think again. You just can't eat a whole lot of it, as every gram of carbohydrate eaten must be counted.

Coarse ground cornmeal makes wonderful polenta, but it takes about 25 minutes to prepare and then it needs to cool until it's firm, at least another 30 minutes. An imported precooked instant polenta is available in some markets that needs only 5 to 10 minutes to cook. If you're using that, follow the package directions.

Here's how to make polenta from cornmeal that's crispy on the outside and creamy inside.

Lightly brush a 9 × 13-inch baking dish with olive oil. Set aside.

In a large saucepan pot, bring the broth and cream to a boil. Add the salt and then add the cornmeal in a slow thin stream, whisking constantly to prevent lumps. Once the cornmeal is incorporated, reduce the heat to medium-low and start stirring with a large wooden spoon. Cook the polenta, stirring frequently, until thick and creamy, 15 to 20 minutes. If any lumps form, press them out against the side of the pan with the back of the spoon.

When the polenta has the consistency of whipped potatoes, remove from the heat and stir in the cheese and one or two of the flavorings, if using. Spread the polenta evenly in the prepared baking dish. Allow to cool until firm, at least 30 minutes.

Turn the polenta out onto a cutting board. Cut into thirds crosswise into thirds and then in half lengthwise to make 6 squares. Cut the squares diagonally to form 12 triangles.

If broiling, preheat a broiler and brush the polenta triangles with 1 tablespoon oil. Broil for about 5 minutes, until lightly brown and crisp around the edges.

If frying, heat 1 tablespoon oil in a large nonstick skillet over medium-high heat. Fry the triangles in 2 batches for about 1 minute per side, until golden brown.

○ **PER 2-TRIANGLE SERVING:** 9 g carbohydrate (includes 1 g dietary fiber), 4 g protein, 6 g fat, 102 calories
○ **DIABETIC EXCHANGES:** ½ bread/starch, 1 fat

Quick Greek Chicken

MAKES 4 SERVINGS

4 (6-ounce) boneless, skinless
 chicken breast halves
4 ounces (about 1 cup) Greek
 feta cheese, crumbled
1½ tablespoons chopped fresh
 chives
1½ tablespoons chopped fresh
 oregano
1½ tablespoons chopped flat-
 leaf parsley
1 clove garlic, minced
3 tablespoons extra-virgin olive
 oil
½ cup canned low-sodium
 chicken broth
1 large egg
1 tablespoon fresh lemon juice
1 teaspoon grated lemon zest
Salt and freshly ground pepper,
 to taste

*This is a lovely chicken dish, worthy of a dinner party. It's so easy to as-
semble and cook, and you can even start the dish the night before.
Start with Zucchini Soup (page 137), and serve couscous flavored with
chopped fresh mint alongside.*

Place each chicken breast half between two sheets of heavy plas-
tic wrap and, using a meat mallet, flatten each to ¼-inch thickness.

In a bowl, combine the cheese, chives, oregano, parsley, gar-
lic, and 1 tablespoon of the oil. Mix to form a smooth paste.
Place one-fourth of the cheese mixture in the center of each
chicken breast. Fold up the bottom and fold in the sides of the
breasts. Fold down the top, completely enclosing the cheese
mixture. Set aside. If made before you're ready to cook, cover
and refrigerate for up to 24 hours.

When ready to cook, heat the remaining 2 tablespoons oil in a
large heavy skillet over medium-high heat. Add the chicken, seams
side down, and sauté until nicely browned, about 5 minutes.
Turn carefully, loosening the chicken from the bottom of the
pan. Sauté until the chicken is cooked through, 3 to 5 minutes.

Transfer the chicken to a plate. Drain the fat from the skillet
and stir in the chicken broth, scraping up any browned bits. Cook,
stirring, over medium heat, until the broth comes to a simmer.

Meanwhile, whisk the egg until it is light and fluffy. Whisk
in the lemon juice and zest. Add this to the simmering broth,
whisking continuously. Season the sauce with salt and pepper.
Return the chicken to the skillet and simmer, spooning the
sauce over the chicken until lightly coated and the sauce is
slightly thickened, 2 to 3 minutes. Arrange the chicken on a
serving platter and nap with the sauce. Serve at once.

○ PER SERVING: 2 g carbohydrate (includes a trace dietary fiber), 46 g
 protein, 13 g fat, 320 calories
○ DIABETIC EXCHANGES: 5 very lean meat, 1 lean meat, 1½ fat

Chicken Provençal

Another quick way to prepare chicken, the dish is transformed from ordinary fare to company perfect with fresh fennel, plum tomatoes, and wine.

I can buy chicken thighs at my local supermarket that have the skin and bones already removed. If your market doesn't carry them, use slightly larger bone-in thighs and remove the skin.

Cut the fennel bulb in half lengthwise. Cut each half into 6 wedges. Set aside.

Heat the oil in a large nonstick skillet with a lid over medium-high heat. Add the tomatoes, onions, wine, orange zest, vinegar, and red pepper flakes. Cook over medium heat, stirring occasionally, until mixture comes to a boil. Reduce heat to medium-low.

Meanwhile, remove all visible fat from the chicken thighs. Rinse and pat dry with paper towels. Arrange the chicken thighs and fennel on top of the tomato mixture, and sprinkle with the thyme. Cover and cook until chicken is cooked through and fennel is tender, 20 to 25 minutes. Using a slotted spoon, transfer the chicken and vegetables to heated individual plates or to one large serving dish.

Increase heat to high and cook, stirring occasionally, until the remaining sauce in the skillet has thickened, about 5 minutes. Spoon the sauce over the chicken and vegetables. If using, garnish with parsley and sprigs of fresh thyme. Serve hot.

○ **PER SERVING:** 9 g carbohydrate (includes 2 g dietary fiber), 28 g protein, 12 g fat, 264 calories

○ **DIABETIC EXCHANGES:** 1½ vegetable, 3½ very lean meat, ½ fat

MAKES 6 SERVINGS

1 large fennel bulb, trimmed

1 tablespoon extra-virgin olive oil

3 large plum tomatoes, seeded and diced

6 ounces pearl onions, peeled and cut in half

⅓ cup dry white wine

1 tablespoon grated orange zest

2 teaspoons balsamic vinegar

⅛ teaspoon red pepper flakes

6 (5-ounce) boneless, skinless chicken thighs

1 teaspoon fresh thyme leaves

Chopped fresh parsley for garnish (optional)

Sprigs of fresh thyme for garnish (optional)

Herb-Mustard Grilled Game Hens with Sweet Onion-Peach Salsa

**MAKES 4 SERVINGS; MAKES
ABOUT 2 CUPS SALSA**

Herb-Mustard Basting Sauce
2 tablespoons dry white wine
1/3 cup canola oil
3 tablespoons white wine
 vinegar
1 tablespoon finely minced
 garlic
1/2 teaspoon crushed dried
 Italian herb seasoning
1/2 teaspoon freshly ground
 pepper
2 tablespoons spicy brown
 mustard

Game Hens
Canola oil, for brushing the
 grill rack
2 (1 1/2-pound) Cornish game
 hens, split lengthwise

Sweet Onion-Peach Salsa
1 cup diced sweet onion
1 cup diced fresh peaches
1 tablespoon fresh lime juice
1/8 teaspoon crushed red pepper
 flakes
2 tablespoons minced cilantro
 or fresh mint

Game hens are easy to grill; each half makes one serving. While the hens are cooking, there's plenty of time to make the salsa. Serve this with Grilled Portobello Mushrooms and Red Peppers (page 164) and a big salad of lightly dressed greens.

Although you can split the hens yourself using kitchen or poultry shears, it's easier to ask your butcher to do it for you. Most will do so without an extra charge. If fresh peaches aren't available for the salsa, use finely diced fresh pineapple. The carbs and exchanges won't change that much. This makes a great dinner entrée as the recipe easily doubles or triples to serve more.

To make the basting sauce: In a small bowl, whisk together all the ingredients for the sauce. Mix well. Set aside.

To grill the game hens: Light a grill for medium-low heat and lightly oil the grill rack. Rinse the hens and pat dry with paper towels.

When the grill is ready, baste the skin side of the game hens with the basting sauce and place the hens, skin side down, on the grill rack. Baste the exposed sides of the hens. After 12 to 15 minutes, turn the hens over and continue to grill for 12 to 15 minutes, again basting the exposed sides of the hens. Cook, basting the hens frequently, until the meat near the thighbone is no longer pink when cut with a sharp knife.

To make the salsa: In a small bowl, combine all the ingredients for the salsa. Transfer to a serving dish and pass to spoon alongside the game hens.

Transfer the hens to a heated serving platter and serve with the salsa.

○ PER SERVING (HENS AND SALSA): 10 g carbohydrate (includes 2 g dietary fiber), 30 g protein, 16 g fat, 311 calories

○ DIABETIC EXCHANGES: ½ fruit, ½ vegetable, 4 very lean meat, 2½ fat

○ PER SERVING ½ CUP SALSA: 9 g carbohydrate (includes 2 g dietary fiber), 1 g protein, trace fat, 36 calories

○ DIABETIC EXCHANGES: ½ fruit, ½ vegetable

Quick Chicken with Fontina and Prosciutto

MAKES 4 SERVINGS

4 (5-ounce) boneless, skinless
 chicken breast halves
4 ounces Italian Fontina
 cheese, thinly sliced
4 ounces thinly sliced
 prosciutto or low-fat ham
4 fresh sage leaves
Salt and freshly ground pepper,
 to taste
1 tablespoon unsalted butter
1 tablespoon olive oil
2 tablespoons minced shallots
 (see page 56)
½ cup canned low-salt chicken
 broth
½ cup dry Marsala wine or dry
 red wine

I love veal saltimbocca, but really good veal is very expensive. Even many of the finer Italian restaurants in the Dallas metroplex have started offering a chicken version. It takes only minutes to assemble and even fewer to cook. I grow several varieties of sage in my garden so there's plenty to pick year round.

Trim any visible fat from the chicken, rinse, and pat dry with paper towels. Place each breast half between two sheets of heavy-duty plastic wrap and pound to ⅛-inch thickness. Remove the top pieces of plastic wrap and divide the cheese and prosciutto evenly among the chicken pieces. Top with a sage leaf. Starting at one end, roll up each breast with the filling inside. Season the chicken bundles lightly with salt and pepper.

Heat the butter and oil in a large, heavy skillet over medium heat. Add the shallots and sauté for 5 minutes, until the shallots are limp. Add the chicken bundles, seams side down, and sauté until golden, about 3 minutes. Carefully turn the bundles to brown the other side for about 3 minutes. Transfer the chicken to a plate and keep warm.

Add the chicken broth and wine to the skillet, scraping up any browned bits on the bottom of the skillet. Raise the heat and boil, whisking, until the mixture slightly thickens, about 1 minute. Return the chicken to the skillet and spoon the sauce over each bundle. Simmer for another minute and serve, spooning pan sauce over each serving.

○ **PER SERVING:** 4 g carbohydrate (includes trace dietary fiber), 48 g protein, 18 g fat, 394 calories
○ **DIABETIC EXCHANGES:** 4½ very lean meat, 2 lean meat, 2 fat

Grilled Chicken with Onions, Raisins, and Sunflower Seeds

If you keep chicken breast halves in the freezer already pounded, you're only minutes away from a quick meal using any number of interesting toppings. Here I've used golden raisins and sunflower seeds, which go well all year round.

Light a grill and lightly oil the grill rack. Slice the onion crosswise into 4 slices, about 1 inch thick. Set aside. Reserve the rest of the onion for another use.

Trim any visible fat from the chicken, rinse, and pat dry with paper towels. Place each chicken breast half between two pieces of heavy-duty plastic wrap and pound chicken breast pieces to about ¼-inch thickness. Sprinkle the chicken with the thyme and parsley. Season with salt and pepper.

Place the onion slices and the chicken pieces on the hot grill and grill for about 5 minutes per side, turning once, until the onion is nicely browned and the chicken is cooked through (cut to test). Transfer the onion slices to a platter and top each slice with a chicken breast.

Heat the butter and white wine in a small skillet over medium heat. Add the raisins and sunflower seeds. Cook until heated through and the raisins have plumped, 2 to 3 minutes. Spoon the mixture over the chicken breasts and serve at once.

○ PER SERVING: 9 g carbohydrate (includes 2 g dietary fiber), 34 g protein, 6 g fat, 232 calories
○ DIABETIC EXCHANGES: 1 vegetable, 4½ very lean meat, 1 fat

MAKES 4 SERVINGS

Olive oil, for brushing the grill rack
1 large Vidalia or other sweet onion
1 (5-ounce) boneless, skinless chicken breast halves
2 teaspoons fresh thyme leaves
1 tablespoon minced fresh parsley
Salt and freshly ground pepper, to taste
1 tablespoon unsalted butter
2 tablespoons dry white wine
1 tablespoon golden raisins
1 tablespoon unsalted dry-roasted sunflower seeds

Chicken Stuffed with Pesto

MAKES 6 SERVINGS

Unsalted butter for greasing
 the baking dish
6 (5-ounce) boneless, skinless
 chicken breast halves
Salt and freshly ground pepper,
 to taste
3 tablespoons whipped cream
 cheese
6 tablespoons Pesto (see page
 91)
1/2 cup freshly grated Parmesan
 cheese
1/2 teaspoon sweet paprika

Use an assembly line when stuffing these delicious chicken breasts. If you have the chicken breasts already pounded, you're halfway home to getting the dish into the oven. After that, it's just spread and roll—couldn't be easier.

Preheat the oven to 350°F. Lightly butter a shallow baking dish.

Rinse chicken breasts and pat dry. Remove any visible fat. Place each chicken breast half between two sheets of heavy plastic wrap, and using a meat mallet, flatten each to 1/8-inch thickness.

Lay the chicken breast halves on a work surface. Season with salt and pepper. Combine the cream cheese and pesto, stirring with a fork, until well mixed. Divide the cheese-pesto mixture among the chicken pieces and spread evenly. In a shallow dish, combine the Parmesan cheese and paprika. Roll up the chicken pieces crosswise and roll in the Parmesan cheese to coat mixture. Place in the prepared baking dish, seams side down. (May be made ahead to this point, covered, and refrigerated for up to 24 hours.)

Bake for 30 to 35 minutes, until the chicken is cooked through. Serve hot.

○ **PER SERVING:** 1 g carbohydrate (includes trace dietary fiber), 50 g protein, 16 g fat, 360 calories
○ **DIABETIC EXCHANGES:** 4 1/2 very lean meat, 1/2 lean meat, 1 1/2 fat

Pesto

Summer is officially back when my herb garden produces enough fresh basil to make pesto—that marvelous Genoese basil sauce for spooning over slices of ripe, luscious tomatoes, or adding an Italian touch to my recipes.

Although you can buy decent pesto in most supermarkets, once you understand the principles of pesto you are limited only by the green herbs growing in your garden or available at the market.

MAKES ABOUT 1¹/₂ CUPS

2 cups packed fresh basil
 leaves, washed and dried
2 cloves garlic, peeled
¹/₂ cup pine nuts
¹/₄ cup freshly grated Parmesan
 cheese
²/₃ cup extra-virgin olive oil

Place the basil and garlic in a food processor. Blend to a fine paste, scraping down the sides of the bowl as necessary. Add the pine nuts and cheese and process until smooth.

With the motor running, pour the olive oil through the feed tube in a slow, steady stream. Mix until smooth. Transfer to a container and store in the refrigerator for up to 2 days. Use as directed.

O **PER 1-TABLESPOON SERVING:** 1 g carbohydrate (includes trace dietary fiber), 1 g protein, 8 g fat, 73 calories
O **DIABETIC EXCHANGES:** 1¹/₂ fat

VARIATIONS

Other fresh herbs to try are equivalent amounts of arugula, cilantro, mint, oregano, and flat-leaf parsley.

Pecan-Crusted Chicken Strips with Quick Mustard Sauce

MAKES 4 SERVINGS

Pecan-Crusted Chicken Strips
Extra-virgin olive oil for greasing the baking sheet, plus 2 tablespoons
1 cup pecan pieces
2 tablespoons stone-ground cornmeal
1 teaspoon crushed dried thyme
1 teaspoon Hungarian sweet paprika
¼ teaspoon garlic powder
¼ teaspoon onion powder
¼ teaspoon crushed dried oregano
⅛ teaspoon freshly ground black pepper
⅛ teaspoon cayenne pepper
2 large eggs
4 (5-ounce) boneless, skinless chicken breast halves, cut lengthwise into strips

Quick Mustard Sauce
½ cup mayonnaise
2 tablespoons spicy whole-grain or Dijon mustard, or to taste

Pecan-crusted chicken is very popular these days and so easy to make. I use stone-ground cornmeal instead of flour or bread crumbs to extend the pecans with excellent results. Youngsters love this dish with the mustard sauce!

Preheat oven to 375°F. Lightly oil a large baking sheet.

To prepare the chicken: Combine the pecans, cornmeal, thyme, paprika, garlic powder, onion powder, oregano, black pepper, and cayenne in a food processor. Pulse until the pecans are finely chopped. Pour into a shallow dish.

In a bowl, beat together the eggs and 2 tablespoons oil. One at a time, dip the chicken strips into the egg mixture; dredge the chicken in the pecan mixture, shaking each piece to remove any excess. Place on the prepared baking sheet. Repeat until all chicken strips are coated. Bake, turning once, 15 to 20 minutes, until the chicken strips are cooked through.

To make the sauce: While the chicken is baking, combine the mayonnaise and mustard in a small bowl. Transfer to a small serving dish. Serve the chicken hot with the dipping sauce on the side.

○ PER SERVING: 7 g carbohydrate (includes 2 g dietary fiber), 39 g protein, 31 g fat, 460 calories
○ DIABETIC EXCHANGES: 4½ very lean meat, ½ lean meat, 5 fat

Indian Chicken with Peaches

This dish smells so wonderful as it's cooking, you might get family members wandering into the kitchen. If that happens, put them to work making a salad and another dish, such as Sautéed Broccoli Rabe (page 156), to serve with this sweet and spicy chicken. If you think you need something to help cool the heat, mix a cup of plain nonfat or low-fat yogurt with a couple of minced scallions for a simple raita to serve alongside.

MAKES 4 SERVINGS

4 (5-ounce) boneless, skinless chicken breast halves

2 tablespoons extra-virgin olive oil

¼ cup minced shallots (see page 56)

1 tablespoon minced fresh ginger

1 serrano chile, seeded and minced

2 teaspoons ground cumin

⅛ teaspoon ground cinnamon

1½ cups canned low-sodium chicken broth

Salt and freshly ground pepper, to taste

2 large peaches

¼ cup minced cilantro for garnish (optional)

Remove all visible fat from the chicken, rinse, and pat dry with paper towels. Heat 1 tablespoon of the olive oil in a large non-stick skillet over medium-high heat. Add the chicken and brown on both sides, turning once, 3 to 4 minutes per side. Transfer chicken to a plate and keep warm.

Add the remaining oil to the skillet, along with the shallots, ginger, and chile. Sauté, stirring frequently, until the shallots are limp, about 4 minutes. Stir in the cumin, cinnamon, and chicken broth. Bring the mixture to a boil and cook, stirring constantly, until the mixture begins to thicken and forms a rich sauce. Taste and add salt and pepper. Return the chicken to the skillet and reduce the heat. Simmer for 3 to 4 minutes, basting the chicken frequently with the sauce.

Cut the peaches in half and remove the pits. Slice each peach into 8 wedges and add to the skillet. Cook, basting frequently, until peaches are heated through, 1 to 2 minutes.

Arrange the chicken and peaches on a heated serving plate and pour the sauce over all. If using, sprinkle with the cilantro and serve immediately.

○ PER SERVING: 12 g carbohydrate (includes 2 g dietary fiber), 35 g protein, 9 g fat, 274 calories

○ DIABETIC EXCHANGES: ½ fruit, ½ vegetable, 4½ very lean meat, 1 fat

Tequila and Lime Chicken

MAKES 4 SERVINGS

4 (5-ounce) boneless, skinless
 chicken breast halves
$^1/_2$ cup gold tequila
$^1/_4$ cup canola oil
$^1/_4$ cup fresh lime juice
1 tablespoon light brown sugar
$^1/_8$ teaspoon ground cumin
$^1/_4$ cup chopped fresh cilantro
2 cloves garlic, minced
1 serrano chile, seeded and
 minced
2 tablespoons unsalted butter
$^1/_4$ cup sliced almonds, toasted

Most every chef has come up with a rendition of chicken that's first marinated with tequila and lime. A fan of David Paul's Tequila Shrimp, a signature dish at David Paul's Lahaina Grill on the island of Maui, I used some of his ingredients and came up with this surefire version. This must be marinated for at least 1 hour, but you can start the process the night before or early in the day.

If you can afford the extra carbs, serve this with steamed brown rice; $^1/_4$ cup cooked brown rice will cost you 15 carbs (includes 5 grams of dietary fiber) and 1 diabetic bread/starch exchange.

Trim off all visible fat from the chicken, rinse, and pat dry with paper towels. Place the chicken in a large, heavy-duty, self-sealing plastic bag.

In a measuring cup, combine the tequila, oil, lime juice, brown sugar, cumin, cilantro, garlic, and chile. Pour the mixture into the bag with the chicken, close to seal, and turn over several times to coat the chicken with the mixture. Refrigerate for at least 1 hour or up to 24 hours, turning the bag over several times.

When ready to cook, drain the chicken and reserve the marinade. In a heavy skillet over high heat, melt the butter. Add the chicken and cook, turning once, until nicely browned, 5 to 6 minutes on each side. Transfer the chicken to a plate and add the reserved marinade to the skillet. Boil over high heat until the mixture is reduced by half. Return the chicken to the skillet, cover, and simmer until chicken is cooked through, about 10 minutes. Sprinkle with the sliced almonds. Serve hot with the sauce.

○ **PER SERVING:** 7 g carbohydrate (includes 1 g dietary fiber), 34 g protein, 10 g fat, 317 calories
○ **DIABETIC EXCHANGES:** 4$^1/_2$ very lean meat, 1$^1/_2$ fat

Singapore Chicken Stir-Fry

Ready-packed or sold-by-bulk stir-fry vegetable blends are now available at most supermarkets, which are a great timesaver. You can also make up your own blends with small quantities of baby carrots, snow peas, sliced celery, sliced onions, chopped Chinese cabbage, and fresh bean sprouts. Either way it makes a delicious quick meal—especially quick if your market also sells the chicken strips cut for stir-fry.

MAKES 2 SERVINGS

2 tablespoons peanut or canola oil

1 tablespoon Thai red curry paste

10 ounces boneless chicken strips cut for stir-fry

8 ounces mixed stir-fry vegetables (snow peas, carrots, onion, celery, Chinese cabbage, and bean sprouts)

1 tablespoon minced fresh ginger

$3/4$ cup canned unsweetened coconut milk

2 tablespoons reduced-sodium soy sauce

Salt and fresh ground pepper, to taste

$1/4$ cup shredded fresh basil

Heat the oil in a wok or heavy large skillet over high heat. Add the curry paste and cook, stirring, until fragrant. Add the chicken and stir-fry until the chicken begins to brown, about 3 minutes. Using a slotted spoon, transfer the chicken to a bowl.

Add the vegetables and ginger to the wok and stir-fry for 2 minutes. Return the chicken to the skillet and add the coconut milk and soy sauce. Cook, stirring frequently, until the chicken is cooked through and the sauce thickens slightly, about 3 minutes. Season with salt and pepper; sprinkle with the basil. Serve immediately.

- ○ PER SERVING: 12 g carbohydrate (includes 2 g dietary fiber), 36 g protein, 24 g fat, 408 calories
- ○ DIABETIC EXCHANGES: 1 vegetable, $4^1/2$ very lean meat, $2^1/2$ fat

Parmesan-Dijon Turkey Cutlets

MAKES 4 SERVINGS

1¼ pounds turkey breast
 cutlets
½ cup freshly grated Parmesan
 cheese
2 tablespoons finely minced
 fresh basil
2 tablespoons fresh lemon juice
2 tablespoons extra-virgin olive
 oil
1 tablespoon Dijon mustard
2 cloves garlic, peeled
¼ teaspoon freshly ground
 pepper
1 tablespoon unsalted butter

The secret to this scrumptious dish is the mustard-garlic paste that's brushed onto the turkey before it's dredged in a basil and Parmesan cheese mixture. Have the rest of the meal well in hand before you start the turkey—from start to finish it only takes 25 minutes.

Rinse the turkey cutlets and pat dry with paper towels. If large, cut in half crosswise. Place the cutlets between two sheets of heavy-duty plastic wrap and gently pound to ¼-inch thickness. Set aside.

In a shallow dish, combine the Parmesan cheese and basil. Set aside.

In a food processor, combine the lemon juice, 1 tablespoon of the oil, the mustard, garlic, and pepper. Process until smooth. Brush the mixture over the turkey cutlets. Dip the cutlets into the Parmesan cheese mixture, pressing the mixture into the cutlets.

Heat ½ tablespoon of the remaining oil and ½ tablespoon of the butter in a large heavy skillet over medium-high heat. Place half of the turkey cutlets in the skillet (do not crowd). Cook, turning over once, until golden and just cooked through, about 4 minutes total. Repeat with the remaining oil, butter, and cutlets. Serve hot.

○ **PER SERVING:** 2 g carbohydrate (includes trace dietary fiber), 39 g protein, 13 g fat, 289 calories
○ **DIABETIC EXCHANGES:** 4 very lean meat, ½ lean meat, 2 fat

Fresh Seafood

Grilled Sea Bass with Tapenade

When I visited the open-air market in Nice, a stall that offered several different kinds of tapenade, some made with black olives and others made with green olives, particularly intrigued me. Sampling was encouraged, the woman tending the stall placing a tiny spoonful of the tapenade you wanted to try on a small leaf of lettuce. I'd been making tapenade for years, using the ripe olives from California, but once I sampled this rendition, I knew that only imported olives such as kalamata could duplicate the irresistible flavor.

To make the tapenade: Place the garlic, almonds, capers, anchovy fillets, olives, and Cognac in a food processor. Pulse until finely chopped. Add the oil, *herbes de Provence*, and pepper. Pulse until just combined. Transfer the mixture to a bowl to mellow while you prepare the fish.

To grill the sea bass: Light a grill and lightly oil a grill rack. Rinse the fish and pat dry. Combine 1 tablespoon olive oil and lemon juice and brush onto both sides of the fish. Grill until the fish is slightly charred on the underside, 7 to 8 minutes. Flip the fish and grill until the fish is just cooked through the center, another 4 to 5 minutes. Transfer the fish to individual dinner plates and serve hot, smeared with 2 tablespoons of the tapenade.

○ PER SERVING: 4 g carbohydrate (includes trace dietary fiber), 34 g protein, 17 g fat, 309 calories
○ DIABETIC EXCHANGES: ¹/₂ vegetable, 5 very lean meat, 1 fat

○ PER 2-TABLESPOON SERVING TAPENADE ONLY: 4 g (includes trace dietary fiber), 1 g protein, 10 g fat, 104 calories
○ DIABETIC EXCHANGES: ¹/₂ vegetable, 1 fat

MAKES 4 SERVINGS;
MAKES 1¹/₃ CUPS TAPENADE

Tapenade
1 clove garlic, coarsely chopped
¹/₄ cup slivered almonds, lightly toasted and coarsely chopped
1 tablespoon capers, rinsed and drained
2 anchovy fillets, drained
1 cup imported black olives, such as kalamata, pitted
1 tablespoon Cognac or brandy
1 tablespoon extra-virgin olive oil
¹/₂ teaspoon *herbes de Provence* (see page 100)
Freshly ground pepper, to taste

Grilled Sea Bass
Extra-virgin olive oil for brushing the grill rack, plus 1 tablespoon
4 (6-ounce) skinless sea bass fillets
2 tablespoons fresh lemon juice

Grilled Sea Bass with Tomatillo Salsa

**MAKES 4 SERVINGS; MAKES 2
CUPS SALSA**

Tomatillo Salsa
3/4 pound fresh tomatillos,
 papery skin removed and
 rinsed (see insert)
4 cloves garlic, peeled
2 jalapeño chiles, seeded and
 coarsely chopped
1/3 cup water
4 scallions, white part and 2
 inches green, coarsely
 chopped
1/2 cup loosely packed fresh
 cilantro leaves
Salt and freshly ground pepper,
 to taste

Grilled Sea Bass
4 (5-ounce) sea bass fillets,
 preferably Chilean
1 tablespoon finely chopped
 fresh cilantro
1 clove garlic, minced
1/4 teaspoon crushed red pepper
 flakes, or to taste
2 tablespoons dry white wine
1 tablespoon extra-virgin olive
 oil, plus extra for brushing
 the grill rack

Chilean sea bass is plentiful (but expensive), and this is a wonderful way to heighten its rich, delicate flavor. Greenland turbot can be substituted for the sea bass. You can also bake or broil the fish.

Keep the salsa in mind when you're grilling meats, poultry, or other fish. It also makes a great dip with vegetable chips.

To make the salsa: Cut the tomatillos into quarters and place in a food processor along with the garlic, chiles, and water. Pulse to form a chunky purée. Add the scallions and cilantro. Season with salt and pepper. Transfer to a serving dish, cover, and chill until ready to serve (the salsa will keep in the refrigerator for up to 3 days).

To grill the sea bass: Rinse the fish and pat dry with paper towels. Place in a shallow baking dish. Combine the cilantro, garlic, red pepper flakes, wine, and 1 tablespoon of the oil. Brush over the fish. Turn the fillets and brush the other side. Let the fish stand while you light the grill. Lightly oil the grill rack.

ABOUT TOMATILLOS

The tomatillo bears a resemblance to both the tomato and the Cape gooseberry. A parchment-like papery outer skin easily peels away to reveal the fruit, which looks like an unripe tomato. Tomatillos will eventually ripen to a soft yellow fruit, but they are usually used green to add crunch and a delicious fruity, acidic flavor to salsas, salads, and sauces.

Select hard fruit with a dry, closely fitting outer skin. When ready to use, peel away the outer skin, rinse to remove any sticky residue, then use as directed.

Grill the fish for 5 to 7 minutes per side, until done to taste. Pass the salsa separately.

○ PER SERVING (FISH PLUS $\frac{1}{4}$ CUP SALSA): 5 g carbohydrate (includes 1 g dietary fiber), 29 g protein, 6 g fat, 203 calories
○ DIABETIC EXCHANGES: 1 vegetable, 4 very lean meat, 1 fat

○ PER $\frac{1}{4}$-CUP SERVING SALSA ONLY: 5 g carbohydrate (includes 1 g dietary fiber), 1 g protein, less than 1 g fat, 25 calories
○ DIABETIC EXCHANGE: 1 vegetable

Herbes de Provence

MAKES ABOUT 7 TABLESPOONS

2 tablespoons dried basil

4 teaspoons dried oregano

2 teaspoons dried marjoram

2 teaspoons dried thyme

1 teaspoon dried sage

1 teaspoon dried mint

1 teaspoon dried rosemary

1 teaspoon fennel seeds

1 teaspoon dried lavender
 (optional)

Market stalls in Provence sell a mixture of dried herbs called herbes de Provence *sometimes packaged in little cloth sacks, plastic bags, or, as more commonly found in the United States, tiny clay crocks. You can make your own for a fraction of the cost of those you'd buy in a specialty shop. Use it with fish or poultry, in omelets or scrambled eggs, and with steamed vegetables, rice, or other grains.*

Pulse all the ingredients into a fine powder in a food processor or blender. Transfer to an airtight container and store away from light and heat. Use within 3 months.

Baked Fish in Parchment with Julienne Vegetables

This is a great low-fat way to bake most any fish—snapper, flounder, cod, or any other mild-flavored fish. With low-carb vegetables baking along with the fish, your supper is quickly on the table, needing only a green salad, if you like, or a piece of fruit for dessert.

Preheat the oven to 425°F. Rinse the fish and pat dry. Season with salt and pepper.

Cut 4 circles of parchment paper or heavy-duty aluminum foil 18 inches in diameter. Lay a fish fillet on one side of each piece of parchment paper.

In a heavy nonstick skillet, heat the oil over medium-high heat. Add the garlic, fennel, leeks, and zucchini. Sauté for 5 minutes, stirring occasionally. Add the tomatoes, thyme, and wine. Cook for 1 minute. Spoon one-quarter of the mixture over each fillet and top with a squeeze of lemon juice. Fold the parchment paper over the fish and crimp the edges well. Place the packets on a large baking sheet and bake for 15 minutes.

To serve, place each parchment packet on a serving plate. Carefully slit open the top and serve.

○ **PER SERVING:** 12 g carbohydrate (includes 3 g dietary fiber), 37 g protein, 6 g fat, 256 calories
○ **DIABETIC EXCHANGES:** 2 vegetable, 5 very lean meat, ½ fat

MAKES 4 SERVINGS

4 (6-ounce) red snapper fillets
Salt and freshly ground pepper, to taste
1 tablespoon extra-virgin olive oil
1 clove garlic, minced
1 small fennel bulb, sliced into julienne strips
2 small leeks, white part only, rinsed and sliced into julienne strips
1 small zucchini, sliced into julienne strips
2 small plum tomatoes, halved, seeded, and sliced into julienne strips
½ teaspoon crushed dried thyme
2 tablespoons dry white wine
½ lemon

Roasted Cod with Leeks and Tomatoes

MAKES 4 SERVINGS

1½ tablespoons minced fresh
 ginger

1½ tablespoons fresh lemon
 juice

1 tablespoon reduced-sodium
 soy sauce

1 tablespoon extra-virgin olive
 oil, plus extra for brushing
 the baking dish

⅓ teaspoon crushed red pepper
 flakes

4 (5-ounce) cod fillets, skin on

2 leeks, white part and some
 pale green, cut in half
 lengthwise and well rinsed

4 plum tomatoes, quartered
 lengthwise

1 teaspoon fresh thyme

When I worked on my last diabetic cookbook, Stan Frankenthaler, one of the most knowledgeable seafood chefs in the country, wrote me that he considered cod to be the king of the saltwater fish. Having grown up on frozen cod, I was unimpressed; but when I tested his recipe for the book, I agreed. Since then, whenever I could buy fresh cod, I've played around with this versatile fish. This is a recipe that is particularly easy, low-carb, and delicious.

Preheat the oven to 425°F. Lightly oil a large shallow baking dish.

In a small bowl, combine the ginger, lemon juice, soy sauce, 1 tablespoon of the oil, and the red pepper flakes. Set aside.

Arrange the fillets in the prepared dish. Cut the leeks into thin julienne strips and scatter around the fish along with the tomatoes. Drizzle the fish and tomatoes with the ginger-oil mixture. Sprinkle with the thyme. Bake for 10 minutes and test the fish for doneness; it should be opaque throughout. If necessary, return to the oven and bake until the fish and vegetables are done.

Spoon the vegetables onto 4 plates and top each with a piece of fish. Serve hot.

○ **PER SERVING:** 10 g carbohydrate (includes 2 g dietary fiber), 27 g protein, 5 g fat, 192 calories

○ **DIABETIC EXCHANGES:** 2 vegetable, 3½ very lean meat, ½ fat

Asian Halibut with Wasabi Cream

Fresh wasabi is hard to come by and is perishable. Most supermarkets, however, carry wasabi powder, which is made primarily from dried ground horseradish and mustard powder. It's convenient and inexpensive, and although it doesn't pack quite the flavor wallop of fresh wasabi, it'll do just fine in this recipe. Look for the powder in the Asian or spice section of your supermarket. For other uses for the sambal oelek, the fiery Southeast Asian chile condiment, see pages 67 and 146.

MAKES 4 SERVINGS

Asian Halibut
1 (1¹/₂-pound) halibut steak, cut
 into 4 pieces and skin
 removed
¹/₄ cup minced fresh cilantro or
 flat-leaf parsley
4 tablespoons canola oil
1 tablespoon fresh lime juice
1 to 2 teaspoons sambal oelek
¹/₄ teaspoon Dijon mustard

Wasabi Cream
2 teaspoons wasabi powder
3 tablespoons water
¹/₄ cup sour cream

To prepare the halibut: Preheat the oven to 400°F. Rinse the fish and pat dry with paper towels. Press the cilantro onto one side of each piece of halibut.

Set a well-seasoned cast-iron skillet over high heat. When the skillet is hot, add 1 tablespoon of the oil and then the fish, cilantro sides up. Let the fish sear until the undersides are brown, 1 minute. Transfer the skillet to the oven and bake for 4 to 5 minutes, until the fish is cooked through.

Meanwhile, whisk together the remaining oil, the lime juice, sambal oelek, and mustard. Set aside.

To make the cream: In a bowl, whisk the wasabi powder and water until smooth. Whisk in the sour cream.

To serve, spoon 1 tablespoon of the oil-lime juice mixture onto each of 4 large plates, spreading to cover the area the size of a halibut fillet. Top with a piece of fish and a dollop of the cream. Serve immediately.

○ **PER SERVING:** 2 g carbohydrate (includes trace dietary fiber), 36 g protein, 21 g fat, 348 calories
○ **DIABETIC EXCHANGES:** 5 very lean meat, 3 fat

Flash-in-the-Pan Sole

MAKES 4 SERVINGS

1½ pounds boneless, skinless
 Dover sole fillets
Garlic salt and freshly ground
 pepper, to taste
1 tablespoon unsalted butter
1 tablespoon extra-virgin olive
 oil
2 tablespoons minced fresh
 parsley
3 tablespoons reduced-sodium
 soy sauce
Lemon wedges

A marvelous way to prepare Dover sole. If your market doesn't carry it, flounder, fluke, or other varieties of sole will cook up just as nicely. Because this cooks very quickly, have the rest of the meal almost ready so everything comes out at the same time.

Rinse the fish and pat dry with paper towels. Lightly season with garlic salt and pepper.

Heat the butter and oil in a large heavy nonstick skillet over medium-high heat. Without crowding, add the fish and cook, carefully turning once, until fish is golden on each side and flakes easily when prodded in the thickest portion with a fork, 1 to 1½ minutes per side. Sprinkle with the parsley and then drizzle on the soy sauce. Serve with the lemon wedges.

○ **PER SERVING:** 1 g carbohydrate (includes trace dietary fiber), 33 g protein, 8 g fat, 217 calories
○ **DIABETIC EXCHANGES:** 4½ very lean meat, 1 fat

East Meets West Salmon with Citrus Sauce

Whenever we dine at a great seafood restaurant, my husband always orders salmon in the hopes that I'll re-create the dish at home with my own unique touches. Such is the inspiration behind this recipe—a flavor combination of two salmon dishes that he enjoyed on opposite coasts: one in New York City and the other in San Francisco.

To make the sauce: In a glass jar, combine the orange juice, vinegar, soy sauce, onion, ginger, 1 teaspoon of the basil, 1 teaspoon of the mint, 1 teaspoon of the parsley, and the cayenne. Shake well. Mix remaining herbs together in a small bowl and set aside.

To grill the salmon: Light a grill and lightly oil the grill rack.

Baste the fillets on both sides with the sauce. Grill, brushing frequently with the sauce, until the fish flakes easily when prodded in the center with a fork, 5 to 7 minutes per side, depending on the thickness of the fillets. Transfer the fish to individual plates and sprinkle with the reserved herbs.

○ **PER SERVING:** 3 g carbohydrate (includes trace dietary fiber), 33 g protein, 10 g fat, 245 calories
○ **DIABETIC EXCHANGES:** 4½ lean meat

MAKES 4 SERVINGS

Citrus Sauce
¼ cup fresh orange juice
1 tablespoon balsamic vinegar
1 tablespoon reduced-sodium soy sauce
2 tablespoons finely minced red onion
1 tablespoon finely minced fresh ginger
2 teaspoons minced fresh basil
2 teaspoons minced fresh mint
2 teaspoons minced parsley
⅓ teaspoon cayenne pepper

Salmon
Canola oil for brushing the grill rack
4 (5-ounce) salmon fillets

Salmon Steaks with Lemon-Dill Sauce

MAKES 4 SERVINGS

1 tablespoon extra-virgin olive
 oil
4 (6-ounce) salmon steaks
Salt and freshly ground pepper,
 to taste
½ cup dry white wine
2 tablespoons fresh lemon juice
1 teaspoon grated lemon zest
⅓ cup snipped fresh dill
2 tablespoons unsalted butter
Fresh dill sprigs for garnish
 (optional)

Sometimes the simplest of recipes are the best to use when you've in-vited company to share a meal. This dazzling dish takes only minutes, leaving you plenty of time to prepare the rest of the meal and visit with your friends as you work.

Preheat the oven to 200°F.

Place a large nonstick skillet over medium-high heat. When hot, drizzle with the olive oil and turn the heat up to high. Add the fish and sauté for 3 to 4 minutes per side, depending on their thickness, turning once. Season with salt and pepper. The fish

SUBSTITUTES FOR ALCOHOL IN COOKING

Although some of the alcohol is eliminated in cooking, researchers have found that contrary to what was once thought, some of the alcohol remains even after prolonged cooking (see page 76). If you want to avoid using alcohol, here are some substitutions to consider:

For 1 cup (8 fluid ounces) of wine or spirits, use:

- an equal amount of nonalcoholic wine;
- ⅞ cup (7 fluid ounces) canned low-sodium chicken broth, beef broth, or vegetable broth and ⅛ cup (1 fluid ounce) fresh lemon juice;
- ⅞ cup (7 fluid ounces) water and ⅛ cup (1 fluid ounce) white or red wine vinegar, raspberry vinegar, or tarragon vinegar; or
- 1 cup water plus similarly flavored extract (such as rum extract or brandy extract).

should be nicely browned but not quite cooked through. Transfer the fish to an oven-proof platter and place in the oven to hold.

Add the wine to the skillet, reduce the heat to medium-high, and cook, stirring to release any browned bits on the bottom of the skillet. When wine has reduced by half, stir in the lemon juice and zest, snipped dill, and butter. Whisk until the butter is melted and a light sauce has formed. Spoon the sauce over the fish. If using, garnish with dill sprigs, and serve immediately.

O **PER SERVING:** 1 g carbohydrate (includes trace dietary fiber), 31 g protein, 26 g fat, 380 calories

O **DIABETIC EXCHANGES:** 4 lean meat, 1 fat

Cold Poached Salmon with Cilantro Salsa

MAKES 6 SERVINGS; MAKES ³/₄ CUP SALSA

Poached Salmon
1 small onion, thinly sliced
1 (3-inch) piece carrot, peeled
1 small celery rib with some
 leaves
2 cloves garlic, peeled
2 bay leaves
1 sprig fresh thyme
6 whole black peppercorns
¹/₂ cup dry white wine
6 (6-ounce) salmon fillets
Salt and freshly ground pepper,
 to taste

Cilantro Salsa
2 cups loosely packed fresh
 cilantro leaves
2 scallions, white part and 1
 inch green, coarsely chopped
2 tablespoons canola oil
1 tablespoon fresh lime juice
1 tablespoon sherry vinegar
1 jalapeño chile, seeded and
 coarsely chopped

When it's too hot to cook, remember this recipe. Of course, if your seafood market will poach the salmon for you, have them do so. Otherwise, poach the salmon at home early in the morning while you're preparing breakfast and let it chill during the day. Team the salmon with Last-Minute Tomato Salad (page 151) and Summer Slaw with Poppy Seed Dressing (page 149), and you'll have supper on the table without turning on the stove. Another time, try this recipe using halibut instead of salmon.

To poach the salmon: In a large heavy skillet, combine the onion, carrot, celery, garlic, bay leaves, thyme, peppercorns, and wine. Rinse the fish and pat dry with paper towels. Season with salt and pepper. Add the fish to the skillet and add water to come 1½ inches up the sides of the skillet. Bring the liquid to a rapid boil; reduce the heat, cover, and let stand until the fish is opaque throughout, 8 to 12 minutes. Transfer the fish to a plate, cover, and refrigerate until ready to use. Discard the poaching liquid and solids.

To make the salsa: Combine all ingredients for the salsa in a food processor or blender. Pulse until finely chopped.

Transfer the salsa to a bowl and serve alongside the salmon, allowing about 2 tablespoons salsa per serving of fish.

- PER SERVING (SALMON AND SALSA): 2 g carbohydrate (includes trace dietary fiber), 34 g protein, 16 g fat, 294 calories
- DIABETIC EXCHANGES: 4¹/₂ lean meat, 1 fat

- PER 2 TABLESPOONS SALSA ONLY SERVING: 2 g carbohydrate (includes trace dietary fiber), less than 1 gram protein, 5 g fat, 49 calories
- DIABETIC EXCHANGES: 1 fat

MAKING SALSA

Salsas are a great healthy, low-carb way to add excitement to your meals. You can make salsa out of almost any vegetable or fruit. The common ingredient is chiles—from the mildest to fiery hot habaneros. To this you add fresh herbs for their aroma and taste and a bit of fresh citrus juice for an acidic bite. Most salsas contain some minced onion, shallots, and/or garlic.

From here on, it's up to you. Over the years I've made salsa with apples, apricots, artichokes, avocados, blueberries, cactus, cabbage, carrots, cherries (Bing and sour), cucumbers, kiwifruit, mangos, melons (all kinds), olives, oranges, papayas, peaches, peanuts, plums, pineapple, pomegranates, raspberries, sun-dried tomatoes, strawberries, tangerines, tomatoes, and zucchini. Some of the salsas included two or more of these fruits and vegetables. Be inventive and maybe someday your family and friends will nickname you the Salsa Queen or the Salsa King.

Broiled Salmon with Red Onion Confit

MAKES 4 SERVINGS.

Red Onion Confit
1 tablespoon olive oil
1 large red onion, very thinly
 sliced
¼ teaspoon salt
½ teaspoon sugar
1 tablespoon red wine vinegar

Broiled Salmon
3 tablespoons reduced-sodium
 soy sauce
1 teaspoon anchovy paste
4 (6-ounce) salmon fillets, with
 skin on, rinsed and dried
 with a paper towel
¼ cup chopped scallions, white
 part and 1 inch green
2 tablespoons chopped fresh
 flat-leaf parsley
2 tablespoons chopped fresh
 dill
2 tablespoons fresh lemon juice
1 tablespoon unsalted butter,
 cut into small bits
Freshly ground pepper, to taste

If you like, you can substitute halibut, swordfish, or red snapper for the salmon. This is a great way to cook most any kind of fish.

To make the confit: In a large nonstick skillet over medium-low heat, warm ½ tablespoon of the oil. Add the onion and sauté until it is wilted but not browned. Add the remaining oil, salt, and sugar. Cook over low heat until the onion begins to caramelize, about 10 minutes. Sprinkle with the vinegar and cook for 1 to 2 minutes. Set aside and keep warm.

To broil the salmon: In the meantime, preheat the broiler and line a shallow baking pan with aluminum foil. Whisk together the soy sauce and anchovy paste. Pour into the prepared pan and lay the fish, skin side down, in the pan. Turn the fish twice to evenly coat with the soy sauce mixture, ending with the skin side down. Sprinkle the fish with the scallions, parsley, and dill. Sprinkle with the lemon juice and dot with the butter. Broil without turning about 6 inches from source of heat until the fish flakes when prodded with a fork, 5 to 8 minutes. Season with pepper.

Transfer the fish to individual serving plates and top with the onion confit. Serve at once.

○ PER SERVING: 8 g carbohydrate (includes 2 g dietary fiber), 41 g protein, 19 g fat, 371 calories
○ DIABETIC EXCHANGES: 1 vegetable, 5½ lean meat, ½ fat

Cajun-Spiced Snapper with Tropical Salsa

Red snapper, with its distinctive red-pink flesh, is a wonderful fish for grilling. Here it's seasoned with Cajun spices and served with a salsa made with fresh tropical fruits to tame the hotness. Another time, serve this fresh-tasting salsa with grilled chicken or pork.

To make the salsa: In a bowl, combine all the ingredients for the salsa, mixing gently. Set aside until ready to serve.

To grill the snapper: Light a grill and lightly oil the grill rack. Rinse the fish and pat dry with paper towels. Lay the fillets on a work surface, flesh side up, and brush with 1 tablespoon olive oil. Drizzle with the lime juice and sprinkle with the Cajun Spice Mix. When the grill is medium-hot, transfer the fillets to the grill rack, flesh side down, and grill without turning until the flesh is just cooked through and the fish flakes easily at its thickest point, 8 to 10 minutes.

Using a wide spatula, transfer the fillets to dinner plates and top each serving with equal amounts of the salsa. Serve at once.

○ PER SERVING (FISH AND SALSA): 8 g carbohydrate (includes 1 g dietary fiber), 36 g protein, 5 g fat, 221 calories
○ DIABETIC EXCHANGES: ¹/₂ fruit, ¹/₂ vegetable, 5 very lean meat, ¹/₂ fat

○ PER ¹/₂-CUP SALSA ONLY: 7 g carbohydrate (includes 1 g dietary fiber), 1 g protein, trace fat, 30 calories
○ DIABETIC EXCHANGES: ¹/₂ fruit, ¹/₂ vegetable

MAKES 6 SERVINGS; MAKES ABOUT 3 CUPS SALSA

Tropical Salsa
¹/₂ cup diced papaya
¹/₂ cup diced pineapple
¹/₂ cup diced mango
¹/₂ cup seeded diced plum tomato
¹/₃ cup diced peeled hothouse (seedless) cucumber
¹/₃ cup diced red onion
1 clove garlic, minced
1 jalapeño chile, seeded and minced
3 tablespoons minced fresh basil

Cajun-Spiced Snapper
Extra-virgin olive oil for brushing the grill rack, plus 1 tablespoon
6 (6-ounce) red snapper fillets, skin on
1 tablespoon fresh lime juice
1 tablespoon Cajun Spice Mix (see page 112)

Cajun Spice Mix

MAKES ABOUT ¾ CUP

3 tablespoons garlic powder

3 tablespoons onion powder

2 tablespoons Hungarian sweet
 paprika

1 tablespoon cayenne pepper

1 tablespoon lemon pepper

½ tablespoon chili powder

½ tablespoon ground cumin

1 teaspoon kosher salt

Although there are several excellent Cajun spice blends available at the grocery store, you can easily make your own—with a lot less salt than commercial blends. Store it in an airtight container and use within 3 months.

Combine all ingredients and transfer to a jar with a lid. Store in a dark place away from the heat.

Grilled Swordfish with Simple Mustard Sauce

You're going to love this mustard sauce—it's also great with grilled chicken or spooned onto grilled steak or even a grilled hamburger without the bun. Another time, instead of using chives, make the sauce with snipped fresh dill.

To grill the swordfish: Light the grill and lightly oil the grill rack. Rinse the fish and pat dry with paper towels. Brush the fish on both sides with 1 tablespoon of the oil and season with salt and pepper. Grill, turning once and brushing with the remaining oil, until the fish is nicely browned and flakes when prodded with a fork in the thickest part, 3 to 4 minutes per side.

To make the sauce: While fish is grilling, combine all the ingredients for the sauce in a small bowl. Spoon the sauce onto each of 4 plates and place the grilled fish on top of the sauce. Serve at once.

○ PER SERVING: 2 g carbohydrate (includes trace dietary fiber), 32 g protein, 13 g fat, 278 calories

○ DIABETIC EXCHANGES: 4½ very lean meat, 2 fat

MAKES 4 SERVINGS

Grilled Swordfish
Extra-virgin olive oil for brushing the grill rack, plus 2 tablespoons
4 6-ounce swordfish steaks, cut about ³⁄₄ inch thick
Salt and freshly ground pepper, to taste

Simple Mustard Sauce
¹⁄₃ cup Dijon mustard
¹⁄₃ cup sour cream
3 tablespoons finely minced shallots (see page 56)
¹⁄₄ cup snipped fresh chives

Swordfish Brochettes with Herbed Aïoli

MAKES 4 SERVINGS

1¼ pounds swordfish steaks

¼ cup extra-virgin olive oil

2 tablespoons red wine vinegar

3 tablespoons chopped fresh herbs, such as dill, basil, thyme, or a mixture

2 cloves garlic, minced

⅓ cup mayonnaise

Salt and freshly ground pepper, to taste

1 medium red onion, cut in half

12 cherry tomatoes

Swordfish is marvelous grilled because of its fine, firm texture. This dish is best if the fish has time to marinate, so start it early in the day. You can vary the dish by using different herbs—during the summer months use fresh herbs. In colder months, use crushed dried herbs and cook the brochettes inside on an indoor grill or under a preheated broiler. When measuring herbs, remember the ratio of fresh to dry is 1 tablespoon fresh herb to 1 teaspoon crushed dried.

In a small bowl, whisk together the oil, vinegar, herbs, and garlic. Measure out 1½ tablespoons of the mixture and whisk it into the mayonnaise to make the aïoli. Transfer to a small serving dish, cover, and refrigerate.

Rinse the fish, pat dry, and cut into 24 cubes. Place the fish cubes in a shallow glass baking dish. Season the fish with salt and pepper. Drizzle the remaining oil-herb mixture over the fish, turning to coat. Cover and refrigerate for at least 4 hours or up to 24 hours.

Preheat a grill or broiler. Cut each onion half into 8 wedges. Alternate the fish, tomatoes, and onions on 8 metal skewers, beginning and ending with an onion wedge. Grill, brushing with any remaining marinade, until the fish is opaque and flakes easily with a fork, 3 to 4 minutes per side.

Divide the aïoli among 4 serving plates. Lay 2 skewers onto each pool of aïoli and serve.

○ **PER SERVING:** 5 g carbohydrate (includes 1 g dietary fiber), 27 g protein, 34 g fat, 436 calories

○ **DIABETIC EXCHANGES:** 1 vegetable, 3½ lean meat, 3 fat

Gingered Swordfish with Lime-Jalapeño Sauce

Where I live, I can get only frozen swordfish, so I always ask my fish-monger for swordfish from the freezer—not the defrosted swordfish that's displayed in the seafood case. That way, I can defrost the fish just before cooking and know that it's the freshest possible. Here it's teamed with a lively sauce that shakes up its otherwise bland flavor.

To grill the swordfish: Rinse the fish and pat dry. Put the fish into a shallow glass baking dish. In a small bowl, mix together the vinegar, oil, soy sauce, ginger, and garlic. Pour it over the fish and turn to coat both sides. Season with salt and pepper. Let the fish stand for 10 minutes to absorb the flavors.

Light a grill and lightly oil the grill rack. Grill the fish about 6 inches from the heat source for about 3 minutes per side, turning once and basting frequently with remaining vinegar-oil mixture.

To make the sauce: While the fish is cooking, melt the butter in a small sauté pan over medium heat. Add the shallots and chiles. Sauté until the vegetables are limp, about 3 minutes. Stir in the sour cream and cook until the sauce is heated through. Do not allow the sauce to boil, because the sour cream will curdle. Remove from the heat and stir in the lime zest and juice. Make a puddle of the sauce in the center of 4 large plates. Place the fish on top of the sauce and serve at once.

○ PER SERVING: 7 g carbohydrate (includes 1 g dietary fiber), 34 g protein, 24 g fat, 377 calories
○ DIABETIC EXCHANGES: 1 vegetable, 4½ lean meat, 2 fat

MAKES 4 SERVINGS

Gingered Swordfish
4 (6-ounce) swordfish steaks, cut about ¾ inch thick
2 tablespoons rice wine vinegar
1 tablespoon canola oil, plus extra for brushing the grill rack
1 tablespoon reduced-sodium soy sauce
1 tablespoon finely minced fresh ginger
1 clove garlic, minced
Salt and freshly ground pepper, to taste

Lime-Jalapeño Sauce
2 tablespoons unsalted butter
¼ cup minced shallots (see page 56)
2 jalapeño chiles, seeded and minced
¾ cup sour cream
Grated zest and juice of 1 small lime

Grilled Tuna with Tomatoes and Black Olives

MAKES 4 SERVINGS

Canola oil, for brushing the
 grill rack
4 (6-ounce) fresh tuna steaks
 (see page 117), cut 1 inch
 thick
Salt and freshly ground pepper,
 to taste
1 (14½-ounce) can Italian plum
 tomatoes, drained and cut
 into quarters
2 tablespoons balsamic vinegar
2 tablespoons dry red wine
2 large bay leaves, broken in
 half
¼ cup chopped imported pitted
 black olives

I have eaten tuna prepared this way in several Italian restaurants, the most memorable at a seaside trattoria in Positano, Italy, where the menu said it was prepared with Gaeta olives—small black olives grown nearby. Look for these mild-flavored beauties at Italian markets or shop for them on the Internet. Make sure the canned tomatoes are also imported from Italy. They will have the flavor of a vine-ripened summer tomato.

Prepare a grill and lightly oil the grill rack. Rinse the fish and pat dry with paper towels. Season with salt and pepper. Grill the fish until nicely browned but still translucent in the center, 2 to 3 minutes per side for rare and 3 to 5 minutes per side for medium-rare. Transfer the fish to a platter and keep warm.

Meanwhile, in a medium saucepan, cook the tomatoes, vinegar, wine, and bay leaves over medium-high heat until the mixture forms a thick sauce, 5 to 6 minutes. Discard the bay leaves and stir in the olives. Cook for 1 minute, then spoon the sauce over the tuna and serve.

○ PER SERVING: 5 g carbohydrate (includes 1 g dietary fiber), 41 g protein, 2 g fat, 223 calories
○ DIABETIC EXCHANGES: 1 vegetable, 5½ very lean meat

ALL ABOUT TUNA

Fresh tuna can sometimes be intimidating to the home cook. Popular at restaurants, tuna can be quickly and easily prepared at home once you know what's you're buying. The "bloodline"— the dark, almost black, marking on the side—can be easily trimmed away.

Tuna types

- Big eye (ahi)—deep ruby red flesh and high fat content with a rich, meaty taste and texture. Availability can be spotty.

- Yellowfin (also sometimes called ahi)—similar to big eye, but slightly leaner and firmer flesh with much milder flavor. Widely available. Because it doesn't crumble, it's ideal for beginning grillers.

- Albacore (tombo)—light red to pink when raw, albacore is a mild tasting fish that firms in texture when cooked. Available year round.

- Bluefin—the darkest and fattiest tuna with a mild, distinctive flavor. It resembles beef steak in color and firmness.

- Skipjack (striped tuna and bonito)—has a flavor stronger than other tunas, with a firm flesh that increases in firmness when cooked. Available year round.

Tuscan Tuna Salad

MAKES 4 SERVINGS

½ pound yellowfin tuna (see page 117)

⅔ pound albacore tuna (see page 117)

½ small red onion, very finely diced

⅓ cup very finely diced fennel bulb

2 teaspoons minced fresh garlic

⅓ cup rough chopped pitted kalamata olives

2 tablespoons capers, rinsed and drained

2 tablespoons finely chopped fresh basil

3 tablespoons finely chopped fresh parsley

3 tablespoons mayonnaise

2 tablespoons extra-virgin olive oil

2 tablespoons balsamic vinegar

Salt and freshly ground pepper, to taste

The recipe for this terrific main-dish salad comes from Central Market, a fresh market extraordinaire here in Texas for people who are passionate about food. With stores in Austin, Dallas, Fort Worth, Houston, Plano, and San Antonio, they sell more than 700 varieties of straight-from-the-farm produce, 100 kinds of fresh and saltwater fish and shellfish, cheeses from around the world, and specialty foods, as well as meat, game, and poultry.

This salad is sold in their Café on the Run, where you can buy all kinds of chef-made foods for take-away meals. Made early in the day, the salad will star in a cold meal that night.

Steam or poach the fish until cooked all the way through, 12 to 15 minutes. Cool the fish and flake into small pieces.

Combine the fish with the onion, fennel, garlic, olives, capers, basil, and parsley. Toss until well combined. Add the mayonnaise, oil, and vinegar, and mix well. Season with salt and pepper. Refrigerate until ready to serve.

○ PER SERVING: 4 g carbohydrate (includes less than 1 g dietary fiber), 30 g protein, 15 g fat, 272 calories

○ DIABETIC EXCHANGES: 4 very lean meat, 2½ fat

Trout Baked with Lemon Butter

Fishing for trout was a part of my summer in years past, but today I'd rather catch a rainbow trout at my local supermarket. Luckily for us, rainbow trout are farm raised with a consistent year-round supply. You can dress trout with a scrumptious, complicated sauce, but I think it's best with a simple butter sauce. Although the recipe calls for the trout to be baked, you could grill or broil it, basting with the butter sauce.

MAKES 6 SERVINGS

Canola oil, for brushing the baking sheet

6 (8-ounce) cleaned and boned whole trout, heads and tails removed with fillets still attached

Salt and freshly ground pepper, to taste

$^1/_3$ cup unsalted butter

2 tablespoons finely minced fresh parsley

2 tablespoons minced red onion

1 tablespoon capers, rinsed, drained, and chopped

Grated zest and juice of 1 lemon

Preheat the oven to 400°F. Lightly oil a large baking sheet.

Rinse the trout and pat dry with paper towels. Open the fillets like a book and place, skin side down, on the prepared baking sheet. Sprinkle with salt and pepper.

In a small saucepan, melt the butter. Brush the fillets with 1 tablespoon of the melted butter and bake for 8 to 10 minutes, until the fish is opaque but still moist-looking in the center of the thickest part (cut to test). Using a wide spatula, transfer the fish to individual plates. Keep warm.

Add the parsley, onion, capers, and lemon zest and juice to the remaining melted butter. Heat until the mixture is bubbling. Drizzle some of the butter sauce over each trout and serve.

○ **PER SERVING:** less than 1 g carbohydrate (includes trace dietary fiber), 48 g protein, 22 g fat, 404 calories

○ **DIABETIC EXCHANGES:** $6^1/_2$ very lean meat, $3^1/_2$ fat

Grilled Clams with Tomato, Mango, and Basil Citrus Sauce

MAKES 8 SERVINGS

Extra-virgin olive oil for
 brushing the grill rack, plus
 1 tablespoon
2 large ripe but firm tomatoes
2 large ripe mangos
1 medium red onion
⅓ cup minced fresh basil
3 tablespoons fresh lemon juice
2 tablespoons fresh lime juice
Freshly ground pepper, to taste
5 pounds clams, littlenecks or
 cherrystone, scrubbed

When I developed the recipes for my first cookbook, Kitchen Herbs, my clamming buddies in Connecticut suggested that I include a recipe for barbecued clams with an herb butter dipping sauce. I miss the fun of digging my own clams, but excellent clams are available even here in the land-locked Dallas area. Clams are particularly exceptional with this piquant sauce. Remember this for your next outdoor party.

Preheat the grill and lightly oil the grill rack. Core the tomatoes and slice crosswise into ½-inch-thick slices. Using a very sharp vegetable knife, remove the ends of the mangos and peel off their skins. Cut along the pits, removing the mango flesh in large pieces. Peel the onion and cut it crosswise into ½-inch-thick slices. Brush the vegetables and mangos with 1 tablespoon oil.

Grill the vegetables and mangos until the tomato and onion slices are slightly charred and the mango is golden brown, 2 to 3 minutes per side. Transfer the vegetables and mangos to a chopping board and finely dice. Place in a bowl and toss with the basil, lemon juice, and lime juice. Season with pepper. Set aside.

Place the clams on the grill and grill, turning once, until they open. This can take 3 to 6 minutes per side. Discard any unopened clams. Place 1 teaspoon of the tomato-mango sauce on each clam and grill for 1 to 2 minutes, until the sauce starts to bubble. Serve hot.

○ **PER SERVING:** 20 g carbohydrate (includes 2 g dietary fiber), 37 g protein, 5 g fat, 276 calories
○ **DIABETIC EXCHANGES:** ½ fruit, ½ vegetable, 5 very lean meat, ½ fat

Mussels Marinière

This is a wonderfully effortless dish but festive enough to serve to company. Follow with a salad of baby greens and fresh herbs dressed with a simple vinaigrette and a cheese board with a bit of fresh fruit. Put on some French music and you'll think you're dining in a Paris bistro.

Clean the mussels as described below. Set the mussels aside.

Melt the butter in a nonreactive large Dutch oven over medium heat. Add the shallots, celery, tomatoes, and garlic; sauté, stirring occasionally, until the vegetables are limp, about 5 minutes. Add the thyme, wine, and mussels; bring to a boil. Cover and cook until mussels open, about 5 minutes; do not overcook. Discard any mussels that do not open.

Using a slotted spoon, transfer the mussels to individual shallow serving bowls. Ladle the cooking liquid over each serving. Sprinkle with parsley and season with pepper. Serve hot.

○ PER SERVING: 18 g carbohydrate (includes 1 g dietary fiber), 41 g protein, 10 g fat, 355 calories

○ DIABETIC EXCHANGES: 1 vegetable, 5½ lean meat, ½ fat

MAKES 4 SERVINGS

4 pounds fresh mussels

1 tablespoon unsalted butter

4 large shallots (see page 56), finely minced

1 medium celery rib, finely minced

2 cups diced fresh plum tomatoes

1 clove garlic, finely minced

1 tablespoon fresh thyme

2 cups dry white wine

½ cup lightly packed minced fresh parsley

Freshly ground pepper, to taste

CLEANING MUSSELS

Ask your fishmonger for the freshest mussels available. Vigorously scrub the mussels with a stiff brush and rinse in several changes of cold water. Just before cooking, debeard the mussels by tearing the beard (the tough fibers along side of shell that it uses to suspend itself from the rocks and pilings) off each mussel with a quick tug. *Caution:* This is a last-minute before cooking job. If you remove the beards ahead of time, the mussels will die and be unsuitable for eating.

Grilled Shrimp with Intense Rémoulade

MAKES 6 SERVINGS

Intense Rémoulade
1 (4-inch) kosher dill pickle,
 chopped
1 tablespoon capers, rinsed and
 drained
1 tablespoon chopped fresh dill
3/4 cup mayonnaise
1/4 cup sour cream
1/2 tablespoon prepared horse-
 radish

Grilled Shrimp
Extra-virgin olive oil for
 brushing the grill rack, plus
 1 tablespoon
4 cloves garlic, minced
1 teaspoon ground cumin
1 tablespoon fresh lemon juice
2 tablespoons finely minced
 fresh basil
2 1/4 pounds large shrimp,
 peeled and deveined

This makes a quick and simple meal. It can be served as I've suggested here or placed atop a mixture of shredded red and green cabbage with few added carbs.

To make the rémoulade: Place all the ingredients for the rémoulade in a food processor or blender. Pulse 2 or 3 times until just blended. Divide the rémoulade among 4 serving bowls and refrigerate until ready to use.

To grill the shrimp: Light a grill and lightly oil the grill rack. In a mixing bowl, combine the garlic, cumin, 1 tablespoon oil, the lemon juice, and basil. Add the shrimp and toss to evenly coat with the oil–lemon juice mixture. Let stand for 15 minutes; thread the shrimp onto 4 metal skewers.

When the grill is medium-hot, grill the shrimp until they turn pink and are lightly charred around the edges, 3 to 4 minutes per side.

Slide the shrimp off the skewers and divide among 4 large plates. Add a bowl of rémoulade to each plate and serve at once.

○ **PER SERVING:** 4 g carbohydrate (includes trace dietary fiber), 36 g protein, 30 g fat, 428 calories
○ **DIABETIC EXCHANGES:** 5 very lean meat, 5 1/2 fat

Grilled Shrimp with Chimichurri Sauce

Use the largest shrimp you can find for this dish, preferably U-12 (12 to 13 shrimp per pound). In Argentina, chimichurri is as common as ketchup—remember it when you're grilling steaks or poultry.

To make the sauce: In a food processor or blender, combine all the ingredients for the sauce. Process until fairly smooth, about 20 seconds. Remove ¼ cup of the sauce and set aside.

To grill the shrimp: Prepare a grill and lightly oil the grilling rack. Place the shrimp in a shallow dish and cover with the remaining chimichurri. Toss gently to evenly coat. Let stand for 10 minutes.

Drain the shrimp, reserving the marinade. Grill the shrimp, turning occasionally and basting with the reserved marinade, until pink and cooked through, about 3 minutes per side. Serve at once with 1 tablespoon of the reserved sauce drizzled over each serving.

○ PER SERVING: 15 g carbohydrate (includes 1 g dietary fiber), 24 g protein, 29 g fat, 415 calories
○ DIABETIC EXCHANGES: 1 vegetable, 2½ lean meat, 5 fat

MAKES 4 SERVINGS

Chimichurri Sauce
⅓ cup chopped garlic
½ cup chopped fresh flat-leaf parsley
¼ cup chopped fresh oregano
2 serrano chiles, seeded and chopped
2 tablespoons sherry vinegar
Grated zest and juice of 1 small lime
½ cup extra-virgin olive oil

Grilled Shrimp
Olive oil, for brushing the grill rack
1 pound jumbo prawns, peeled and deveined with tails left on

Sautéed Shrimp with Herbs

MAKES 4 SERVINGS

1½ pounds large shrimp peeled
 and deveined, with tails left
 on
2 cloves garlic, minced
½ tablespoon finely chopped
 fresh flat-leaf parsley
½ tablespoon finely chopped
 fresh rosemary
½ tablespoon fresh thyme
 leaves
2 tablespoons extra-virgin olive
 oil
1 tablespoon fresh lemon juice
½ cup canned low-sodium
 chicken broth
Dash Worcestershire sauce
2 tablespoons unsalted butter,
 cut into 8 pieces
Salt and freshly ground pepper,
 to taste

The herbs used in this dish blend wonderfully into the rich sauce that's served with the shrimp. If you're having company for drinks and hors d'oeuvres, you'll find this a surefire hit served with tooth-picks. For an entrée, pile the shrimp over strands of cooked spaghetti squash. Wonderful.

In a large bowl, toss the shrimp with the garlic, parsley, rosemary, thyme, and 1 tablespoon of the oil. Set aside for 15 minutes. (The dish may be prepared to this point, covered, and refrigerated for up to 24 hours.)

When ready to cook, place the remaining oil in a heavy nonstick skillet over medium-high heat. When the oil is hot, add the shrimp and its marinade. Sauté, turning the shrimp frequently, until the shrimp are opaque and cooked through, about 5 minutes. Transfer the shrimp to a serving dish and keep warm.

Stir the lemon juice, broth, and Worcestershire sauce into the skillet, scraping up any browned bits on the bottom of the skillet. Cook the mixture, stirring often, until reduced by half. Add the butter and cook, whisking, until melted and a smooth sauce has formed. Taste and then season with salt and pepper. Pour the sauce over the shrimp and serve hot.

○ **PER SERVING:** 3 g carbohydrate (includes trace dietary fiber), 35 g protein, 16 g fat, 298 calories
○ **DIABETIC EXCHANGES:** 5 very lean meat, 2½ fat

COOKING WITH FRESH HERBS

I can't imagine not using fresh herbs in my cooking. During the warm months, I have an extensive herb garden that supplies my needs. When the outside temperature dips below 50°F at night, I grow pots of basil, oregano, mint, rosemary, sage, and thyme indoors. Even the smallest of apartments has room for a pot or two of your favorites. Just pick a sunny windowsill and be careful not to overwater, as herbs don't like soil that's too damp. Parsley and cilantro both freeze well. Buy them on special at the supermarket and finely chop in the food processor. Freeze in a plastic container so you can reach in for a handful or a sprinkle any time you need it.

Shrimp or Scallops Grilled in Basil Leaves

MAKES 4 SERVINGS

Canola oil, for brushing the
 grill rack
32 large shrimp or 32 large dry-
 packed sea scallops
3 tablespoons fresh lime juice
3 tablespoons unsalted butter,
 melted
$1/2$ teaspoon crushed red pepper
 flakes
32 whole large fresh basil
 leaves, about 2 inches long

You can use either large shrimp or dry-packed scallops for this deli-cious seafood dish. Dry-packed scallops are now available in most markets and have a better flavor than scallops floating in liquid. If you live in an area where they sell day-boat scallops, buy them, as those scallops were swimming in the ocean the day before or that very day. They are also sold dry-packed.

Soak 16 bamboo skewers in water for 30 minutes. Light a grill and lightly oil the grill rack. Peel and devein the shrimp, leaving the tails on. If using the scallops, remove the muscle, rinse, and pat dry. Mix the shrimp with the lime juice, butter, and red pep-per flakes.

Rinse the basil leaves and pat dry. Fold a basil leaf around each shrimp and thread two wrapped shrimp onto each skewer. Brush with any remaining butter mixture.

Grill, turning once, until the shrimp are opaque throughout (cut to test), 4 to 5 minutes. Serve immediately.

○ **PER SERVING:** 2 g carbohydrate (includes trace dietary fiber), 12 g protein, 10 g fat, 139 calories
○ **DIABETIC EXCHANGES:** $1^{1}/2$ very lean meat, $1^{1}/2$ fat

GRILLING WITH FRESH HERBS
AND AROMATIC WOODS

Nothing is more tantalizing than the aroma of smoky wood and fresh herbs filling the air, imparting their tantalizing flavors to the grilling of simple, fresh foods. Besides using fresh herbs liberally in your marinades, sauces, or directly on the item to be grilled, there are other ways to impart their fantastic flavors.

Herb brushes can add seasoning while you're grilling. To make an herb brush, simply attach a bunch of fresh herbs to the end of the handle of a wooden spoon with kitchen string. Dip the brush into extra-virgin olive oil and baste the meat, poultry, or fish with the oil. Herbs that are particularly great for making herb brushes are bay leaves, chive blossoms, dill, lavender flowers, flat-leaf parsley, marjoram, rosemary, sage, and thyme. You can also make a mixed bouquet of several herbs. After you're finished basting the food, untie the brush and throw the savory sprigs into the fire.

Strip the leaves from sturdy sprigs of fresh rosemary so they can be used as skewers for pieces of meat, chicken, fish, or shellfish. Collect the woody stalks of spent basil and throw them onto the fire. A gourmet shop in Connecticut actually sells these dry sprigs wrapped together with raffia. Expensive to buy, but inexpensive to make, sprig bundles would make a great gift to give to a friend who's keen on grilling.

Aromatic woods also impart wonderful flavor when grilling. The most popular are mesquite logs, hickory logs, grapevine branches and roots, apple twigs and logs, crabapple twigs, and cherry twigs. These woods can be used on both charcoal fires and gas grills, following your grill's instructions.

Italian Shrimp and Scallop Stew

MAKES 4 SERVINGS

2 large leeks, white part and
 some pale green, well rinsed

1 tablespoon extra-virgin olive
 oil

3 cloves garlic, minced

1 jalapeño chile, seeded and
 minced

$1/2$ teaspoon ground cumin

$1/8$ teaspoon crushed red pepper
 flakes

$1^1/4$ cups dry white wine

1 ($14^1/2$-ounce) can Italian plum
 tomatoes, with juice,
 coarsely chopped

2 tablespoons tomato paste

2 tablespoons minced fresh
 basil

$3/4$ pound medium deveined,
 shelled shrimp

$3/4$ pound dry-pack sea scallops,
 muscles removed and cut in
 half crosswise

$1/4$ cup chopped fresh flat-leaf
 parsley

*This quick, delicious seafood dish is reminiscent of cioppino, the sa-
vory seafood stew prepared by West Coast fishermen and restaurant
chefs. It goes together quickly, making it perfect year round—even in
the hot summer when you're keeping at-the-stove time to a mini-
mum.*

Cut the leeks in half lengthwise, and then crosswise into $1/2$-inch
slices. In a large pot, heat the oil over medium heat. Add the
leeks, garlic, and chile. Sauté until the vegetables are limp, about
5 minutes. Add the cumin, red pepper flakes, wine, tomatoes
with juice, tomato paste, and basil. Simmer, stirring often, for 10
minutes.

Meanwhile, rinse the shrimp and scallops. Stir the shrimp
and scallops into the tomato mixture and cook just until
opaque, 4 to 6 minutes. Ladle into wide shallow bowls and
sprinkle with the parsley. Serve at once.

○ PER SERVING: 18 g carbohydrate (includes 3 g dietary fiber), 34 g pro-
 tein, 6 g fat, 291 calories

○ DIABETIC EXCHANGES: 3 vegetable, $4^1/2$ very lean meat, 1 fat

Citrus Scallops with Asian Greens and Hot Ginger Vinaigrette

If you make the entire recipe, your meal is virtually done. Another time, make just the scallops to serve over a bed of low-carb pasta.

To prepare the scallops: In a large bowl, toss the scallops with the lemon juice, parsley, orange zest, lime zest, fennel seeds, and garlic. Season with salt and pepper. Cover and chill for 10 minutes. Heat the oil in a large nonstick skillet over medium-high heat. Add the scallop mixture and sauté until the scallops are opaque, about 1 minute per side. The scallops should be tender, not chewy. Remove from the heat and keep warm.

Divide the greens among 4 large plates and place the scallops around them.

To make the vinaigrette: In a small saucepan, combine all the ingredients for the vinaigrette. Bring to a boil. Remove from the heat and spoon the hot vinaigrette over the greens and serve.

○ PER SERVING: 7 g carbohydrate (less than 1 g dietary fiber), 19 g protein, 18 g fat, 264 calories
○ DIABETIC EXCHANGES: 5½ very lean meat, 3 fat

MAKES 4 SERVINGS

Citrus Scallops
1 pound sea scallops, rinsed and dried
2 tablespoons fresh lemon juice
1 tablespoon chopped fresh parsley
1 teaspoon grated orange zest
1 teaspoon grated lime zest
½ teaspoon fennel seeds
2 cloves garlic, minced
Salt and freshly ground pepper, to taste
1 tablespoon extra-virgin olive oil

2 cups mixed greens with some Asian greens, such as mizuna, tatsoi, Japanese mustard, or pea sprouts, washed and crisped

Hot Ginger Vinaigrette
2 tablespoons fresh lime juice
1 tablespoon rice wine or white wine vinegar
1 tablespoon finely minced shallot (see page 56)
1 tablespoon finely minced fresh ginger
¼ cup extra-virgin olive oil

Simple Soups, Salads, and Vegetable Side Dishes

An INDISPENSABLE PART of a complete, wholesome meal, these soups, salads, and vegetable side dishes all have a common denominator—the vibrant flavor of garden fresh vegetables. While only nonstarchy vegetables are low in carb count, all vegetables are chock full of the vitamins, minerals, and other nutrients so important to us. They are also a good source of dietary fiber. For those who are following a net carb diet, don't forget to subtract the grams of dietary fiber from the grams of carbohydrate to get the net carb count. Those on a diabetic or heart healthy carb-counting regime, you'll need to count the total carbs.

I can't think of a vegetable that I don't like. Unfortunately for me, I dearly love the starchy ones—potatoes, corn, peas, winter squash, and all the legumes. Following a diabetic carb-counting regime, I am allowed (and encouraged) to eat these carb-laden vegetables. My body can't handle them, however, and my blood sugar levels soar despite diabetes medication. When I restrict myself to nonstarchy vegetables, my blood sugar levels run within my target range. So when I look at a steaming ear of fresh picked corn, a bowl of fluffy mashed potatoes, or a pile of shelled green peas, the decision is up to me: do I want to enjoy a few fleeting moments of blissful eating, or do I want to feel good physically? No choice here, as there's plenty from the plant kingdom to satisfy me.

Some of the recipes in this chapter give a new twist to vegetable dishes we all grew up with, while others are simple dishes that you can make on a week night

with a house full of kids after a day at the office or afternoon of driving those kids to and from their various lessons or after-school activities. Many of my recipes came about from my zeal to re-create a vegetable dish I've enjoyed in great restaurants while traveling here or abroad. All offer a more flavorful alternative to just throwing a vegetable into a pot of boiling water. If you're used to boiled carrots and canned spinach, there's a whole world of flavor here for you to discover.

In all cooking, the freshness of the ingredients that you choose is a key to success. It's important to take time to choose only those vegetables that are in perfect condition. Buy in quantities that you can use promptly. Experience is the best teacher, but here are a few guidelines for finding the freshest:

- *Check* asparagus, broccoli, cauliflower, celery, and fennel for signs of freshness—look for tightly packed florets or tips, firm stalks, and no signs of wilting or browning edges. Beets should look "dusty" with their green tops attached. Pass up Brussels sprouts that are yellowed and withered. Break a green bean (if it doesn't snap, it's not fresh). Avoid onions with soft or sprouting tops. Spinach should look crisp and dark green with no signs of wilting. Check stem ends of zucchini and yellow summer squash and avoid those with soft spots.

- *Lift* artichokes, cabbage, cucumbers, eggplant, and turnips. All should feel heavy for their size.

- *Squeeze* cucumbers for firmness; lettuce should feel spongy with no wilting leaves; bell peppers should be firm with no soft spots; mushrooms should be firm and dry to the touch; tomatoes should give slightly under gentle pressure.

Simple Soups

Apple and Onion Soup

MAKES 6 SERVINGS

1 tablespoon unsalted butter

1 pound medium onions, thinly
 sliced

2 medium Granny Smith
 apples, peeled, cored, and
 chopped

6 cups low-sodium canned
 chicken broth

1/2 teaspoon crushed dried
 thyme

Salt and freshly ground pepper,
 to taste

1/3 cup shredded Swiss cheese

Several restaurants around the country serve this delicious soup, especially in the fall when the new crop of apples is harvested. I've had it made both with and without curry powder. I prefer it without, but you can always add curry powder to taste. Use of the microwave gives you a head start on cooking the onions.

Place the butter in a large, microwave-safe bowl. Microwave on High for 1 minute, until the butter melts. Stir in the onions and apples. Microwave on High for 5 minutes. Stir and microwave

ONIONS HAVE CARBS

While relatively low in carbohydrates, onions in their various forms do have carbs that must be counted in a low-carb or carb-counting diet. Here's how their carb counts stack up:

- *Chives:* so low in carbs they can be counted as free

- *Garlic:* 1 carb gram (no dietary fiber) per clove

- *Leeks:* 6 carb grams per 1/2 cup chopped (includes 1 gram dietary fiber)

- *Onions (all varieties):* 7 carb grams per 1/2 cup chopped (includes 1 gram dietary fiber)

- *Scallions:* 1 carb gram per scallion (includes a trace dietary fiber)

- *Shallots:* 1 carb gram per 1 tablespoon minced (no dietary fiber)

for another 5 minutes, until the apples are tender and the onions are very soft.

Transfer the mixture to a large pot on top of the stove over medium-high heat. Add the broth and thyme. Bring to a simmer, partially cover, and cook, stirring occasionally, for 20 minutes. Taste and add salt, if needed, and pepper.

Place a scant tablespoon of the cheese in the bottom of each of 6 bowls. Ladle on the hot soup and serve.

○ **PER SERVING:** 10 g carbohydrate (includes 1 g dietary fiber), 4 g protein, 4 g fat, 88 calories
○ **DIABETIC EXCHANGES:** 1 vegetable, ½ fat

Bonnell's Gazpacho

MAKES 8 SERVINGS

6 plum tomatoes (about 1¹/₂
 pounds total), cut in half
 lengthwise and seeded
1 hothouse (seedless) cucumber,
 peeled and chopped
¹/₂ cup chopped green bell
 pepper
¹/₂ cup chopped red bell pepper
¹/₄ cup chopped red onion
2 cloves garlic, peeled
15 fresh basil leaves
¹/₄ cup fresh lime juice
¹/₂ cup fresh orange juice
¹/₄ cup red wine vinegar
5 tablespoons extra-virgin olive
 oil
Salt and cayenne pepper, to
 taste
8 tablespoons toasted low-carb
 bread crumbs
2 fluid ounces premium brand
 vodka, freezer chilled

Jon Bonnell, executive chef and owner of Bonnell's Fine Texas Cuisine in Fort Worth, is renowned for his eclectic combinations of flavors as exemplified by this delicious gazpacho, which is garnished with an optional splash of frozen vodka. The bright flavors of the soup are especially welcome at the height of the summer tomato season, but it can be made year round with tomatoes from the market that are still attached to a section of their growing vine. If you choose to omit the vodka, you'll save 16 calories but no carbs. The gazpacho needs a couple of hours in the fridge, so plan ahead and make this early in the day or even the night before.

Place the tomatoes, cucumber, bell peppers, onion, garlic, and basil in a food processor and pulse until finely chopped. Add the juices, vinegar, and oil. Pulse for 1 to 2 seconds to just blend. Transfer to a covered container and refrigerate for at least 2 hours or overnight. Check for seasoning and add salt and cayenne pepper as needed.

To serve, place 1 tablespoon of the bread crumbs in each of 8 chilled serving bowls. Ladle in the gazpacho and float ¼ fluid ounce of the chilled vodka into each bowl. Serve at once.

○ **PER SERVING:** 15 g carbohydrate (includes 2 g dietary fiber), 2 g protein, 9 g fat, 163 calories
○ **DIABETIC EXCHANGES:** 1¹/₂ vegetable, 2 fat

Cream of Cauliflower Soup

Cauliflower makes a surprisingly delicious cream soup. Served hot or cold, it makes a delightful addition to almost any simple meal. If the soup is to be served cold, allow it to chill for at least 2 hours before serving. If you like curry, try this soup with 1 teaspoon curry powder instead of the thyme.

MAKES 8 SERVINGS

1 tablespoon extra-virgin oil
1 cup chopped onion
$\frac{1}{2}$ cup chopped red bell pepper
$\frac{1}{4}$ cup chopped celery
$\frac{1}{4}$ teaspoon crushed dried
 thyme
4 cups canned low-sodium
 chicken broth
1 pound cauliflower florets,
 trimmed and chopped
$\frac{1}{3}$ cup heavy cream
1 cup half-and-half
Salt and freshly ground pepper,
 to taste
Chopped parsley for garnish
 (optional)

In a large pot, heat the oil over medium heat. Add the onion, bell pepper, and celery and sauté until the vegetables are limp, about 5 minutes. Stir in the thyme and broth. Add the cauliflower, cover, and cook until the vegetables are tender, 10 to 15 minutes.

Transfer the mixture to a food processor in two batches and purée until smooth. Return the soup to the pot and stir in the heavy cream and half-and-half. Season with salt and pepper. Heat the soup through, being careful not to let it boil. Ladle into soup bowls and sprinkle with parsley, if using.

○ **PER SERVING:** 6 g carbohydrate (includes 2 g dietary fiber), 4 g protein, 9 g fat, 123 calories
○ **DIABETIC EXCHANGES:** 1 vegetable, 1$\frac{1}{2}$ fat

My Best Tomato Soup with Basil

MAKES 10 SERVINGS

1 tablespoon extra-virgin olive
 oil

2 large onions, sliced

¼ cup minced shallots (see
 page 56)

2 cloves garlic, minced

1 cup diced carrots

1 cup diced celery

1 large red bell pepper, diced

2 tablespoons fresh lemon juice

1 teaspoon sugar

3 cups canned low-sodium
 chicken broth

3 pounds very ripe fresh or
 canned Italian plum
 tomatoes, peeled, seeded,
 and diced

1 tablespoon gin (optional)

16 large fresh basil leaves

I can get wonderful fresh plum tomatoes year round here in Texas, but I know that in some areas of the country, they look anemic and are quite flavorless in the winter months. Unless you can buy vine-ripened plum tomatoes, use canned ones imported from Italy. They'll taste almost like fresh. A splash of gin is the secret ingredient in this wonderful, warming soup. Almost of the alcohol will have burned off, but if you choose to leave it out, you'll save 3 calories but no carbs per serving. This soup freezes beautifully; add the basil just before serving.

In a large, heavy soup pot, heat the oil over medium heat. Add the onions, shallots, and garlic and sauté over medium heat, stirring occasionally, for 5 minutes. Add the carrots, celery, bell pepper, lemon juice, sugar, and broth.

Simmer for 15 minutes. Strain out and reserve the vegetables and return the broth to the pot.

Purée the vegetables in a food processor and return to the soup pot. Add the tomatoes and gin, if using. Simmer until the soup begins to thicken, 10 minutes. Watch carefully and don't allow it to burn.

Stack 4 basil leaves on top of one another. Roll up tightly lengthwise and cut crosswise into thin strips to make a chiffonade. Repeat until all basil leaves are cut. Ladle the hot soup into bowls and sprinkle the basil chiffonade on top. Serve at once.

○ **PER SERVING:** 14 g carbohydrate (includes 3 g dietary fiber), 3 g protein, 2 g fat, 82 calories

○ **DIABETIC EXCHANGES:** 2½ vegetable

Zucchini Soup

This simple, quick-fix soup is equally delicious hot or cold.

In a heavy pot, heat the oil over medium heat. Add the onion and garlic and sauté until the onion is limp, about 4 minutes. Add the zucchini and sauté for 1 minute. Stir in the broth and marjoram. Bring to a boil; reduce heat, cover, and simmer for 15 minutes.

In two batches, purée the hot soup in a food processor or blender until smooth. If serving the soup hot, return to the pot and reheat. Ladle into soup bowls and serve. If serving the soup cold, transfer the puréed soup to a container, cover, and refrigerate for at least 1 hour. Whisk the half-and-half into the chilled soup, ladle into soup bowls, and serve.

○ PER SERVING SERVED HOT: 5 g carbohydrate (includes 1 g dietary fiber), 3 g protein, 3 g fat, 60 calories
○ DIABETIC EXCHANGES: 1 vegetable, ½ fat

○ PER SERVING SERVED COLD: 6 g carbohydrate (includes 1 g dietary fiber), 4 g protein, 5 g fat, 80 calories
○ DIABETIC EXCHANGES: 1 vegetable, 1 fat

MAKES 4 SERVINGS

2 teaspoons canola oil

1 medium onion, finely chopped

1 clove garlic, minced

½ pound small zucchini, coarsely shredded with peel still on

2 cups canned low-sodium chicken broth

1½ tablespoons minced fresh marjoram or ½ teaspoon crushed dried

Salt and freshly ground pepper, to taste

¼ cup half-and-half (if serving cold)

Cream of Wild Mushroom Soup

MAKES 6 SERVINGS

½ ounce dried morels

½ cup dry white wine

2 tablespoons unsalted butter

1 clove garlic, minced

1 small leek, white part only,
 well rinsed and thinly sliced

2 celery ribs, cut into 1-inch
 pieces

8 ounces shiitake mushrooms,
 stems removed, caps cleaned
 and sliced

4 ounces cremini mushrooms,
 caps and stems cleaned and
 sliced

4 cups canned beef broth

Cheesecloth bag containing 1
 large bay leaf, 8 black
 peppercorns, and 1
 tablespoon fresh thyme
 leaves

½ cup heavy cream

Salt, to taste

Fresh thyme leaves for garnish
 (optional)

In years past, most supermarkets carried just four kinds of mushrooms—fresh white or brown button mushrooms and canned white or brown button mushrooms. Although we still don't have the plethora of mushrooms as they do in Europe, Americans are discovering exotic mushrooms with more and more varieties flown in from distant lands and grown commercially here in the States.

True, this is not your everyday soup, but it's so easy to make and it tastes so sublime that you'll want this soup in your repertoire when you're planning a special meal. I can get fresh morels for only a few short weeks in the spring, but dried morels are actually cheaper and work wonderfully. I like to make this soup ahead of time, adding the cream when reheating before serving. The recipe doubles easily if you're having guests. Almost all of the alcohol in the wine is burned off (see page 76), but if you prefer you can use extra beef broth and a splash of white wine vinegar.

Cook the morels and wine in a small saucepan over medium-high heat until softened, about 5 minutes. Set aside; do not discard the liquid.

In a soup pot, melt the butter over medium heat. Add the garlic, leek, and celery. Sauté, stirring occasionally, until the vegetables are limp, about 5 minutes. Slice the morels into thin rounds and add to the pot along with the shiitake and cremini mushrooms. Add the morel cooking liquid and bring to a boil, stirring occasionally, for 5 minutes. Stir in the beef broth and add the cheesecloth bag. Bring to a simmer and cook, stirring frequently, until the mushrooms are soft and can be cut with a wooden spoon, about 30 minutes. Discard the cheesecloth bag.

Transfer the soup to a food processor and pulse until it is completely smooth. (The soup can be made ahead up to this point and refrigerated in a covered container for up to 3 days.)

When ready to serve, reheat the soup and slowly add the cream. Return the soup to a gentle simmer. Allow the soup to simmer for a few minutes, then taste and add salt as needed. Ladle the hot soup into bowls and garnish with thyme leaves, if using.

○ **PER SERVING:** 6 g carbohydrate (includes 1 g dietary fiber), 5 g protein, 12 g fat, 199 calories

○ **DIABETIC EXCHANGES:** ½ vegetable, ½ lean meat, 2 fat

Salads

Avocado Salad with Jicama and Shallot Vinaigrette

MAKES 4 SERVINGS

2 tablespoons white wine
 vinegar
1 tablespoon fresh lemon juice
½ teaspoon Dijon mustard
¼ cup grapeseed oil
Salt and freshly ground pepper,
 to taste
1 tablespoon minced shallot
 (see page 56)
3 tablespoons minced fresh
 herbs, such as dill, chervil,
 parsley, and thyme
2 ripe Hass avocados
½ cup shredded jicama

A simple vinaigrette made with shallots and fresh herbs turns an avocado into a terrific salad. Eaten at lunch with a piece of your favorite cheese, it becomes a meal. Don't worry about the high-fat content of this salad—the fats are mainly good ones, monounsaturated and polyunsaturated, and there are no trans-fats.

In a small bowl, whisk together the vinegar, lemon juice, mustard, and oil. Season with salt and pepper. Whisk in the shallot and herbs.

Slice the avocados lengthwise, rotating the knife around the pit. Twist the two halves of each avocado in opposite directions to separate. Embed the knife into the pit and twist to separate the avocado and the pit. Place each avocado half in a small bowl and sprinkle with some of the jicama. Spoon the shallot vinaigrette over the avocados and serve immediately with a spoon for eating.

○ **PER SERVING:** 8 g carbohydrate (includes 5 g dietary fiber), 2 g protein, 22 g fat, 225 calories
○ **DIABETIC EXCHANGES:** ½ fruit, ½ vegetable, 4 fat

Warm Arugula with Mozzarella and Balsamic Vinaigrette

The culinary genius behind this salad is Michael Herschman, chef-owner of Mojo, a marvelous restaurant located in trendy, upscale Tremont, a redeveloping neighborhood in Cleveland, Ohio. The first time I ordered this at the restaurant, Michael had been entertaining 30 of his chef friends for dinner and the kitchen was out of arugula. When my order was placed, he dashed across the street to his brother-in-law's restaurant and "stole" some arugula from its kitchen.

In a large stainless-steel mixing bowl, combine the shallots, garlic, thyme, parsley, vinegar, and olive oil. Whisk for 30 seconds. Season with pepper.

Place the bowl on the stove over low heat. When the mixture begins to sizzle, add the arugula and mozzarella and, using metal tongs, constantly stir the mixture (be careful to not bruise the leaves) until the cheese melts and the mixture is thoroughly combined. When the arugula is warm, remove from the heat and divide onto 2 large plates.

O **PER SERVING:** 8 g carbohydrate (includes 2 g dietary fiber), 7 g protein, 8 g fat, 117 calories
O **DIABETIC EXCHANGES:** 1 vegetable, ½ lean meat, 1 fat

MAKES 2 SERVINGS

2 tablespoons minced shallots (see page 56)
1 teaspoon minced garlic
½ teaspoon finely chopped fresh thyme
1 tablespoon finely chopped fresh flat-leaf parsley
2 teaspoons balsamic vinegar
2 teaspoons extra-virgin olive oil
Freshly ground pepper, to taste
8 ounces fresh arugula leaves and tender stems, washed and crisped
¼ cup shredded part-skim mozzarella cheese

Baby Arugula and Spinach Salad with Raspberries

MAKES 4 SERVINGS

3 cups loosely packed arugula
 leaves and tender stems,
 washed and crisped

3 cups loosely packed baby
 spinach leaves and tender
 stems, washed and crisped

2 tablespoons raspberry
 vinegar

3 tablespoons canola oil

2 tablespoons extra-virgin olive
 oil

1 teaspoon minced shallot (see
 page 56)

1 teaspoon Dijon mustard

½ cup fresh raspberries, rinsed
 and drained

The combination of the bitter greens and the sweetness of raspberries makes a wonderful salad to complement most any grilled meat, fish, or poultry. Be sure to save a few of the perfect berries for a garnish.

Place the arugula and spinach in a salad bowl and place in the refrigerator.

When ready to serve, whisk together the vinegar, oils, shallot, mustard, and ¼ cup of the raspberries. Pour over the greens and toss. Arrange on individual salad plates and garnish with the remaining raspberries.

○ PER SERVING: 6 g carbohydrate (includes 2 g dietary fiber), 1 g protein, 11 g fat, 120 calories

○ DIABETIC EXCHANGES: ½ vegetable, 2 fat

FAVORITE GREENS COMBINATIONS

Because these greens are so low in carbs and calories, I often eat a salad of nothing but fresh greens, sprinkled with a few drops of extra-virgin olive oil and balsamic or red wine vinegar, for lunch or dinner.

Here are my favorite combinations:

- Mixed baby lettuces (red oak leaf, green oak leaf, ruffly red and edible flowers)

- Radicchio, Belgian endive, and fennel

- Arugula and Bibb lettuce

- Spinach and mung bean sprouts

- Frisée and mixed baby lettuces (red oak leaf, green oak leaf, ruffly red)

- Mesclun mixture of dandelion, red oak leaf, watercress, arugula, radicchio, frisée, parsley, and mint

- Watercress and Belgian endive

- Mâche and radicchio

- Dandelion, arugula, and Bibb lettuce

- Spinach and watercress

All combinations benefit from a generous sprinkling of minced fresh herbs—use a combination of as many as you have or like: basil, chives, parsley, mint, oregano, and thyme.

Most people make the mistake of overdressing their salad. The dressing is supposed to complement the salad, not overpower it. I dress my salads lightly, using no more than 1 tablespoon dressing per cup of greens, sometimes less if the dressing is highly flavored.

Cantaloupe, Tomato, Avocado, and Sweet Onion Salad

MAKES 12 SERVINGS

1 medium cantaloupe (about 2 pounds), cut into 1-inch cubes

2 medium tomatoes, coarsely chopped

2 large ripe avocados, cut into 1-inch cubes

½ medium sweet onion, minced

Juice of 1 large lemon

8 green-leaf lettuce leaves, washed and crisped

Freshly ground pepper, to taste

Minced flat-leaf parsley for garnish (optional)

This recipe comes from my sister-in-law Gloria Giedt, from whom I've learned a lot of flavor combination tricks. The first time she served this salad, I thought it rather bizarre, but the combination of sweet, strong, and mild flavors really works and the salad gets raves from everyone who tries it. The recipe makes a lot and travels well, making it a good candidate for a potluck supper or picnic.

In a large bowl, combine the cantaloupe, tomatoes, avocados, and onion. Drizzle with the lemon juice and toss gently to mix.

Line a large salad bowl with lettuce leaves. Spoon the cantaloupe mixture into the center and season with pepper. If using, sprinkle parsley on top. Serve at once, or cover and refrigerate for up to 6 hours. Return to room temperature before serving.

○ PER SERVING: 8 g carbohydrate (includes 2 g dietary fiber), 1 g protein, 5 g fat, 76 calories

○ DIABETIC EXCHANGES: ½ fruit, ½ vegetable, 1 fat

Greens and Vegetables with Lemon Vinaigrette

Several companies now package mixed baby greens—a marvelous mixture of baby lettuces—and many supermarkets also offer this blend in bulk form. It's the perfect counterpart to a mix of spring vegetables.

Pour ½ tablespoon of the oil into a large nonstick skillet and heat over medium heat. Add the onion and sauté until the onion is limp, about 4 minutes. Remove from the heat and cool.

Meanwhile, cook the asparagus in boiling water to cover until crisp-tender, about 3 minutes. Using a slotted spoon, remove the asparagus from the pan and rinse under cold running water to cool. Drain and place in a large bowl.

Add the carrots to the same boiling water and cook until crisp-tender, about 4 minutes. Drain and rinse with cold running water; drain again. Add the carrots to the bowl, along with the onion. Peel the daikon radish and coarsely grate into the bowl.

In a small bowl, whisk the lemon juice, yogurt, and mustard. Whisk in the remaining oil and season with salt and pepper.

Add the greens to the vegetables, and drizzle with the lemon-yogurt mixture. Lightly toss and serve.

○ PER SERVING: 7 g carbohydrate (includes 2 g fiber), 2 g protein, 10 g fat, 114 calories
○ DIABETIC EXCHANGES: 1 vegetable, 2 fat

MAKES 4 SERVINGS

¼ cup extra-virgin olive oil

1 medium red onion, slivered lengthwise

8 ounces small asparagus spears, trimmed and cut into 1½-inch pieces

8 ounces baby carrots

1 (3-inch) piece daikon radish

2 tablespoons fresh lemon juice

1 tablespoon plain yogurt

1 teaspoon Dijon mustard

Salt and freshly ground pepper, to taste

8 ounces mixed baby greens

Thai Carrot Salad

MAKES 8 SERVINGS

2 cups lightly packed, finely
 shredded carrots

½ cup lightly packed, finely
 shredded red radishes

1 (8-ounce) can sliced water
 chestnuts, drained

1 tablespoon fresh lemon juice

3 tablespoons extra-virgin olive
 oil

1 teaspoon sambal oelek, or to
 taste

¼ cup chopped fresh cilantro
 or flat-leaf parsley

8 small Boston lettuce leaves,
 rinsed and crisped

This tastes nothing like the carrot salad you likely remember from your childhood—shredded carrots with raisins and a mayonnaise-based dressing. This salad's key flavoring ingredient, sambal oelek, is showing up in a lot of restaurants' dishes these days. Be careful! This Thai condiment, made of ground hot chiles, garlic, and spices, is very hot, and a little goes a long way. Available in Asian markets and specialty food stores, it'll keep for up to 9 months in the fridge. The water chestnuts give the salad a nice crunch.

In a bowl, combine the carrots, radishes, and water chestnuts. Whisk together the lemon juice, oil, and sambal oelek. Drizzle over the carrot mixture and sprinkle with the cilantro. Toss to combine.

To serve, arrange the lettuce leaves on a serving platter or individual salad plates. Pile some of the salad onto each lettuce leaf. Serve cold.

○ **PER SERVING:** 7 g carbohydrate (includes 2 g dietary fiber), <1 g protein, 5 g fat, 76 calories

○ **DIABETIC EXCHANGES:** 1 vegetable, 1 fat

CARROTS AND CARB COUNT

Carrots have frequently been excluded from low-carb diets simply because of their reported high glycemic index and immediate effect on blood glucose levels. Just ½ cup of carrots contains 8 grams of carbohydrate and 3 grams of dietary fiber (if you're counting net carbs, that's 5 grams of net carbs).

As far as the glycemic index goes, the best-selling book *The New Glucose Revolution* by Jennie Brand-Miller, Thomas M. S. Wolever, Kaye Foster-Powell, and Stephen Colagiuri (Marlowe and Company, 2003) states that when carrots were first tested in 1981, the result was a glycemic index of 92, but only five people were included in the study, the variation among them was huge, and the reference food was tested only once. When carrots were assessed more recently, ten people were examined, the reference food was tested twice, and a mean value of 32 was obtained with narrow variation. The authors concluded that this result was more accurate and the earlier value should be ignored. This is a good example of the need for reliable, standardized methodology for glycemic index testing.

Spinach and Orange Salad

MAKES 4 SERVINGS

1 navel orange

Fresh orange juice, as needed

1 (10-ounce) package fresh
spinach leaves, rinsed and
crisped

¼ cup coarsely chopped pecans

¼ cup thinly sliced red onion

2 tablespoons extra-virgin olive
oil

1 tablespoon sherry vinegar

1 clove garlic, minced

¼ teaspoon crushed dried
oregano

⅛ teaspoon dry mustard

Salt and freshly ground pepper,
to taste

This salad is vibrant in color and flavor while being full of essential vitamins and minerals. If you have young children, this is a great way to get them to eat spinach.

Working over a bowl and using a small sharp knife, peel the orange, removing all of the white pith. Cut the orange into quarters and remove any tiny strings on the cut surfaces. Thinly slice the quarters crosswise and set aside. Measure the juice and add additional orange juice to make 2 tablespoons. Set aside.

Place the spinach in a large salad bowl. Top with the orange slices, pecans, and onion.

In a small bowl, combine the reserved orange juice, oil, vinegar, garlic, oregano, and mustard. Season with salt and pepper. Whisk well. Pour the mixture over the salad and toss to evenly coat. Serve at once.

○ PER SERVING: 9 g carbohydrate (includes 4 g dietary fiber), 3 g protein, 12 g fat, 147 calories
○ DIABETIC EXCHANGES: ½ fruit, ½ vegetable, 2 fat

Summer Slaw with Poppy Seed Dressing

Inspired by a similar slaw served at one of my favorite lobster houses in Maine, this salad has become a favorite at our house whenever we're serving seafood of any kind.

In a small bowl, whisk together the crème fraîche, ginger, orange juice, and poppy seeds. Refrigerate the dressing until needed.

In a medium bowl, combine the cabbages, carrots, hearts of palm, and avocado. Pour on the dressing and lightly toss to combine. Refrigerate until ready to serve.

○ PER SERVING: 7 g carbohydrate (includes 3 g dietary fiber), 2 g protein, 8 g fat, 97 calories

○ DIABETIC EXCHANGES: ½ vegetable, 1 fat

MAKES 6 SERVINGS

3 tablespoons crème fraîche (see page 150) or reduced-fat sour cream

1 tablespoon grated fresh ginger

2½ tablespoons fresh orange juice

1 scant teaspoon poppy seeds

1 cup shredded red cabbage

1 cup shredded green cabbage

½ cup shredded carrots

1 cup julienned canned hearts of palm

1 large avocado, thinly sliced

Crème Fraîche

MAKES 2 CUPS

1 cup heavy cream
1 cup sour cream

Although several dairy producers now sell crème fraîche in supermarkets, it's so easy and less expensive to make it at home. It's a marvelous topping for fresh berries and other desserts or as a part of a recipe. Crème fraîche will keep in the refrigerator for up to 1 week.

Mix the two ingredients together and place in a large jar with a tight-fitting lid. Let set in a warm place for 12 hours, until the mixture thickens. Refrigerate until ready to use.

○ PER 2-TABLESPOON SERVING: 1 g carbohydrate (includes 0 dietary fiber), 1 g protein, 9 g fat, 82 calories
○ DIABETIC EXCHANGES: 1¹/₂ fat

Last-Minute Tomato Salad

I keep a bowl of fresh tomatoes sitting on my counter and find myself making this salad often when I need something special to complete the meal.

Place the tomatoes in a bowl or on a plate. Combine the remaining ingredients and drizzle over the tomatoes. Serve at once.

○ **PER SERVING:** 5 g carbohydrate (includes 1 g dietary fiber), 1 g protein, 4 g fat, 51 calories
○ **DIABETIC EXCHANGES:** 1 vegetable, ½ fat

MAKES 4 SERVINGS

2 medium tomatoes, cored and each cut into 6 wedges
1 tablespoon fresh lemon juice
1 tablespoon extra-virgin olive oil
1 small jalapeño chile, seeded and finely minced
2 to 3 tablespoons finely minced fresh basil or cilantro
Freshly ground pepper, to taste

TOMATO TIDBITS

Where I live in Texas and if I'm willing to pay the price, I can buy wonderful tomatoes with exceptional flavor year round, sometimes still attached to the vine. During the winter months they will have been frequently flown in by overnight jet air freight from Australia, Mexico, South or Central America, or Israel. Handle these tomatoes correctly and you can have the full flavor of just-picked tomatoes whenever you want.

The main rule for tomatoes: Never store a tomato in the refrigerator and never buy a tomato from a refrigerated case. Temperatures below 55°F will destroy the flavor and aroma of the tomato, diminish the tomato's ability to keep ripening, and will convert the tomato's natural sugars to starch, giving it a mealy texture. Always store tomatoes at room temperature. I keep mine in a colorful hand-painted pottery bowl sitting on the kitchen counter. They're a lovely addition to the décor of my kitchen and with them in sight several times each day, I can keep close tabs on their ripening. That way I don't lose a single one from not using it at its peak.

Tomatoes start losing their wonderful aroma within 15 minutes of cutting, so if you're serving them uncooked, don't slice or dice them hours ahead. Do that as close to serving time as possible.

Vegetable Side Dishes

Garlicky Roasted Asparagus

MAKES 4 SERVINGS

1 pound medium asparagus
 spears, tough ends snapped
 off
1 clove garlic, minced
2 tablespoons extra-virgin olive
 oil
½ teaspoon sea salt
Freshly ground pepper, to taste
1 tablespoon fresh lemon juice
¼ cup freshly grated Parmesan
 cheese

Roasting at a very high oven temperature is a marvelous way to quickly and effortlessly cook vegetables. The process brings out asparagus's fabulous nutty flavor. Serve this as a side dish to grilled meats, fish, or poultry or as a first course, topped with a bit of minced prosciutto.

Preheat the oven to 450°F. Place the asparagus in a single layer in the bottom of a roasting pan. Sprinkle with the garlic, oil, salt, and pepper. Shake the pan to evenly coat the asparagus. Roast, uncovered, for 15 minutes, gently tossing or pushing the asparagus around with a spoon every 5 minutes to help the asparagus cook evenly.

Arrange the asparagus on a serving platter and sprinkle with the lemon juice and cheese. Serve hot.

○ PER SERVING: 6 g carbohydrate (includes 2 g dietary fiber), 5 g protein, 8 g fat, 111 calories
○ DIABETIC EXCHANGES: 1 vegetable, 1½ fat

Pan-Steamed Asparagus

This is a wonderful way to cook fresh asparagus. It always comes out perfect and evenly coated with the lemon butter.

MAKES 4 SERVINGS

2 tablespoons unsalted butter
1 tablespoon fresh lemon juice
1 pound asparagus, tough ends snapped off
Salt and freshly ground pepper, to taste
1 teaspoon grated lemon zest

Melt the butter in a deep skillet with a lid. Add the lemon juice. Rinse the asparagus and add to the skillet. Do not add any water, as the water still on the asparagus will be sufficient. Cover and cook over medium heat for 5 minutes, shaking the pan occasionally. Check to make sure the asparagus is not sticking to the pan. Lower the heat to medium-low and cook, covered and shaking the pan once or twice, until the asparagus is crisp-tender, 2 to 3 minutes, depending on the size of the spears. Do not overcook. Transfer the asparagus to a heated serving dish and season with salt and pepper. Sprinkle with the lemon zest and serve immediately.

O **PER SERVING:** 6 g carbohydrate (includes 2 g dietary fiber), 3 g protein, 6 g fat, 77 calories
O **DIABETIC EXCHANGES:** 1 vegetable, 1 fat

Orange-Scented Beets

MAKES 4 SERVINGS

⅓ cup water

¾ pound beets, peeled and
 shredded

1 tablespoon balsamic vinegar

½ tablespoon unsalted butter

½ tablespoon grated orange
 zest

Salt and freshly ground pepper,
 to taste

Beets are a higher-carb vegetable but, eaten in moderation, they can fit well into a low-carb regime. I love the sweet bite that balsamic vinegar gives to the dish. Although shredded beets cook in a fraction of the time of whole beets, you'll save even more minutes by using a food processor fitted with the shredding blade. Be sure to peel the beets first.

In a medium skillet, bring the water to a boil. Add the beets, cover, and cook over medium-high heat for 5 minutes, stirring once. Uncover and cook until most of the liquid has evaporated.

Stir in the vinegar, butter, and orange zest. Season with salt and pepper. Transfer to a serving dish and serve hot.

○ **PER SERVING:** 9 g carbohydrate (includes 3 g fiber), 1 g protein, 2 g fat, 52 calories
○ **DIABETIC EXCHANGES:** 1 vegetable

Sautéed Broccoli with Toasted Almonds and Bacon

The Italians' creativity with simple vegetables never ceases to amaze me. I've tried several renditions of this dish in Italian restaurants around the country, but I like this version best—broccoli and almonds seem to have an affinity for each other. The bacon adds a nice finish.

Cook the broccoli in boiling water until barely tender, 2 to 3 minutes. Drain well.

Heat the oil in a large nonstick skillet over medium heat. Add the garlic and cook for 3 to 4 minutes to infuse the oil with the garlic flavor. Remove and discard the garlic.

Add the broccoli to the skillet and sauté until the broccoli is done to your liking, about 1 minute. Toss in the almonds, lemon zest, and bacon. Lightly stir to combine. Season with salt and pepper and serve at once.

○ **PER SERVING:** 4 g carbohydrate (includes 2 g dietary fiber), 3 g protein, 10 g fat, 113 calories

○ **DIABETIC EXCHANGES:** ¹/₂ vegetable, 2 fat

MAKES 6 SERVINGS

3 cups broccoli florets

2 tablespoons extra-virgin olive oil

2 cloves garlic, slightly mashed

2 tablespoons sliced almonds, toasted

1 teaspoon grated lemon zest

2 slices bacon, cooked crisp and crumbled

Salt and freshly ground pepper, to taste

Simple Sautéed Broccoli Rabe

MAKES 4 SERVINGS

1 pound broccoli rabe, tough
 stems and yellow leaves
 discarded
1 tablespoon unsalted butter
1 clove garlic, minced
1/8 teaspoon crushed red pepper
 flakes (optional)
Salt and freshly ground pepper,
 to taste

Broccoli rabe (also called rapini) has more flavor punch than its broccoli cousin. It also has a skinnier, leafier stem and tiny flower buds at the stalk tips. It's easily found in most supermarkets but often overlooked. It's best when sautéed briefly and not overcooked.

Cook the broccoli rabe in a large pot of boiling water until just tender, about 4 minutes. Drain and set aside.

Add the butter to the same pot and place over medium heat. Add the garlic and the pepper flakes, if using. Cook, stirring, until the garlic releases its fragrance, 30 seconds. Add the broccoli rabe and cook, tossing the broccoli rabe with the butter mixture, for 30 seconds. Season with salt and pepper and serve hot.

○ PER SERVING: 6 g carbohydrate (includes trace fiber), 5 g protein, 3 g fat, 60 calories
○ DIABETIC EXCHANGES: 1 vegetable, 1/2 fat

Sautéed Brussels Sprouts with Shallots, Bacon, and Thyme

A quick sauté brings out the sweet, nutty flavor of this increasingly popular old-fashioned vegetable. Look for small, bright green sprouts with compact heads.

Place a large heavy skillet over medium-high heat. Add the oil, Brussels sprouts, shallots, and thyme. Sauté, stirring frequently, until the Brussels sprouts are bright green and crisp-tender, 3 to 5 minutes. Season with salt and pepper.

Transfer the Brussels sprouts to a heated serving dish and sprinkle with the bacon. Serve at once.

○ **PER SERVING:** 10 g carbohydrate plus 2 g fiber, 4 g protein, 5 g fat, 92 calories

○ **DIABETIC EXCHANGES:** 2 vegetable, 1 fat

MAKES 4 SERVINGS

1 tablespoon extra-virgin olive oil

12 ounces Brussels sprouts, stems trimmed, and thinly sliced

2 shallots (see page 56), minced

1 teaspoon fresh thyme leaves or ¼ teaspoon crushed dried

Salt and freshly ground pepper, to taste

2 strips bacon, cooked crisp and crumbled

Sautéed Green Beans with Onions, Tomatoes, and Thyme

MAKES 4 SERVINGS

2 tablespoons extra-virgin olive oil

2 small onions (about ½ pound total), each cut in half, then slivered lengthwise

2 cloves garlic, slivered

1 pound green beans, stem ends trimmed

¼ cup canned low-salt chicken broth

2 large plum tomatoes, halved lengthwise, seeded, and cut into thin slivers

2 tablespoons fresh thyme leaves

Salt and freshly ground pepper, to taste

4 wedges of fresh lime or 1 tablespoon fresh lime juice

On a cruise ship off the coast of Martinique, the chef's vegetable one night was green beans sautéed with small onions, tomatoes, and lots of wild thyme. That morning, the chef had gone ashore with us on the tender. We could see him climbing the hill above the dock to pick the wild thyme that was perfuming the air. Whenever my herb garden is overrun with thyme, this recipe comes to mind. It's quite delicious! Traditionally, the dish is served with small wedges of lime to squeeze on top, but I sometimes add the juice in the kitchen.

In a large heavy skillet, heat the oil over medium heat. Add the onions and garlic; sauté until the onions are limp, about 3 minutes. Add the beans and cook, stirring frequently, for 5 minutes.

Add the broth, tomatoes, and thyme. Cook, tossing the beans occasionally, until they are tender, about 4 minutes. Season with salt and pepper. Serve the beans with the lime wedges alongside for squeezing.

○ PER SERVING: 14 g carbohydrate (includes 5 g dietary fiber), 3 g protein, 4 g fat, 98 calories

○ DIABETIC EXCHANGES: 2½ vegetable, ½ fat

Smashed Cauliflower with Jalapeño and Cheese

I first tasted cauliflower and cheese prepared in this manner on a Celebrity cruise ship off the coast of Cabo San Lucas, Mexico. It's a wonderful substitute for mashed potatoes. I can buy Mexican manchego cheese in my supermarket, but Monterey Jack cheese would make a good substitute.

Smashed cauliflower is so delicious—it doesn't always need both the cheese and the chile. For a change, make it without one or the other, or both.

MAKES 6 SERVINGS

1 large head cauliflower (about 2 pounds), trimmed and cut into florets

½ cup grated Mexican manchego or Monterey Jack cheese

1 jalapeño chile, seeded and chopped

2 to 3 tablespoons heavy cream

Salt and freshly ground pepper, to taste

2 tablespoons minced fresh cilantro or flat-leaf parsley

Steam the cauliflower in a steamer basket over 2 inches of simmering water until just tender, 12 to 15 minutes. Drain.

Place the cauliflower in a food processor fitted with the metal blade, along with the cheese, chile, and 2 tablespoons cream. Pulse until blended. Taste and add salt and pepper. If needed, add an additional tablespoon of heavy cream to get a smooth consistency.

Transfer to a heated serving dish and sprinkle with the cilantro. Serve at once.

○ **PER SERVING:** 8 g carbohydrate (includes 4 g dietary fiber), 5 g protein, 5 g fat, 89 calories

○ **DIABETIC EXCHANGES:** 1½ vegetable, ½ fat

Italian Cauliflower with Onions and Tomatoes

MAKES 8 SERVINGS

1 large head cauliflower (about
 2 pounds), trimmed and
 broken into florets
2 tablespoons extra-virgin olive
 oil
Salt and freshly ground pepper,
 to taste
1 large onion, quartered and
 thinly sliced
2 cloves garlic, minced
2 large plum tomatoes, seeded
 and diced
1/4 cup dry white wine
1/4 teaspoon crushed dried
 oregano
2 tablespoons chopped parsley
 for garnish (optional)

Oven-roasting intensifies the flavor of fresh cauliflower. While it roasts, sauté the rest of the dish to combine just before serving. Thanks to inventive Italian cooks, we have another delicious way to prepare a common vegetable.

Preheat the oven to 450°F. Toss the cauliflower with 1 tablespoon of the oil and season with salt and pepper. Arrange in a single layer on a baking sheet. Roast about 20 minutes, until the cauliflower is just tender and lightly browned.

Meanwhile, heat the remaining oil in a large nonstick skillet over medium heat. Add the onion and garlic. Sauté until the onion is limp, about 5 minutes. Stir in the tomatoes, wine, and oregano. Cook for 1 minute. Remove from the heat.

When the cauliflower is done, return the skillet to the stove and gently stir in the cauliflower and cook for 1 minute. Serve hot, sprinkled with parsley, if using.

○ PER SERVING: 9 g carbohydrate (includes 3 g dietary fiber), 2 g protein, 5 g fat, 85 calories
○ DIABETIC EXCHANGES: 1½ vegetable, 1 fat

Braised Fennel with Gruyère Cheese

Fennel and cheese, especially Gruyère and Parmesan, have a surprising affinity for each other. If the grill's going, brush the cut fennel with olive oil and char for about 5 minutes per side. Lay cheese slices over the grilled fennel and continue to grill until the cheese melts. More often, I braise the fennel in chicken broth, then cover it with cheese and broil until the cheese melts. Either way, this is a quick side dish that goes great with grilled fish, poultry, or meat.

MAKES 4 SERVINGS

2 large fennel bulbs, trimmed and sliced in half lengthwise
About 1 cup canned low-sodium chicken broth
¹/₂ cup shredded Gruyère cheese
Freshly grated nutmeg, to taste
Freshly ground pepper, to taste

Arrange the fennel, cut side down, in a single layer in a heavy ovenproof sauté pan and add enough chicken broth to cover the fennel. Bring to a boil, reduce heat, and simmer until tender, 15 to 20 minutes. Drain and sprinkle with the cheese.

Preheat the broiler. Broil about 3 inches from source of heat until the cheese melts and begins to brown, 3 to 5 minutes. Remove from broiler and lightly dust with nutmeg and a few grindings of pepper. Serve hot.

○ **PER SERVING:** 9 g carbohydrate (includes 4 g dietary fiber), 6 g protein, 4 g total fat, 95 calories
○ **DIABETIC EXCHANGES:** 1¹/₂ vegetable, ¹/₂ lean meat, ¹/₂ fat

Quick Kale with Lemon

MAKES 6 SERVINGS

1 tablespoon extra-virgin olive oil

¼ cup chopped shallots (see page 56)

1½ pounds kale, tough stems removed

1 cup canned low-sodium chicken broth

Salt and freshly ground pepper, to taste

Grated zest and juice of ½ large lemon

This is a wonderful way to prepare this often neglected member of the cabbage family. Here, the bold-flavored greens are brightened by a dash of fresh lemon juice and grated lemon zest.

In a large nonstick skillet with a lid, heat the oil over medium heat. Add the shallots and sauté until limp, about 4 minutes.

Meanwhile, cut the kale into a very fine chiffonade by stacking 4 to 5 leaves and slicing crosswise into thin slivers. Add the chicken broth to the skillet and bring to a boil. Add the kale, cover, and steam until almost tender, 5 to 7 minutes. Uncover and cook, stirring occasionally, until the kale is tender and most of the broth has cooked away, 4 to 5 minutes. Season with salt and pepper.

Transfer the kale to a serving bowl and sprinkle with the lemon zest and juice. Serve hot.

○ **PER SERVING:** 9 g carbohydrate (includes 2 g dietary fiber), 3 g protein, 3 g fat, 66 calories
○ **DIABETIC EXCHANGES:** 1½ vegetable, ½ fat

Mixed Mushroom Sauté with Hazelnuts and Herbs

The earthy flavor of mushrooms makes a wonderful side dish for almost any meat, poultry, or fish. Resist the urge to wash mushrooms under running water, as they will become waterlogged. Instead, clean them with a soft mushroom brush or gently wipe them with a damp kitchen or paper towel.

Clean the mushrooms, slice, and set aside.

Heat the oil in a large nonstick skillet over medium heat. Add the shallots and garlic and cook, stirring frequently, until the shallots are limp, about 4 minutes. Increase the heat to medium-high and add the mushrooms. Cover and cook until the mushrooms are soft, 5 to 6 minutes.

Add the butter, thyme, parsley, lemon zest, and nuts. Toss the mushrooms and cook, stirring, until most of the mushroom liquid is gone, 4 to 5 minutes. Season with salt and pepper. Serve hot.

○ PER SERVING: 8 g carbohydrate (includes 2 g fiber), 7 g fat, 112 calories

○ DIABETIC EXCHANGES: 1¹/₂ vegetable, 1 fat

MAKES 6 SERVINGS

2 pounds wild mushrooms, such as shiitakes and chanterelles, stems removed

1 tablespoon extra-virgin olive oil

¹/₄ cup minced shallots (see page 56)

2 cloves garlic, minced

2 tablespoons unsalted butter

1 tablespoon fresh thyme leaves

1 tablespoon minced fresh flat-leaf parsley

1 tablespoon finely grated lemon zest

¹/₄ cup chopped hazelnuts

Salt and freshly ground pepper, to taste

Grilled Portobello Mushrooms with Red and Yellow Peppers

MAKES 6 SERVINGS

¼ cup extra-virgin olive oil, plus extra for oiling the grill rack

2 tablespoons balsamic vinegar

1 clove garlic, minced

2 tablespoons minced fresh flat-leaf parsley

3 large portobello mushrooms, cleaned and stems removed

1 medium red bell pepper, halved lengthwise, stemmed, and seeded

1 medium yellow bell pepper, halved lengthwise, stemmed, and seeded

Salt and freshly ground pepper, to taste

2 cups mixed baby lettuces, washed and crisped

This dish tastes great at room temperature, making it a candidate for a make-ahead vegetable, leaving the grill free for the chicken, fish, or meat that you'll be serving to finish off the meal.

In a small bowl, whisk together the oil, vinegar, garlic, and parsley. Brush the mushrooms and bell peppers with half of the mixture.

Light a grill for medium-heat grilling. Lightly oil the grill rack. When the grill is hot, grill the vegetables until tender, turning occasionally, about 6 minutes for the mushrooms and 5 minutes for the bell peppers. Remove the vegetables from the grill and cut into ½-inch strips. Season with salt and pepper and toss with the remaining oil-vinegar mixture.

Line a platter with the lettuce. Top with the mushroom and pepper mixture and serve.

○ PER SERVING: 6 g carbohydrate (includes 2 g dietary fiber), 2 g protein, 9 g fat, 112 calories

○ DIABETIC EXCHANGES: 1 vegetable, 2 fat

PORTOBELLO MUSHROOMS

Wonder why portobello mushrooms were virtually unheard of until recent years? According to mushroom growers, the portobello mushroom is merely an extremely large, fully mature version of the common cultivated brown button mushroom. It came about as a clever marketing ploy to sell the otherwise unglamorous mushrooms that often measure more than 6 inches in diameter with fully exposed gills. The portobello's meaty texture and woodsy flavor have made it particularly popular grilled or sautéed and cut into thick slices.

Smothered Okra

My mother always planted okra in her garden, so I grew up very familiar with and loving its mild flavor. When buying okra, choose firm, brightly colored pods that are no more than 3 inches long. Use okra within a day from when it comes home from the store. When you're cutting off the stem end, be careful not to cut so far down into the pod that you expose the seeds. That cuts down on the slipperiness. The vinegar helps keep the okra from becoming stringy.

Heat the oil in a large heavy skillet over medium heat. Add the onions and garlic. Sauté, stirring occasionally, until the onions are limp, about 5 minutes. Add the whole okra pods, tomatoes with juice, and vinegar. Cover and reduce the heat to low. Simmer, stirring occasionally, until the okra is tender, 15 to 20 minutes. Season with salt and pepper and serve hot.

○ **PER SERVING:** 15 g carbohydrate (includes 4 g dietary fiber), 3 g protein, 3 g fat, 88 calories
○ **DIABETIC EXCHANGES:** 3 vegetable, ½ fat

MAKES 6 SERVINGS

1 tablespoon extra-virgin olive oil
2 small onions, chopped
1 clove garlic, minced
1½ pounds okra, trimmed (see recipe headnote)
1 (14½-ounce) can plum tomatoes with juice, chopped
1 tablespoon distilled white vinegar
Salt and freshly ground pepper, to taste

Five-Minute Pickles

MAKES 6 SERVINGS

6 large red radishes, very thinly
 sliced crosswise

1 Kirby cucumber, very thinly
 sliced crosswise

1 small zucchini, very thinly
 sliced crosswise

1 small carrot, peeled and very
 thinly sliced

½ cup very thinly sliced sweet
 onion

½ tablespoon grated fresh
 ginger

½ cup white wine vinegar

1 tablespoon Splenda sugar
 substitute

¼ teaspoon mustard seeds

¼ teaspoon salt

Serve these crunchy veggies with most any grilled meat, fish, or poultry. They are delicious and any leftovers will keep well in the refrigerator for a couple of days. If you can't find Kirby cucumbers, use part of a long hothouse (seedless) cucumber.

In a medium bowl, combine the vegetables. Place the ginger in a small piece of cheesecloth and squeeze the ginger juice onto the vegetables. Discard the ginger flesh.

In a small saucepan, combine the vinegar, sugar substitute, mustard seeds, and salt. Bring to a boil, stirring constantly, until the sugar substitute dissolves. Pour over the vegetables and toss to evenly coat. If desired, set the mixture into the freezer for a few minutes to chill or transfer to a serving dish to serve immediately.

○ PER SERVING: 5 g carbohydrate (includes 1 g dietary fiber), 1 g protein, trace fat, 24 calories

○ DIABETIC EXCHANGE: ½ vegetable

Microwave Ratatouille

Over the years I've cooked up countless batches of Provençal's most famous vegetable dish, ratatouille—sometimes oven roasting the vegetables at high temperature, other times slowly simmering the dish for upwards of an hour on the stove. These days, however, living in Texas with high energy costs, I find myself using my microwave more and more for making ratatouille, as it gets the job done quickly without heating up the kitchen. The recipe makes a lot, but happily ratatouille is even better the next day and the day after that. Fold some into an omelet for a great morning treat.

Place the onions, eggplant, zucchini, summer squash, and bell peppers in a large microwave-safe casserole. Drizzle with the oil and stir to evenly distribute the oil. Cover and microwave on High for 10 minutes, stirring twice during the cooking time.

Sprinkle with the rosemary and stir in the tomatoes and tomato paste. Microwave, uncovered, on High for 12 to 15 minutes, until the vegetables are tender. Taste and season the ratatouille with salt and pepper. Stir in the basil and serve hot, warm, or at room temperature. Refrigerate any leftovers.

○ PER SERVING: 12 g carbohydrate (includes 3 g dietary fiber), 2 g protein, 5 g fat, 90 calories

○ DIABETIC EXCHANGES: 1½ vegetable, 1 fat

MAKES 12 SERVINGS

2 medium onions, cut crosswise into ¾-inch-thick slices

1 large eggplant (about 1 pound), unpeeled, chopped

2 medium zucchini, cut in half lengthwise, and sliced crosswise into 1-inch-thick half slices

2 medium yellow squash, cut in half lengthwise, and sliced crosswise into 1-inch-thick half slices

1 large red bell pepper, cut into julienne strips

1 large yellow bell pepper, cut into julienne strips

¼ cup extra-virgin olive oil

2 teaspoons chopped fresh rosemary

2 large tomatoes, each cut into 8 wedges

1 tablespoon tomato paste

Salt and freshly ground pepper, to taste

½ cup slivered fresh basil leaves

Quick Stir-Fried Snow Peas with Toasted Almonds

MAKES 4 SERVINGS

1 tablespoon canola oil

1 pound fresh snow peas, rinsed
 and trimmed

2 tablespoons sliced almonds,
 toasted

1 tablespoon reduced-sodium
 soy sauce

2 to 3 drops dark sesame oil

A simple way to prepare a delicious vegetable. Sugar snap peas or young green beans can also be prepared in this manner.

Heat the canola oil in a large, deep skillet or wok over high heat. When the oil sizzles when sprinkled with a few drops of water, add the snow peas and stir-fry, tossing constantly, until they turn bright green and are crisp-tender, about 5 minutes.

Remove from the heat and add the almonds. Toss to evenly mix. Transfer the peas to a serving platter and sprinkle with the soy sauce and sesame oil. Toss again and serve at once.

○ **PER SERVING:** 9 g carbohydrate (includes 3 g dietary fiber), 4 g protein, 5 g fat, 96 calories

○ **DIABETIC EXCHANGES:** ½ bread/starch, 1 fat

Spaghetti Squash with Herb Butter and Parmesan Shavings

Making use of your microwave shortens the baking time for spaghetti squash considerably. Actual cooking times depend on the size and configuration of your microwave. If you're serving a food with a sauce over the spaghetti squash, there's no need to dress it with the butter and Parmesan cheese. If the squash is meant to be a separate side dish, this is a delicious way to go.

Don't forget to pierce the squash to keep it from exploding in the microwave.

MAKES 6 SERVINGS

1 (2-pound) spaghetti squash

3 tablespoons unsalted butter

1 teaspoon minced garlic

1 tablespoon minced shallot (see page 56)

2 to 3 tablespoons minced fresh herbs, such as basil, chives, flat-leaf parsley, oregano, or a combination

Salt and freshly ground pepper, to taste

1 (1-ounce) piece Parmesan cheese, thinly shaved (see page 78)

Using a sharp knife, pierce the squash all over. Place on a folded paper towel in the microwave oven and microwave on High for 6 to 7 minutes. Turn over and microwave on High for 8 to 10 minutes, until the squash yields to gentle pressure. Remove the squash from the microwave and let stand for 5 minutes. (Times are for an 800-watt microwave oven; adjust as needed.)

While squash is standing, melt the butter in a small heavy skillet over medium-low heat. Add the garlic and shallot; sauté, stirring occasionally, until the shallot is limp, about 5 minutes. Stir in the herbs and season with salt and pepper; remove the herb butter from the heat.

Cut the squash in half lengthwise and remove the seeds. Working over a large bowl, scrape the squash flesh with a fork, loosening and separating the strands. Toss the strands with the herb butter and transfer to a serving dish. Sprinkle with the cheese and serve.

○ **PER SERVING:** 7 g carbohydrate (includes 2 g dietary fiber), 2 g protein, 5 g fat, 80 calories

○ **DIABETIC EXCHANGES:** 1½ vegetable, 1 fat

Sautéed Spinach with Garlic

MAKES 4 SERVINGS

2 pounds spinach
2 tablespoons unsalted butter
4 cloves garlic, thinly sliced

This is the simplest way to cook spinach. If you're serving this hot, it's a last-minute dish. It's also great served at room temperature, but then it needs to be made with extra-virgin olive instead of the unsalted butter, as the butter congeals at room temperature. If you like, you can dress this dish up by adding 2 tablespoons toasted sesame seeds or plumped golden raisins, but that adds extra carbs (½ gram or 4 grams per serving, respectively) and it's delicious without.

Carefully wash the spinach and discard any tough stems. Place in a colander to drain.

Melt the butter in a large nonstick skillet with a tight-fitting lid. Add the garlic and cook over medium heat, stirring, until lightly browned, 1 to 2 minutes. If necessary, run cold water over the spinach leaves so that water drops are clinging to the leaves. Place the spinach in the skillet and cover with the lid. Cook for about 1 minute, until the spinach starts to wilt. Using tongs, gently lift the cooked spinach to the top until all the spinach is barely wilted, 1 to 2 minutes.

Remove from the heat and transfer to a serving dish.

○ **PER SERVING:** 9 g carbohydrate (includes 6 g dietary fiber), 7 g protein, 6 g fat, 105 calories
○ **DIABETIC EXCHANGES:** 1½ vegetable, 1 fat

Queso Tomatoes

This is a particularly pretty dish if you use both red and yellow tomatoes. The cayenne pepper is optional, but I think it adds a nice kick to the flavor.

Preheat the oven to 400°F. Lightly oil a baking dish just large enough to hold the tomatoes.

Slice off and discard the stem end from each tomato and arrange the tomatoes in the prepared dish. Sprinkle with the onion and season with salt, black pepper, and cayenne, if using. Mix together ½ tablespoon oil and the vinegar. Drizzle over the tomatoes and distribute the cheese over the top.

Bake 15 to 20 minutes, depending on the ripeness of the tomatoes, until the tomatoes are soft and the cheese has formed a golden crust. Remove from the oven and serve.

○ PER SERVING: 5 g carbohydrate (includes 1 g dietary fiber), 3 g protein, 5 g fat, 71 calories
○ DIABETIC EXCHANGES: 1 vegetable, ½ fat

MAKES 4 SERVINGS

Extra-virgin olive oil for the baking dish, plus ½ tablespoon

4 small ripe red tomatoes (about ½ pound total)

4 small ripe yellow tomatoes (about ½ pound total)

2 tablespoons finely minced onion

Salt and freshly ground black pepper, to taste

Cayenne pepper, to taste (optional)

½ tablespoon balsamic vinegar

½ cup shredded Monterey Jack or Swiss cheese

Tomato-Zucchini Gratin

MAKES 6 SERVINGS

2 tablespoons extra-virgin olive
　oil
3 medium tomatoes, cored and
　cut into ¹/₂-inch slices
2 medium zucchini, stems
　removed, cut on the
　diagonal into ¹/₂-inch slices
1 medium onion, finely minced
3 cloves garlic, peeled and
　sliced
¹/₃ cup finely chopped fresh
　basil
Salt and freshly ground pepper,
　to taste

Frequently when I entertain or just don't want much last-minute cooking for a family meal, I opt for a vegetable gratin. The combinations can be endless—just layers of garden fresh vegetables that are drizzled with olive oil, sprinkled with onion and garlic, and sometimes finished with a thin layer of grated cheese. Once assembled, the dish bakes without attention in the oven.

Coat the bottom of a shallow gratin dish or casserole with 1 tablespoon of the oil. Layer the tomatoes alternately with the zucchini in concentric circles, overlapping slightly. Sprinkle on the onion and garlic. Scatter the basil on top and season with salt and pepper. Drizzle with the remaining 1 tablespoon of oil. (The gratin can be made ahead to this point, covered, and refrigerated for up to 12 hours.)

When ready to bake, preheat the oven to 400°F. Bake the gratin for about 30 minutes, until the vegetables are tender. Serve hot or at room temperature.

○ **PER SERVING:** 5 g carbohydrate (includes 1 g dietary fiber), 1 g protein, 5 g fat, 63 calories
○ **DIABETIC EXCHANGES:** 1 vegetable, 1 fat

Shredded Zucchini and Carrot Pancakes

I first learned to make these delicious little appetizer morsels from a Korean friend, Young An, a young physician who came to this country as a bride. Later, my friend Carole Peck, chef and owner of the Good News Café and frequent guest chef at the James Beard House in Manhattan, served similar pancakes as an appetizer at her café and at chic parties in rural Connecticut. I think these pancakes are too delicious to serve only as hors d'oeuvres, so I came up with this version to serve as a vegetable side dish when zucchini's abundant.

Using the large hole side of a hand-held grater, slice the zucchini into very thin julienne strips, rotating the zucchini to use only the flesh and not the seeds. Place the zucchini strips into a large bowl and toss with the carrot, lemon zest, salt, and pepper. Let stand for about 5 minutes.

In a small bowl, whisk the eggs, lemon juice, cheese, parsley, and basil. Pour over the zucchini mixture and stir to combine into a batter.

On a griddle or in a nonstick skillet, heat the oil and butter until foaming over medium-high heat. Drop the batter by tablespoons onto the hot griddle and cook until golden brown, 2 to 3 minutes per side. Pile the pancakes onto a heated platter and lightly sprinkle with soy sauce, if using. Serve at once.

MAKES 4 SERVINGS

2 medium zucchini, stems removed
1 medium carrot, peeled and shredded
$1/2$ teaspoon lemon zest
$1/4$ teaspoon salt
Freshly ground pepper, to taste
2 large eggs, lightly beaten
1 teaspoon fresh lemon juice
$1/4$ cup freshly grated Parmesan cheese
$1/2$ tablespoon finely minced fresh flat-leaf parsley
$1/2$ tablespoon finely minced fresh basil
1 tablespoon extra-virgin olive oil
1 tablespoon unsalted butter
Soy sauce for sprinkling (optional)

○ **PER SERVING:** 4 g carbohydrate (includes 1 g dietary fiber), 4 g protein, 9 g fat, 110 calories
○ **DIABETIC EXCHANGES:** $1/2$ vegetable, $1/2$ lean meat, $1^1/2$ fat

Two Vegetable Purées

Ever since cookbook authors made vegetable purée fashionable in the 1980s, the subject has fascinated me. Almost any vegetable can be puréed, and the combination possibilities are almost endless. Here are two of my favorites.

Carrot and Cauliflower Purée

MAKES 6 SERVINGS

1 pound baby carrots

½ pound cauliflower florets

2 tablespoons unsalted butter

1 teaspoon fresh lemon juice

3 tablespoons evaporated skim milk

Salt and freshly ground pepper, to taste

Dash grated nutmeg

When teamed with sweet carrots, this usually lily-white member of the cabbage family is tamed and brightened in flavor.

Put the carrots and cauliflower in the top of a steamer and steam over boiling water until tender, about 10 minutes. Transfer the vegetables to a food processor and add the butter, lemon juice, and milk. Process until smooth.

Taste and season with salt and pepper. Transfer the purée to a serving bowl and lightly dust the top with nutmeg. Serve hot.

○ PER SERVING: 11 g carbohydrate (includes 3 g dietary fiber), 2 g protein, 4 g fat, 85 calories
○ DIABETIC EXCHANGES: 1½ vegetable, ½ fat

White Turnip and Apple Purée

Turnips, especially large ones, can have a bitter taste. Here I've sweetened it with apple—sometimes I use a pear with little change in carb count.

Place the turnips in a pot of boiling water to cover. Cook until tender, about 15 minutes. Drain the turnips and place in a food processor along with the apple, butter, and lemon juice. Process until smooth.

Taste and season with salt and pepper. Transfer the purée to a serving bowl and lightly dust the top with cinnamon. Serve hot.

MAKES 6 SERVINGS

8 small white turnips, peeled and coarsely chopped
1 medium Granny Smith apple, peeled, cored, and coarsely chopped
2 tablespoons unsalted butter
2 teaspoons fresh lemon juice
Salt and freshly ground pepper, to taste
Dash ground cinnamon

○ PER SERVING: 8 g carbohydrate (includes 2 g dietary fiber), 1 g protein, 4 g fat, 66 calories
○ DIABETIC EXCHANGES: 1 vegetable, ½ fat

Divine Desserts

DESSERTS—we all love them. For most of us, they are an emotional experience. If you've ever shared a decadent dessert with a loved one or created a fabulous dessert for someone special, you know what I mean. But of all the foods we eat, desserts give us the most problems with our lower-carb diet. At my home, low-carb fruits such as berries, melons, peaches, grapes, kiwifruit, and apricots are the everyday dessert.

Of course, when I'm having company or celebrating a special occasion, I like to offer a special sweet to end the meal. To that end, I gussied up some fruits and created some dessert recipes that will truly be memorable, whether or not the person enjoying them is counting carbs or following diabetic exchanges.

Grilled Peaches with Blackberries and Crème Fraîche

With the advent of overnight air freight, we can get decent peaches most of the year—especially during the summer when domestic peaches are in the markets. If your market doesn't have blackberries, you could use blueberries, raspberries, or sliced strawberries.

I always keep a container of crème fraîche in my fridge to use in a multitude of ways: mixed into a quick sauce, blended into a salad dressing, or topping a terrific dessert. You can now purchase crème fraîche in many supermarkets, but why pay the extra money when it's so easy to make? In my market, brown sugar substitute is sold on the same aisle as regular sugar. It you can't find it, ask your grocery manager to order it or try a natural foods market.

MAKES 4 SERVINGS

Canola oil, for brushing the grill rack

2 large ripe but still firm peaches, cut in half and pitted

4 teaspoons brown sugar substitute

4 teaspoons amaretto liqueur (optional)

½ cup fresh blackberries, rinsed and drained

½ cup crème fraîche (see page 150)

Preheat a grill and lightly oil the grill rack. Place the peaches, cut sides down, on the grill rack. Grill for 3 to 4 minutes and turn. Fill the cavity of each peach with 1 teaspoon of the brown sugar substitute and 1 teaspoon of the amaretto (if using). Grill until the peaches begin to soften, 2 to 3 minutes.

Place each peach half in a dessert bowl and scatter the blackberries on top. Add a generous dollop of crème fraîche and serve.

○ PER SERVING: 19 g carbohydrate (includes 3 g dietary fiber), 2 g protein, 9 g fat, 159 calories

○ DIABETIC EXCHANGES: 1 fruit, 1½ fat

Mango Upside-Down Polenta Cake

MAKES 8 SERVINGS

Mango Layer

1 tablespoon unsalted butter

1 tablespoon dark brown sugar

2 tablespoons dark rum or fresh
orange juice

2 large mangos, peeled, pitted,
and sliced

Polenta Layer

2 tablespoons whole milk

1 teaspoon sugar

¹/₂ (¹/₄-ounce) package active
dry yeast (scant ¹/₂ teaspoon)

2 large egg yolks

¹/₄ cup Splenda sugar substitute

2 teaspoons pure vanilla
extract

²/₃ cup instant polenta or stone-
ground cornmeal

4 large egg whites

When I developed this recipe for my first diabetes cookbook, it called for fresh pineapple and fructose—a form of sugar that is no longer recommended for use by people with diabetes. At the time, sucralose (Splenda no calorie sweetener) was not yet approved for U.S. consumers. Recently, I tried the recipe using sliced mango and Splenda. The result was marvelous.

Preheat the oven to 350°F.

To make the mango layer: Place the butter, brown sugar, and rum in the bottom of a 10-inch cake pan. Bake in the oven about 8 minutes, until the butter and brown sugar melt. Mix well. Arrange the mango slices in the cake pan. Set aside.

To make the polenta layer: In a small saucepan, warm the milk. Remove from the heat add the sugar and yeast. Stir until the yeast is dissolved. Set aside.

In a large bowl, beat together the egg yolks and sugar substitute until the mixture is pale yellow. Add the vanilla and mix well. Sift the polenta into the egg yolk mixture, stirring constantly. Add the yeast mixture and mix well.

Beat the egg whites until they form stiff peaks. Stir one-third of the egg whites into the polenta mixture. Carefully fold in the remaining egg whites. Pour the polenta batter over the mango layer and smooth the top.

Bake for 25 to 30 minutes, until a toothpick inserted in the center comes out clean. Cool the cake on a rack, and then turn out onto a serving plate.

○ **PER SERVING:** 18 g carbohydrate (includes 2 g dietary fiber), 3 g protein, 3 g fat, 121 calories

○ **DIABETIC EXCHANGES:** ¹/₂ bread/starch, ¹/₂ fruit, ¹/₂ fat

Almond Zabaglione with Mixed Berries

My good friend Chesley Sanders is a sixth-generation Texan and a third-generation fireman. Somehow that combination makes him a terrific cook. At a dinner party when he discovered there wasn't suffi-cient heavy cream to whip for a bowl of mixed berries he'd planned for dessert, he got busy at the stove. Within minutes, he'd made the light-est and most delicious zabaglione I've tasted in a while, using amaretto (almond) liqueur instead of the traditional Marsala. Out of deference to me, he used a sugar substitute instead of sugar.

MAKES 6 SERVINGS

6 large egg yolks
3 tablespoons Splenda sugar
 substitute
3 tablespoons amaretto
3 tablespoons heavy cream
3 cups mixed berries,
 blackberries, blueberries,
 and raspberries, rinsed and
 drained
3 tablespoons sliced almonds,
 toasted

In the top of a double boiler or a metal bowl set over a pot of boiling water (don't let the water touch the bottom of the bowl), combine the egg yolks, sugar substitute, and amaretto. Place over medium heat and whisk vigorously until the mixture becomes foamy and begins to thicken.

Remove from the heat and whisk in the cream, whisking until the cream is thoroughly incorporated and the mixture has the consistency of a custard sauce.

Divide the berries into dessert bowls or stemmed glasses. Top each with some of the zabaglione and sprinkle with the al-monds.

○ PER SERVING: 15 g carbohydrate (includes 4 g dietary fiber), 4 g pro-tein, 10 g fat, 179 calories
○ DIABETIC EXCHANGES: ¹/₂ fruit, ¹/₂ lean meat, 1¹/₂ fat

Stir-Fried Fruit with Mascarpone

MAKES 8 SERVINGS

1 tablespoon grapeseed oil

¹/₂ cup diced cantaloupe

¹/₂ cup diced honeydew

¹/₂ cup diced pineapple

¹/₂ cup diced apple with peel

1 cup blackberries

1 cup blueberries

3 tablespoons orange juice

1 cup mascarpone

When I first saw stir-fried fruit on a restaurant menu, the hot fruit was served with a caramel sauce and ginger ice cream—all laden with carbs. My version takes the goodness of summer fruit and pairs it with mascarpone—Italian cream cheese—for a dessert that's elegant and delectable. If your market doesn't carry mascarpone, use cream cheese beaten with a little cream to thin it to the consistency of mayonnaise.

Heat the oil in a sauté pan over medium heat. Add the cantaloupe, honeydew, pineapple, and apple, and stir-fry for 1 minute. Add the blackberries, blueberries, and orange juice. Remove from the heat, and gently stir to combine.

Place a mound of the mascarpone in each of 6 dessert dishes. Spoon the fruit and pan juices around the mascarpone. Serve immediately.

○ PER SERVING: 10 g carbohydrate (includes 2 g dietary fiber), 3 g protein, 15 g fat, 179 calories

○ DIABETIC EXCHANGES: ¹/₂ fruit, 2¹/₂ fat

Baked Apple Wedges

Serve these luscious apple wedges in a pretty dessert bowl unadorned, or topped with a drift of softly whipped cream, a dollop of crème fraîche, or a small scoop of low-carb vanilla ice cream. The nutrition analysis is for the apples served unadorned.

Preheat the oven to 375°F. Butter a large baking sheet.

Place the brown sugar substitute, oats, nuts, and spices in a food processor. Pulse until mixture is finely chopped. Transfer to a shallow bowl.

Peel the apples, core, and cut each into 8 wedges. Dip the apple wedges into the egg mixture, letting the excess drain off, and then roll in the oat mixture and place on the prepared baking sheet. Bake for 10 to 15 minutes, until the apples are soft but not mushy. Serve warm with whipped cream, if desired.

○ PER SERVING: 21 g carbohydrate (includes 4 g dietary fiber), 3 g protein, 5 g fat, 137 calories
○ DIABETIC EXCHANGES: ½ bread/starch, ½ fruit, 1 fat

MAKES 6 SERVINGS

1 tablespoon unsalted butter, for the baking sheet
2 tablespoons brown sugar substitute
½ cup rolled oats
¼ cup sliced almonds, toasted
¼ teaspoon ground cinnamon
¼ teaspoon ground ginger
⅛ teaspoon ground nutmeg
⅛ teaspoon ground cloves
3 medium baking apples such as Jonathan, McIntosh, or Rome Beauty
1 large egg beaten with 2 tablespoons dark rum
Whipped cream, crème fraîche (see page 150), or low-carb ice cream (optional)

Sparkling White Sangria with Frozen Grapes

MAKES 6 SERVINGS

1 cup dry white wine

2 (4-serving-size packages) lemon-flavored sugar-free gelatin

3 cups club soda

2 tablespoons fresh lime juice

1 cup seedless green grapes, rinsed and stemmed

1 cup seedless red grapes, rinsed and stemmed

6 small clusters of blue-black grapes for garnish

To keep the most effervescence in this dessert, prepare it no more than 12 hours before you intend to serve it. It will set firm in as little as 4 hours, but this is definitely a make-ahead dessert. It's a wonderfully light and refreshing end to a heavy meal.

In a small saucepan, bring the wine to a boil. Add the gelatin and stir until completely dissolved. Transfer the gelatin mixture to a large metal bowl and stir in the club soda and lime juice. Set the bowl into a slightly larger bowl filled with ice and water. Let stand about 10 minutes, stirring occasionally, until thickened.

Stir in the green and red grapes and divide equally among 6 stemmed glasses. Cover the top of each glass with a small piece of plastic wrap and refrigerate until firm, about 4 hours.

Rinse the blue-black grapes and place on a small baking sheet. Set into the freezer until you're ready to serve the dessert.

To serve, place each glass on a small dessert plate, removing and discarding the plastic wrap. Garnish each glass with a cluster of frozen grapes. Serve immediately.

○ PER SERVING: 10 g carbohydrate (includes 1 g dietary fiber), 1 g protein, less than 1 g fat, 67 calories

○ DIABETIC EXCHANGES: ½ fruit

THE DESSERT CHEESE TRAY

Always my favorite when abroad or on a luxury cruise ship, the dessert cheese tray is virtually forgotten on this side of the world. I'm always pleased when I offer it to guests after a rich meal and get kudos as if I'd invented the idea. You'll need at least four kinds of cheese with contrasting textures and flavors. Use a woven shallow basket, a carved wooden board, or a pretty tray, lined with real or fake grape leaves to hold the cheese. Position a cheese knife next to each kind of cheese and decorate the tray with tiny clusters of different colors of grapes, whole strawberries, and small piles of spiced nuts and chocolate-covered almonds. Let the cheese soften for at least 30 minutes before serving. Offer small pieces of a specialty nut bread for your non-carb-counting guests and low-carb crackers for the others. Ask your cheese market for recommendations. Here are some possibilities.

- *Hard cheese:* Cheddar, Edam, and Gouda
- *Blue cheese:* Gorgonzola, Maytag blue, Roquefort, Saga, and Stilton
- *Goat cheese:* Boucheron, Montrachet
- *Sheep cheese:* Manchego, Pecorino
- *Soft cheese:* Brie, Camembert, cream Havarti

Oven-Roasted Strawberries with Crème Chantilly

MAKES 4 SERVINGS

Oven-Roasted Strawberries
1 pound large fresh
 strawberries, stems removed
2 tablespoons unsalted butter,
 melted
2 tablespoons Grand Marnier
 liqueur

Crème Chantilly
½ cup heavy cream
1 tablespoon Splenda sugar
 substitute
½ teaspoon pure vanilla
 extract

Oven-roasting of fruit has become very popular. Here, I've roasted large strawberries that have been drizzled with a bit of Grand Marnier. Served with a dollop of Crème Chantilly (lightly sweetened whipped cream), it makes a lovely dessert worthy of special company.

To roast the strawberries: Preheat the oven to 300°F. Rinse the berries and drain briefly on a paper towel. Lay the berries in a single layer, stems side down, in a baking pan. Brush the berries with the melted butter and drizzle with the Grand Marnier. Roast for 6 to 8 minutes, until the berries are quite soft. Remove from the oven and cool in the pan.

To make the crème: Just before serving, whip the cream with the sugar substitute and vanilla until soft peaks form.

Pile the berries into 4 dessert dishes. Drizzle with some of the pan juices and top with a dollop of Crème Chantilly. Serve warm.

○ **PER SERVING:** 11 g carbohydrate (includes 3 g dietary fiber), 1 g protein, 17 g fat, 203 calories
○ **DIABETIC EXCHANGES:** ½ fruit, 3 fat

Black Figs Broiled with Goat Cheese and Walnuts

Domestic black figs have a short growing season, with a harvest in July and again in September. Other times, use a golden-skinned or creamy amber-colored variety, or whatever's available at your local produce market.

MAKES 4 SERVINGS

4 large figs
2 ounces mild fresh goat cheese
2 tablespoons heavy cream
1 teaspoon light brown sugar
1 teaspoon grated orange zest
¼ cup chopped walnuts

Preheat the broiler. Using a sharp knife, cut each fig into sixths, cutting from the top to within 1 inch of the bottom. Spread the segments open like a flower, making sure to not break them apart. Place the figs in a baking dish.

In a bowl, whisk together the cheese, cream, brown sugar, and orange zest. Divide the cheese mixture, placing each quarter in the center of a fig. Broil until the cheese mixture is lightly browned and bubbling, about 4 minutes.

Transfer to 4 dessert plates and sprinkle each with some of the walnuts. Serve immediately.

○ **PER SERVING:** 15 g carbohydrate (includes 3 g dietary fiber), 5 g protein, 12 g fat, 178 calories
○ **DIABETIC EXCHANGES:** 1 fruit, 1 lean meat, 2 fat

Baked Pears with Almond-Lemon Topping

MAKES 4 SERVINGS

Unsalted butter, for the baking
 dish
2 medium Bartlett pears
1/4 cup dry white wine
1/2 cup whole blanched almonds
1 tablespoon Splenda sugar
 substitute
1 teaspoon grated lemon zest
1/4 teaspoon ground cinnamon
1/2 large egg white (about 1 1/2
 tablespoons)
Softly whipped cream
 (optional)

Remember this recipe when the wind's howling outside and you want to serve a warm, comforting dessert.

Preheat the oven to 375°F. Lightly butter a shallow baking dish just large enough to hold the pear halves in a single layer.

Peel the pears, cut in half, and remove the cores. Place the pear halves in a single layer, cut side down, in the prepared dish. Cut each half crosswise into 5 or 6 even slices, taking care to not cut all the way through to the bottom. Pour the wine into the dish and bake for 20 minutes.

In the meantime, place the almonds, sugar substitute, lemon zest, and cinnamon in a food processor. Pulse until the almonds are very finely chopped. Add the egg white and pulse again. Remove from the processor and set aside.

When the pears have baked for 20 minutes, sprinkle them with the almond mixture. Bake for 10 minutes, then broil for 1 minute, until the almond mixture is lightly browned. Transfer the pear halves, cut side down, to dessert plates and top with a dollop of whipped cream, if using.

○ **PER SERVING:** 16 g carbohydrate (includes 4 g dietary fiber), 5 g protein, 9 g fat, 171 calories
○ **DIABETIC EXCHANGES:** 1 fruit, 1/2 very lean meat, 1/2 lean meat, 2 fat

Warm Peach Soufflé

Dessert soufflés are easy to make and fun to serve. You can have the purée ready so that all you have to do at the last minute is to whip the egg whites and fold in the peach purée.

Peel and pit 2 of the peaches. Coarsely chop and then purée in a food processor. Combine with the cornmeal in a small saucepan. Bring to a boil and add the lemon and juice and, if using, the peach brandy. Remove from the heat and set aside.

Lightly butter 6 (1-cup) soufflé dishes. Set the dishes on a baking sheet. (The soufflés can be made ahead to this point.)

When ready to bake, preheat the oven to 350°F. Peel, pit, and dice the remaining 2 peaches.

Using an electric mixer on high speed, whip the egg whites with the brown sugar until stiff peaks form. Gently fold into the purée mixture, and then fold in the diced peaches. Spoon the mixture into the prepared soufflé dishes and bake for 17 minutes, until puffed and lightly browned.

Place each soufflé dish on a dessert plate lined with a folded linen napkin. Serve hot.

○ PER SERVING: 14 g carbohydrate (includes 1 g dietary fiber), 2 g protein, 1 g fat, 66 calories
○ DIABETIC EXCHANGE: ¹/₂ fruit

MAKES 6 SERVINGS

4 medium ripe peaches
1 tablespoon finely ground white cornmeal
Grated zest and juice of 1 lemon
1 tablespoon peach brandy (optional)
1 teaspoon unsalted butter
3 large egg whites
2 tablespoons light brown sugar

Flourless Chocolate Soufflé Cake

MAKES 8 SERVINGS

Butter for the tart pans plus ½
　　cup (1 stick) unsalted butter,
　　cut into 1-inch pieces
8 ounces bittersweet chocolate,
　　chopped
Pinch salt
2 large eggs
6 large egg yolks
2 tablespoons sugar
2 tablespoons Splenda sugar
　　substitute
1¼ teaspoons pure vanilla
　　extract
Softly whipped cream for
　　garnish (optional)

The Princess Resort in Scottsdale, Arizona, used to serve a flourless chocolate cake with a warm, gooey center. The chef wouldn't part with his recipe, but undaunted I went into my kitchen and came up with a close replica. Since the cake is baked in individual tartlet pans and must chill before baking, these are a great make-ahead dessert that can be baking while you're clearing the dinner table and brewing the after-dinner coffee. If you're making this dessert for company, you might want to splurge on a few fresh raspberries for an extra garnish. Although considerably less than most chocolate cakes, this cake is high in carbohydrate and should be saved for very special occasions.

Butter 8 (4½ × ¾-inch) tart pans with removable bottoms. Place the pans on a baking sheet.

In a heavy saucepan over low heat, stir the ½ cup butter and the chocolate until melted and smooth. Remove from the heat and stir in the salt. Cool to lukewarm, stirring occasionally.

Separate the eggs and add the 2 yolks to the other 6 yolks. Using an electric mixer beat the egg yolks, sugar, 1 tablespoon of the sugar substitute, and the vanilla until the mixture is pale yellow and thick, about 5 minutes. Fold one-fourth of the egg mixture into the chocolate mixture, and then fold the chocolate mixture into the egg mixture.

In another bowl, beat the egg whites until soft peaks form. Add the remaining 1 tablespoon sugar substitute and beat until stiff peaks form. Gently stir one-fourth of the beaten egg whites into the chocolate mixture, then carefully fold in the remaining egg whites. Divide the batter among the prepared pans. Cover and chill for at least 6 hours or up to 24 hours.

When ready to bake, preheat the oven to 400°F. Position a rack in the center of the oven. Bake the cakes about 11 minutes, until the edges are set and the centers are still soft. Remove

from the oven and cool in the pans on a rack for 2 to 3 minutes. Loosen cakes by running a small knife around the pan sides. Transfer the cakes to 6 dessert plates, slipping off the removable bottoms. Garnish each cake with a drift of whipped cream, if using. Serve warm.

○ **PER SERVING:** 20 g carbohydrate (includes 2 g dietary fiber), 6 g protein, 26 g fat, 338 calories

○ **DIABETIC EXCHANGES:** 1/2 lean meat, 5 fat

Italian Dessert Ricotta with Ground Espresso

MAKES 4 SERVINGS

2 cups whole-milk ricotta
 cheese
2 tablespoons brown sugar
 substitute
2 teaspoons grated lemon zest
¼ cup strong espresso, chilled
1 tablespoon espresso beans,
 ground

Ricotta cheese, a staple in Italian cooking, tastes surprisingly rich and decadent when served this way. If you don't have an espresso machine, you can use instant espresso, but you will need to buy a few espresso beans to grind in your coffee or spice grinder.

Place the ricotta cheese, brown sugar substitute, and lemon zest in a food processor or blender and pulse until smooth and velvety, about 2 minutes. Divide among 4 dessert dishes. Drizzle 1 tablespoon of the espresso over each serving and sprinkle with some of the ground espresso beans. Serve chilled.

○ PER SERVING: 10 g carbohydrate (less than 1 g dietary fiber), 14 g
 protein, 16 g fat, 229 calories
○ DIABETIC EXCHANGES: 2 lean meat, 2½ fat

CITRUS ZEST

In my cooking, I use a lot of citrus zest. When used in these small amounts here and spread over the number of servings, it adds only a trace of carbohydrate and so much extra flavor. Zest adds amazing flavor to everything from soups to desserts.

You can buy a zester in gourmet cookware shops and many supermarkets. It makes it easy to remove the zest from the bitter white pith underneath. You can also use a hand-held grater to remove the zest,

but be careful not to nick your knuckles. Once the zest is removed, mince it finely unless otherwise directed by the recipe.

Anytime a large amount of zest (in excess of ¼ cup) is called for in a recipe, you can use the equivalent drops of citrus oil to save a carb or two. These oils come in lemon, lime, and orange flavors and are available by mail order or over the Internet from Williams-Sonoma or King Arthur Flour.

Winter Fruit Compote

During the depths of the cold winter months, fresh fruits of high quality are sometimes hard to come by. Not so for pineapple, kiwifruit, and citrus fruits such as tangerines and oranges. Here I've paired them with delicious pomegranate seeds—if their short season has passed, you can substitute dried sour cherries or cranberries.

MAKES 6 SERVINGS

2 large navel oranges
4 cups diced pineapple
3 firm-ripe kiwifruit, peeled
 and sliced into thin rounds
1 cup pomegranate seeds
Juice of 1 tangerine

Peel the oranges, removing all of the white pith. Cut the oranges into thin rounds and arrange in overlapping layers on each of 6 dessert plates. Follow with layers of pineapple and kiwifruit. Sprinkle the pomegranate seeds over all and drizzle with the tangerine juice. Cover and refrigerate until ready to serve.

○ **PER SERVING:** 17 g carbohydrate (includes 2 g dietary fiber), 1 g protein, less than 1 g fat, 69 calories
○ **DIABETIC EXCHANGES:** 1 fruit

SEEDING A POMEGRANATE

If you've ever seeded a pomegranate, you know that without taking precautions, you're likely to get the bright crimson juice all over you and the kitchen. Here's how to easily avoid that. Cut the pomegranate into quarters. Place in a deep bowl of water. While working under the water, gently remove the connecting pulp to free the seeds. Discard the shell and pulp. Drain the seeds on paper towels.

To freeze the seeds for future use, pack in a self-sealing plastic freezer bag (use the smallest possible to minimize the airspace) and place in the freezer. Freeze for up to 6 months. The seeds will separate easily while still frozen.

Blueberry Cobbler

MAKES 6 SERVINGS

Canola cooking spray
2 cups fresh blueberries, rinsed
 and drained
2 teaspoons grated lemon zest
2 tablespoons sugar
2 tablespoons canola oil
1 large egg
½ cup almond flour (see insert)
1 teaspoon baking powder
⅛ teaspoon salt
¼ cup evaporated skim milk

This cobbler is quite rich, so the small portions are plenty. Another time, use fresh peaches, plums, blackberries, or raspberries.

Preheat the oven to 350°F. Lightly coat a 6-inch round metal cake pan with cooking spray. Spread the blueberries in the bottom of the pan and sprinkle with 1 teaspoon of the lemon zest.

In a medium bowl, cream together the sugar and oil. Whisk in the egg until the mixture is thick and smooth. Mix together the almond flour, baking powder, and salt. Add to the egg mixture, alternating with the milk, until well combined. Stir in the remaining 1 teaspoon lemon zest.

Spread the mixture over the blueberries. Bake for 20 to 25 minutes, until a tester inserted in the middle comes out clean. Cool in the pan on a wire rack before serving. To serve, spoon the cobbler into 6 small dessert bowls.

○ PER SERVING: 14 g carbohydrate (includes 1 g dietary fiber), 4 g protein, 10 g fat, 151 calories
○ DIABETIC EXCHANGES: ½ fruit, 1 fat

ALMOND FLOUR

This wonderful, slightly mealy flour is great for low-carb baking. And ¼ cup almond flour has 3 grams of carbohydrate, while the same amount of all-purpose flour contains 24 grams. I can buy almond flour at one of my local supermarkets or at a natural foods store, but you may need to order it from the Internet. Keep almond flour tightly sealed in the refrigerator.

Peach and Golden Raisin Clafouti

My sister-in-law Helen Giedt makes this country French dessert with peaches grown in her backyard. It could also be made with cherries, nectarines, apricots, plums, apples, or a combination of two or more fruits. This is truly a multitude of desserts wrapped up in one recipe.

Preheat the oven to 400°F. Lightly butter a 12-inch round casserole or gratin dish.

Peel, pit, and thinly slice the peaches. Arrange in the bottom of the prepared dish. Set aside.

In a food processor, combine the eggs, 1 cup of the cream, the almond flour, sugar substitute, allspice, and salt. Process until a smooth batter is formed. Pour the batter around the fruit and sprinkle with the raisins.

Bake for 12 minutes, until the top begins to set. Sprinkle with 1 tablespoon of the brown sugar. Bake 8 to 10 minutes, until the clafouti is set and golden brown on the top. Remove from oven and cool in the pan on a rack.

Whip the remaining ¾ cup cream until soft peaks form. Serve the warm clafouti, cut into 8 wedges, with the whipped cream, sprinkled with a bit of the remaining brown sugar.

○ PER SERVING: 10 g carbohydrate (includes 1 g dietary fiber), 3 g protein, 18 g fat, 207 calories
○ DIABETIC EXCHANGES: ½ fruit, 3 fat

MAKES 8 SERVINGS

Unsalted butter, for the baking dish
1 pound fresh peaches
2 large eggs
1¾ cups heavy cream
¼ cup almond flour (see page 192)
¼ cup Splenda sugar substitute
⅛ teaspoon ground allspice
Pinch salt
2 tablespoons golden raisins
1½ tablespoons light brown sugar

Chocolate Fantasy Clusters

MAKES 24 CLUSTERS

5 ounces semisweet chocolate

1 ounce bittersweet chocolate

1 tablespoon hazelnut liqueur
 (optional)

12 dried apricots, finely
 chopped

3/4 cup coarsely chopped toasted
 hazelnuts

Just a few simple ingredients and a few minutes of your time is all that it takes to have a chocolate treat that doesn't cost a lot of carbs. The clusters will keep in the refrigerator for up to 2 weeks or in the freezer for up to 2 months.

If you can buy Turkish dried apricots, use them; they have a superior flavor to the domestic ones.

Line a baking sheet with parchment paper.

Coarsely chop both kinds of chocolate. Place in a microwave-safe bowl and microwave on Medium for 2 minutes, then stir with a wooden spoon. Microwave for 1 minute, until chocolate is melted. If using, stir in the liqueur. Stir vigorously until the chocolate is smooth and glossy.

Add the apricots and the hazelnuts to the chocolate and stir to mix thoroughly. Using a small spoon, scoop out slightly rounded teaspoonfuls of the mixture and drop onto the prepared baking sheet, spacing evenly. Refrigerate, uncovered, until set, about 2 hours. Transfer the hardened clusters to 24 (2-inch) paper candy cups and place in an airtight container. Refrigerate or freeze.

○ PER CLUSTER: 7 g carbohydrate (includes 1 g dietary fiber), 1 g protein, 4 g fat, 67 calories

○ DIABETIC EXCHANGES: 1/2 carbohydrate, 1 fat

Index